風景

WINDSCAPE

風景

Bae, Bien-U

HATJE
CANTZ

WINDSCAPE

風景

GAE BEHN-U

HATJE CANTZ

Jeong-hee Lee-Kalisch

THE SILENT MELODY IN THE WIND

BAE, BIEN-U'S SUBJECTIVE PERCEPTION OF LANDSCAPE

The eye renders the image. The photographic artist Bae, Bien-U, distinguishes himself from many of his contemporaries in that he does not subsequently conceptually supplement or digitally rework his photographs; rather, he uses the artistic capacity of the camera and his eye in order to capture the landscape. He is therefore one of the so-called classic artists, who allow their natural perception to be defined solely by the eye. In the process, Bae's camera is the medium of his heart, which causes his finger to press the release—much like the relationship between the brush and the elbow and heart in traditional East Asian painting. His photographic works are the immediate rendition of each individual aesthetic experience. Ideas and concepts ideally develop before he sets out with his camera. Once he has arrived at the location, Bae relies on intuition and an aesthetic eye, and the conversion of an idea by means of the camera takes only a fraction of a second. With his evanescent perspective, Bae's works visualize an atmosphere that is difficult for the human eye to perceive, and to which it also has no access. The moment conveys the landscape to the viewer as a truly temporary still life in which the breath and the passion of the artist are palpable. Each scene loses its temporal framework and achieves intrinsic value, which reveals itself, timelessly and enduringly, as an objective universal.

It may be for this reason that the landscape spaces photographed by Bae, Bien-U, instantly captivate viewers, causing them to stand in front of them and contemplate them more closely. They are invited to enter, submerge themselves in the world of images, ultimately realizing that they are in harmony with the world being depicted.

Based on the *Windscape* series by Bae, Bien-U, this essay attempts to deal with the following questions: Why does Bae's subjective perception of the landscape so thoroughly permeate the viewer's heart? To what extent do painterly means play a role in his photographic eye? Which of the aesthetic values of the images account for this fascination?

Windscape, Punggyeong

The spectrum of Bae's works encompasses the sea, mountains, and coastal views in the wind, as the title of the series, *Windscape,* indicates. Today, the Korean term *punggyeong* (in Chinese it is *fengjing,* and Japanese, *fūkei*) is generally used to designate landscape scenery; however, with reference to East Asia's art tradition it needs to be more clearly defined in terms of its initial meaning. In East Asia, the term was originally used in the late nineteenth and early twentieth century to refer to landscape painting done in oil or watercolors in the style of European Impressionism. In the East Asian art reception, color depictions of the landscape under alternating light and atmospheric conditions belonged to its primary painterly tasks. The term *punggyeong* distinguished landscape paintings in the European style (*punggyeonghwa*) from traditional landscape painting, *sansuhwa* (paintings of mountains and water), whose goal was to represent *qi* as the essence of nature.

Bae's photographs not only contain the features of the European aesthetic, *punggyeong,* but also aspects of the traditional criteria of *sansu.* On the one hand, his landscapes are true windscapes, not only because photography

and the camera as an artistic medium originated in European art, but also because Bae's art captures an element of the alternating landscape in light and shadow. On the other hand, his images are a recording of the representation of the landscape's very essence.

The Quintessence of Bae's Works

According to Taoist, Buddhist, and neo-Confucian philosophy, nature is subject to the dynamic transformations of the living five elements—fire, earth, metal, water, and wood, or, depending on the tradition, earth, fire, water, wind, and air or ether—and the resulting principles of nature determine their becoming, thriving, balance, declining, passing, or dissolving. If one analyzes the old pictorial graphic characters of yin and yang, the latter includes the sky and sunlight, while yin means the shaded side based on the blanket of clouds over the hill; humankind stands between heaven and earth, and is a part of nature.

All of the factors associated with the transformation of these elements are reflected in Bae's works: at first glance, one believes that the yin element lies over the image—this impression is reinforced by the black-and-white photographs—yet one discovers yang elements in the midst of yin, and likewise yin elements in yang. The five elements are not to be understood as materials but as a primal force, and its dynamic transformations discreetly touch the viewer's senses: audible and inaudible sounds, motion in rest, rest in motion, the changing times of the day and the year, origin and weather, light and shadow, dots and lines, straight lines and curved lines, surfaces and space, contours and structures. In a balanced context this essence of nature manifests as a universal primal force.

The photographic motifs are accessible to anyone. Numerous other photographers avail themselves of nature—mountains, rocks, bodies of water, trees, leaves, the horizon, grasses, the beach, sand, fields, patches of fog, waves and the surf, clouds, hills, and so on. But the question remains whether they are capable of capturing the essentia of nature. When Bae's images lent new singularity to Korean pine trees many photographers tried to imitate him. Yet not everyone succeeds in transforming his or her aesthetic experience into an objective value that touches and captivates the viewer. For the aim of Bae's photography consists of capturing the quintessence of nature on film. If the picture turns out well, one detects the calm in the storm and the motion in rest in the rendering of the landscape. One hears the rush of the water, smells the scent of grass, and senses cold or hot in this tranquil, temporary moment and section of space. And one is sensitive to the atmosphere.

Space and Spatiality

In *Windscape* Bae uses several specific compositional schemes—in addition to the spatial arrangement that comes about due to the camera and the depth effect caused by the differences in size and shades of color of the mountains or islands. Most prevalent are the horizontal elements brought about by the landscape properties of the coasts and the sea horizons, unlike the pine motifs, in which vertical lines dominate. The clear spatial severity of the dividing

lines is broken up by other factors: in the nighttime scenes, the lights of the fishing boats—in part positioned along the sea horizon or sometimes loosely, sometimes more densely distributed over the dark sea, as if the stars are being reflected in the water—connect the realms of the heavens and the ocean. The reflections of the lights in the water function as the vertical element to balance the overall image. The upper, horizontal contours of the fields of grass moving in the wind on the coastal landscape are loosened by the wall made of stones piled one atop the other typically found on islands, which in turn is supported by the horizon in a lighter shade of gray in the background.

The slants and diagonals that run inward into the images are also taken up by the counter-diagonal elements or the luminous horizon. One very striking example of this can be found in a landscape scene with fields of grass being blown by a strong wind. The wiry lines of the reeds reflecting in the light clearly indicate that from the viewer's perspective the wind is blowing from the right. However, the reeds of grass along the upper edge are suddenly lifted back in the opposite direction due to the opposing wind, probably coming from the sea. This natural phenomenon of wind and opposing wind, which is visible in the electrified reeds of grass, spurs a feeling of creative force and dynamic impetus. The blurred tips of the reeds of grass caused by the motion of the wind intensify this impression. The close-up views of the concave or convex curves of the black outlines of the rolling hills, which appear more elastic due to the narrow, vertical format of the picture, inform the image with an energy-laden resilience.

The classic one-corner or one-side composition constitutes another structural principle. By placing the coastal rocks and the arch of the waves in one corner or on one side of the image, which at the same time palpably mark the location of the eye of the camera, the objects gradually disappear into the interior of the image, into the endlessness of nothingness. The light gray strips on the horizon mark the transition into emptiness. The rocks are in part reduced to a minimum, so that only two or three of them are visibly hovering in the seemingly soft veil of mist. Some discover the aesthetic characteristics of the depiction of what cannot be depicted or the simultaneity of contrariety in the representational emptiness. In its contrasts and harmony, this type of representation corresponds with the concept of *yu,* to exist (or *sil,* concrete), and *mu,* to not exist (or *heo,* empty), which in traditional East Asian ink painting is also considered one of the most important aesthetic criteria.

Monochrome, Black and White

The receding color in the photographic works by Bae, Bien-U, allow certain artistic elements to expressively come to the fore, which requires diligence and a different way of seeing things. Bae operates within the entire range of monochrome color nuances from black to white. The resulting photographs are therefore comparable with East Asian ink paintings, in which the brush stroke is considered a direct means of expressing one's heart and mind. What is the *brush ductus* of Bae's photography? What artistic means of expression does he characteristically apply? First of all, dark surfaces are directly contrasted with light surfaces. Their relation to one another varies markedly. The horizontal contour lines in particular are clear, so that when light and dark meet, at first glance a bold, constructive,

and powerful feeling arises, such as the one that occurs when viewing a monochrome painting or Minimal Art. In the case of this contrastive confrontation, the contour lines appear to be evident at the transition. One also encounters the use of strong contour lines and the contrasting of two differing fields in the well-known series *Boden Sea, Uttwill* (1993) by the Japanese photographer Hiroshi Sugimoto. It is above all Bae's nighttime scenes of fishing boats at sea that recall his predecessor. However, it is highly interesting to compare how both artists choose the sea as their motif yet depict it in a different way. In Sugimoto's works, which have already been interpreted numerous times, horizons serve as the essence of the images, and the pictorial surface is divided into equal sections of sky and sea. Just above the separating line of the horizons, light being emitted from a source outside the pictures' surface reflects onto the surface of the sea, and this light reflection serves as a connecting element between the two realms of the sky and the sea. In some works, the horizons are shrouded in fog or mist. Sugimoto's vast oceans radiate a certain inapproachable, mysterious atmosphere. The photo series by Bae is rendered in a panorama format. The horizons, which are positioned at different heights, do not serve as the main elements of the works; rather it is the contrast and the resulting tension between the light and extremely dark surfaces. The source of light that illuminates the surface of the sea is situated within the imagine itself. These are the illuminated dots of the fishing boats, which are sometimes densely, sometimes loosely located along an outermost horizontal boundary and come across as a flicker of hope in the black night. In some works, the lights, at times concentrated while other times loose, are scattered over the dark surface of the sea like the stars in the nighttime sky. Altogether, Bae's images convey an atmosphere of closeness, accessibility, and familiarity with life; it may be that he sees the fishing boats of his father in his photographs.

Moreover, the soft, voluminous, curved structures of the coastal landscape, which form strong contours against the bright surface of the sky, serve as Bae's personal *brush ductus* in his photography. This enlarged silhouette of the hills with their vegetation achieves the three- or even multidimensionality of illusory space in the shallow flicker of light. Like the detailed image of a sculpture or a reclining female figure, the rounded contours convey a sense of sensuousness, femaleness, and motherly protection. It is highly probable that this is the hill of Bae, Bien-U's childhood, which he climbed up time and again in order to take pleasure in the shimmering waves of the ocean and feel the relaxing wind.

A third characteristic is the balance achieved through the use of rich nuances, which lends the black-and-white image a certain stability. In many of the images, the gray surface of the sky is wide and tall; this contrasts with the narrow or dense island world placed along the lower edge of the photograph and captured by the camera from a sharp, natural angle and from a position close to the ground. The islands are reproduced in one or more intense shades of color. Thus, in contrast to the centrifugal force of the silvery, floating clouds or the mist in the vast sky, their gravity balances the image. For the benefit of momentum, in the transition to the sky, many of the outlines of the mountains, hills, and the sea horizons are consciously depicted blending into boundlessness.

In addtion, in his works Bae has the dark surfaces predominate in which an intimate, eventful interior life is intensified. The surfaces in the wind, laden with objects such as grass, evoke the specific structures and textures that develop by means of the interplay between movement in the wind and reflection in light. Depending on the perspective, these imaginary textures create effects ranging from Lyrical Abstraction to the spontaneous artistic improvisation of Art Informel. The close section of an obliquely ascending, curved skyline, which seems to be stationary, is extremely prominent, while in the inner field the reeds of grass chaotically moving in the wind diverge. In several of the monochrome mountain brook scenes with dense trees and leaves—that take up the entire surface—one can detect the wind in the outer motion through the abstracted gray zones, in contrast to the primal tranquility of the bed of the brook, which is presented with precise clarity.

Finally, the apparently empty surfaces described by means of clouds, the sky, mist, or fog, operate as Bae, Bien-U's *ductus.* Like cotton candy, the patches of fog drift forth through the shimmering black pebbles; they seem to recur serially like the high mountaintops over the seas of clouds and some of them look transparent in a translucent sea of light. When viewed up close the structures of the stones with their hollows and scars are razor sharp.

The Shrouded Beauty of Nature

In his treatise on painting, *The Lofty Message of Forest and Streams,* the Chinese landscape painter Guo Xi (1020–ca. 1090), who lived during the Song dynasty, writes that it is precisely fog and mist that lend landscape painting atmosphere. However, this observation by the old Chinese master, which from today's point of view sounds trivial, accurately demonstrates the aesthetic point of view of East Asian painting. Elements such as fog, mist, or clouds are not only absolutely necessary features of a painting in terms of composition; they also lend nature the temper, mood, and emotion of reserve, blush, modesty, protection, and solitariness. A lightly shrouded landscape, a full moon partially veiled by wisps of cloud, or a nude wearing a hint of clothing is more appealing aesthetically than the sheer nakedness of things. On the one hand, the reception of the representation of nature under alternating light conditions, plein air painting in the European tradition, which at the time was unknown in the East Asian tradition, advanced landscape depiction in East Asia in the early twentieth century. On the other hand, East Asian hearts find the romanticism of Caspar David Friedrich (1774–1840) as one of the most emotionally appealing and aesthetically accurate of the European masterpieces. Let us put ourselves in the position of the figure seen from behind in the painting *Wanderer above the Sea of Fog* (1818). What do we see in front of us? We identify with the monk in the painting *The Monk by the Sea* (1808–10) and depict the same emotion. Friedrich succeeds in transferring the landscape to the canvas in particular by shrouding the pictorial surface and thus producing an incredible emptiness that achieves abstraction.

Bae, Bien-U, also avails himself of fog, mist, clouds, and snow in his work, however, they are not produced in his studio: he captures the emotion under real-life circumstances. He does not spare either the effort or the expense

required to be there where he can consummate his concept before daybreak. He time and again emphasizes that photography is painting painted by light, and that light naturally plays an important role. Yet near and far, whether slow or fast, he captures the interplay between the movement of the air through the wind and light. When one looks at his photographs, one has the synaesthetic experience that one is listening to the first movement of the Violin Concerto in D minor, op. 47, written by Jean Sibelius in 1904. At daybreak, the shrouds of fog and mist become all the more perceptible and make the objects in nature all the more visible. In gentle motion, the light—sometimes scattered, sometimes manifested as a ray—is refracted by the misty shroud over the landscape scene, producing a whole range of tone variants and volumes. As Bae describes it, it is the hour of the birth of every day and the awakening of all life that he so much likes to capture. When explaining his immeasurable effort to take a picture at daybreak before the early morning hours he recalls the diligence of his father, a fisherman who had to be at the fish market early and on time in order to have his catch auctioned off. In 2012 Bae was crowned the proud son of his hometown of Yeosu, one of the most beautiful coastal landscapes in the south of Korea with a thousand islands. He wants to objectify the impression that arises at daybreak at the coast or in the forest for the viewer. Yet Bae does not merely depict nature; rather, he permeates nature to its inexhaustible emptiness and transcendentally transfers this metaphysical emotion to film in his own unique way.

Contemplative Tranquility in Motion

Independent of the motifs, one of the most highly interesting phenomena that Bae, Bien-U's works radiate, is contemplative tranquility. His photographs convey the second of calmness in the middle of a stormy sea, a moment of silence, a sanctuary in his microcosmic space. This is precisely what distinguishes his creative moment and his works from many of the old and contemporary landscape photographers.

The *Windscape* series demonstrates his aesthetic eye in all respects: by applying the various compositions, the rich nuances of color in monochrome, and above all the harmony of contrasts, which occurs naturally and without exaggeration; in his gentle way Bae creates a world of subtle tranquility. If one contemplates this world without dogmatic intent and with awareness of what is being depicted, the sounds of the storm cease to hiss, clatter, or roar. Bae, Bien-U captures this silence without any additional drama or graphic consequence for timelessness.

This is the moment when all of the artistic means, such as dots, lines, spots, forms, and colors, join together to form an inner light structure. Hiding and reappearing, lying and advancing, all of the dual forces—emptiness and fullness, clarity and obscurity, sharpness and haziness—seize their sides, contours and volumes, and are prepared to transmute. Silence sets in. Some describe tranquility as the meditative effect of Zen or achieving nirvana, or the enlightenment of Tao. Others might simply feel personal inner peace and all-embracing freedom. It is the moment of transmutation, of enlightenment, in which everyone merges into one. It is in this contemplative tranquility that the melody of one's own inner ear originates—a silent melody in the wind.

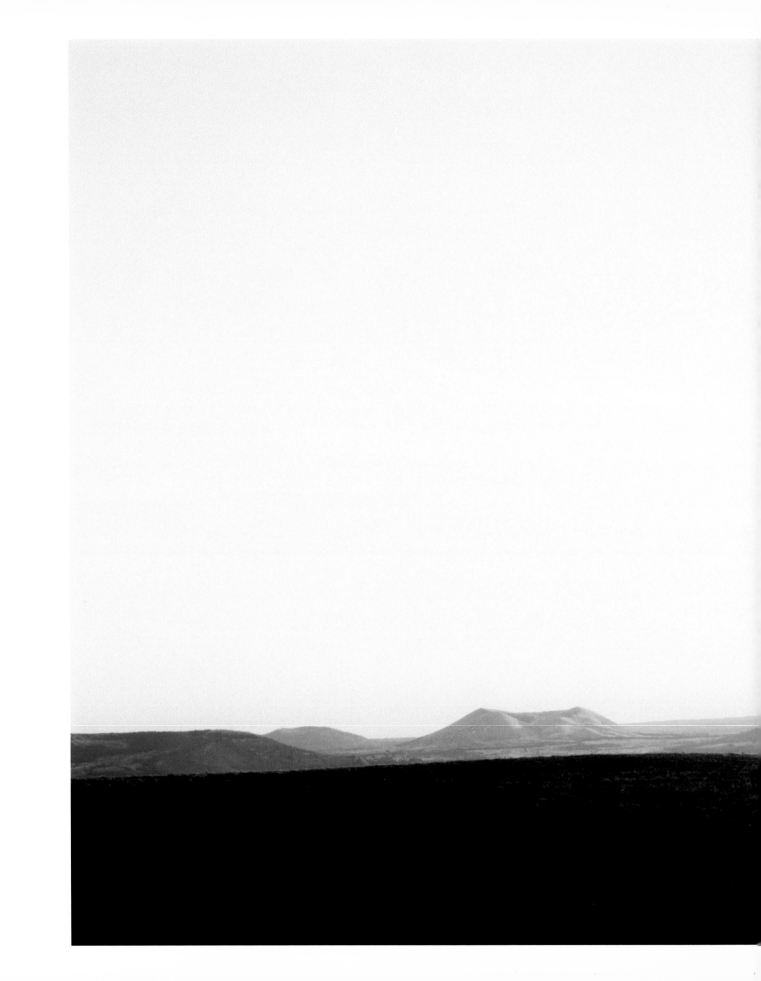

14 om1a-032h, 2002

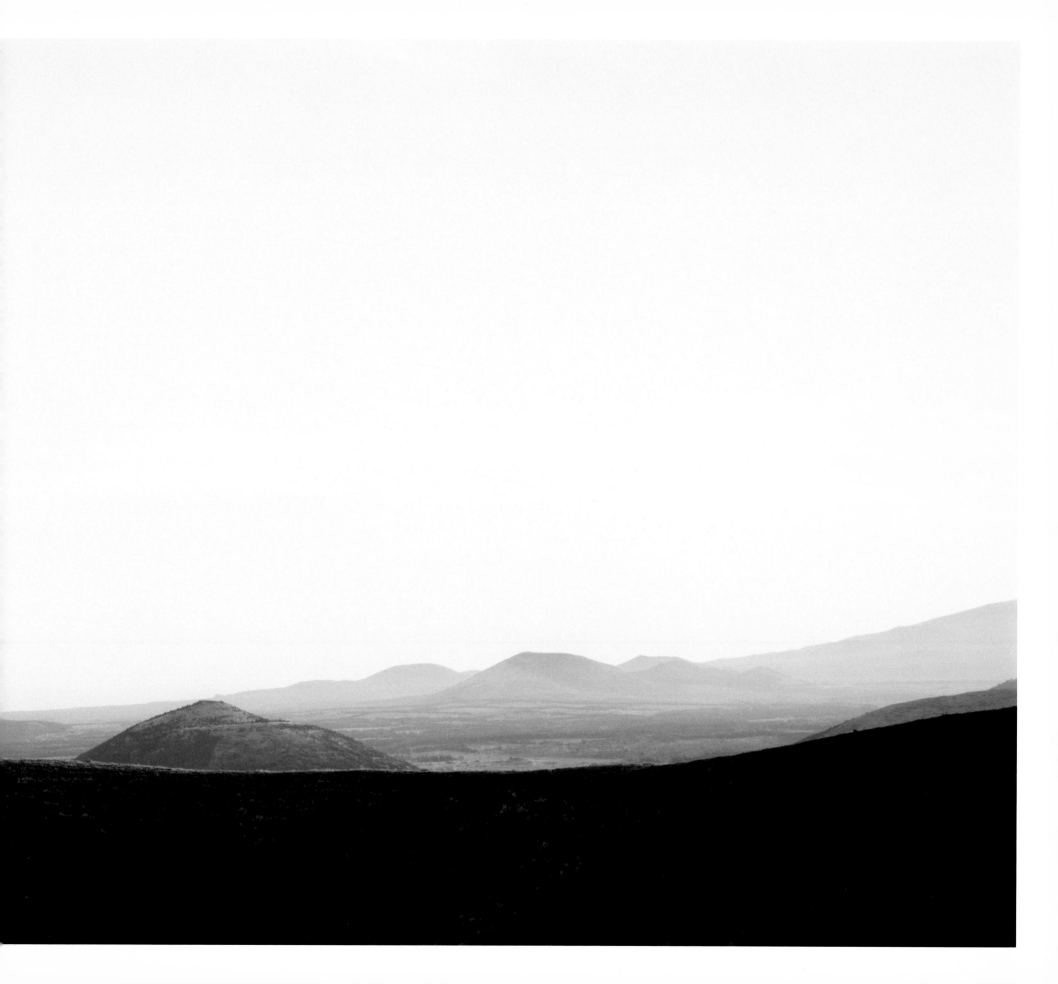

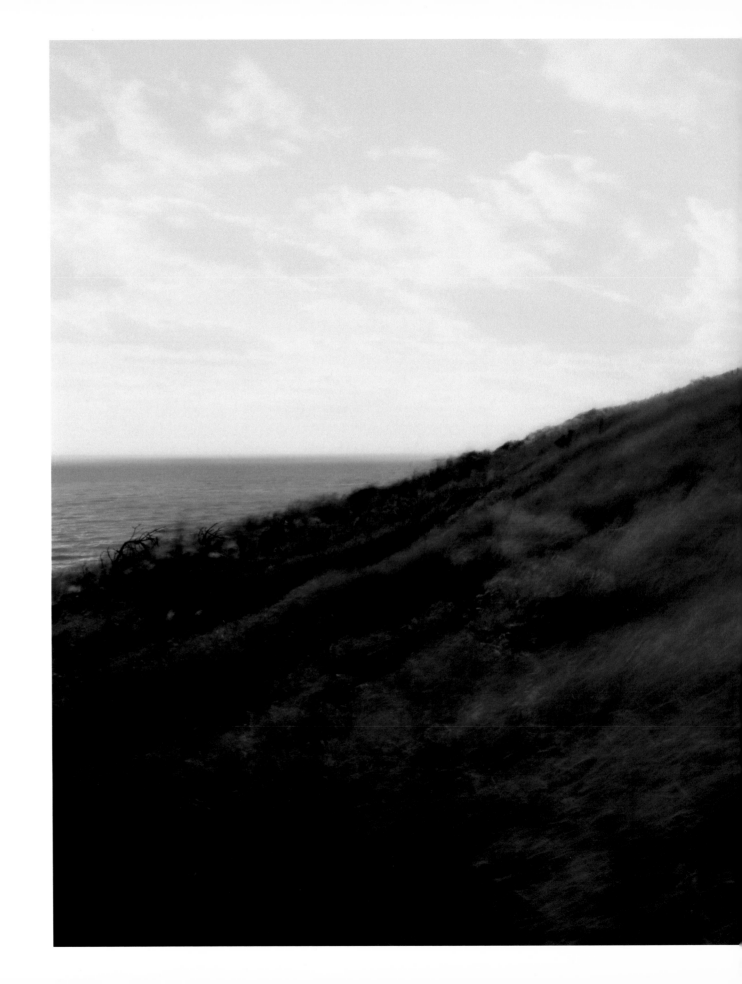

16 om1a-030h, 2007

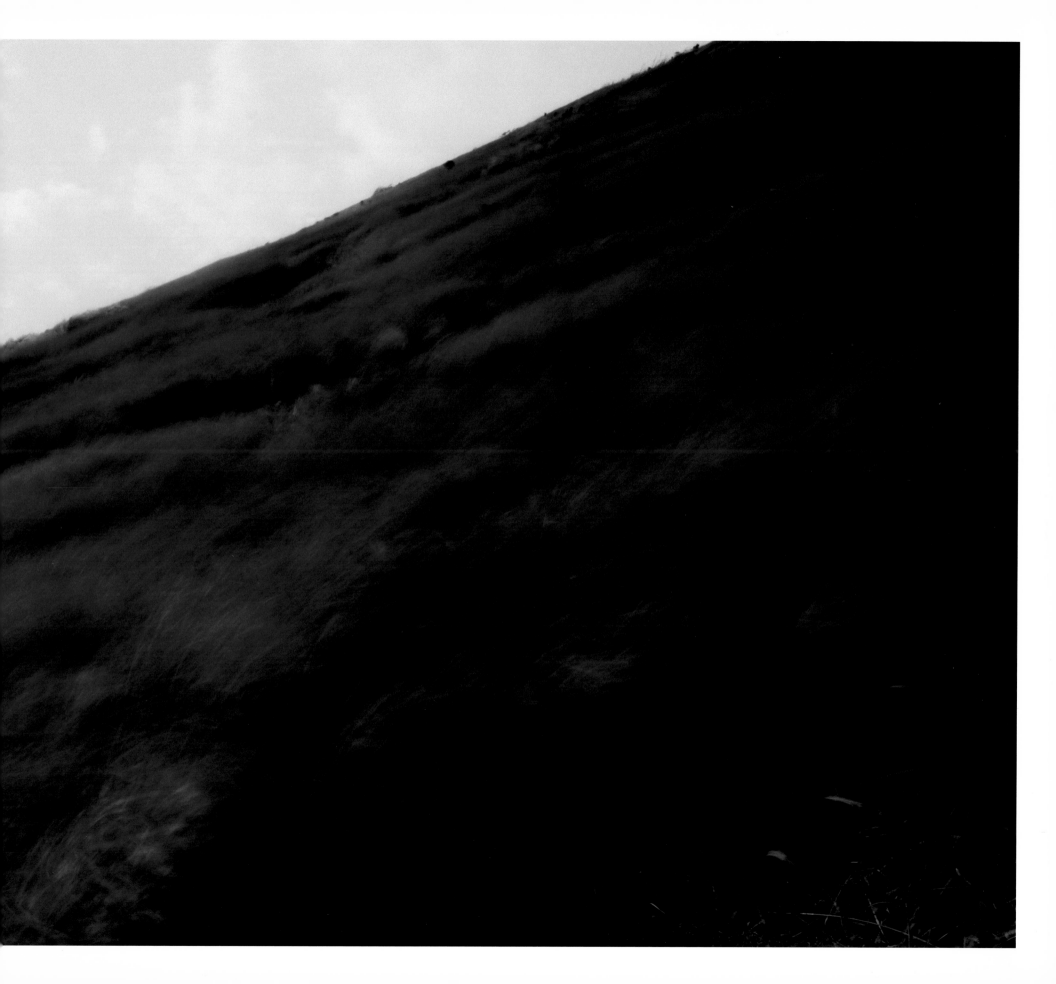

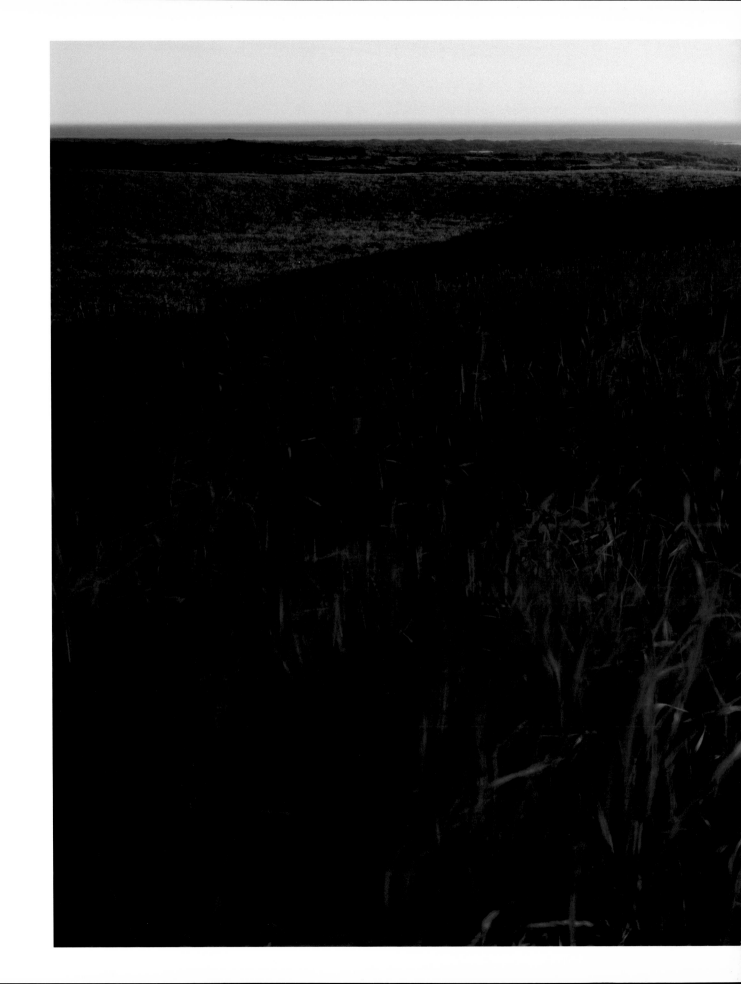

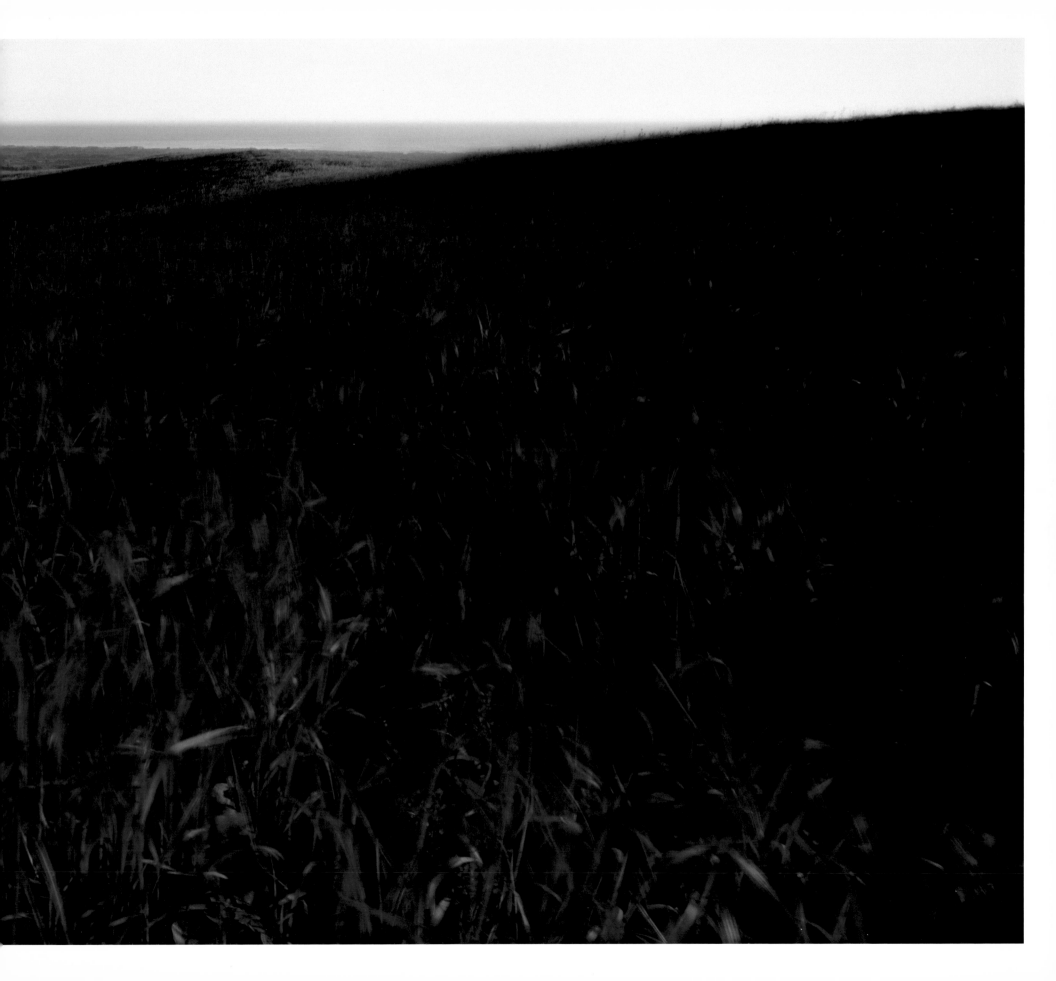

om1a-034v, 2011

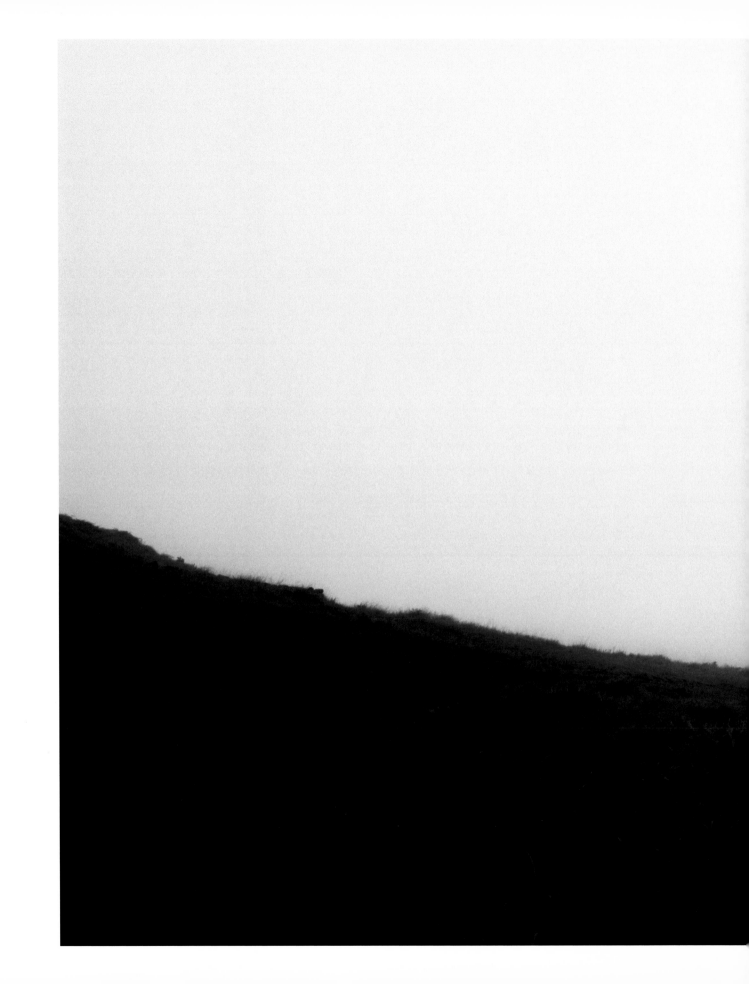

24 om1a-036h, 2009

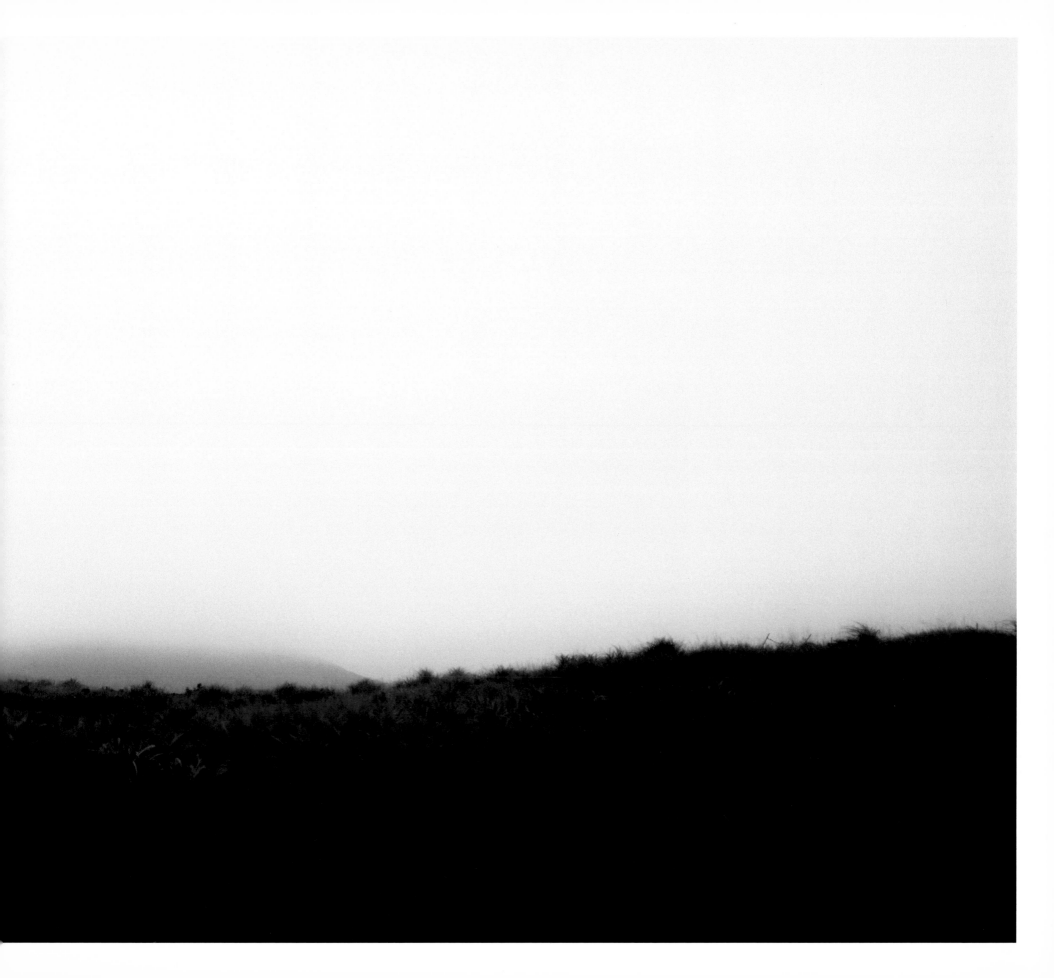

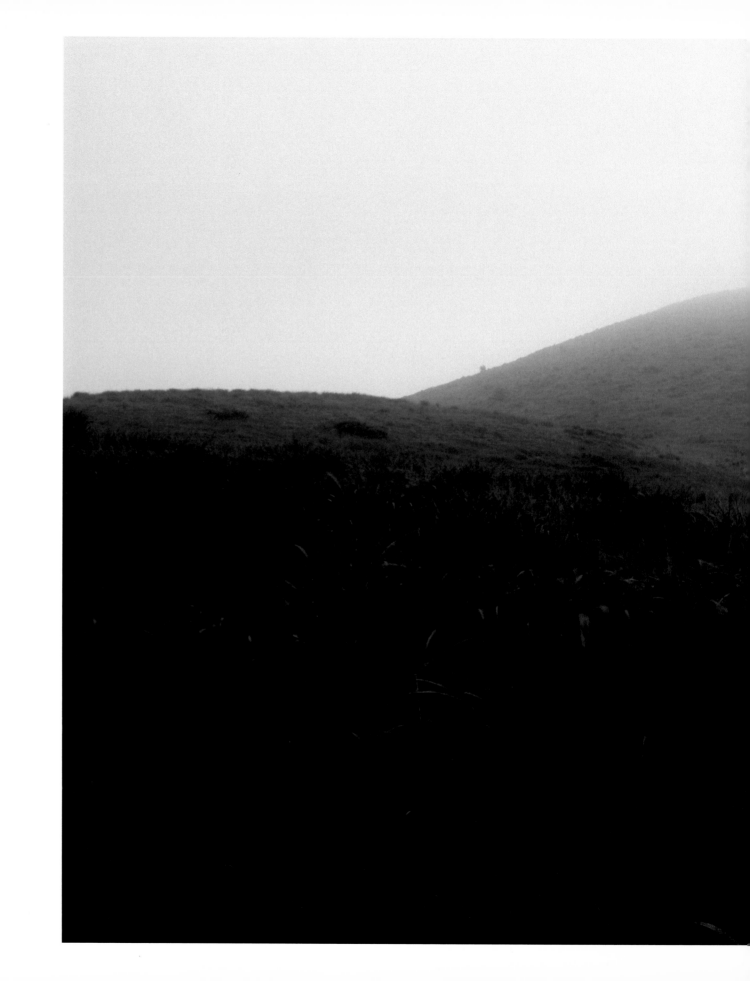

om1a-037h, 2009

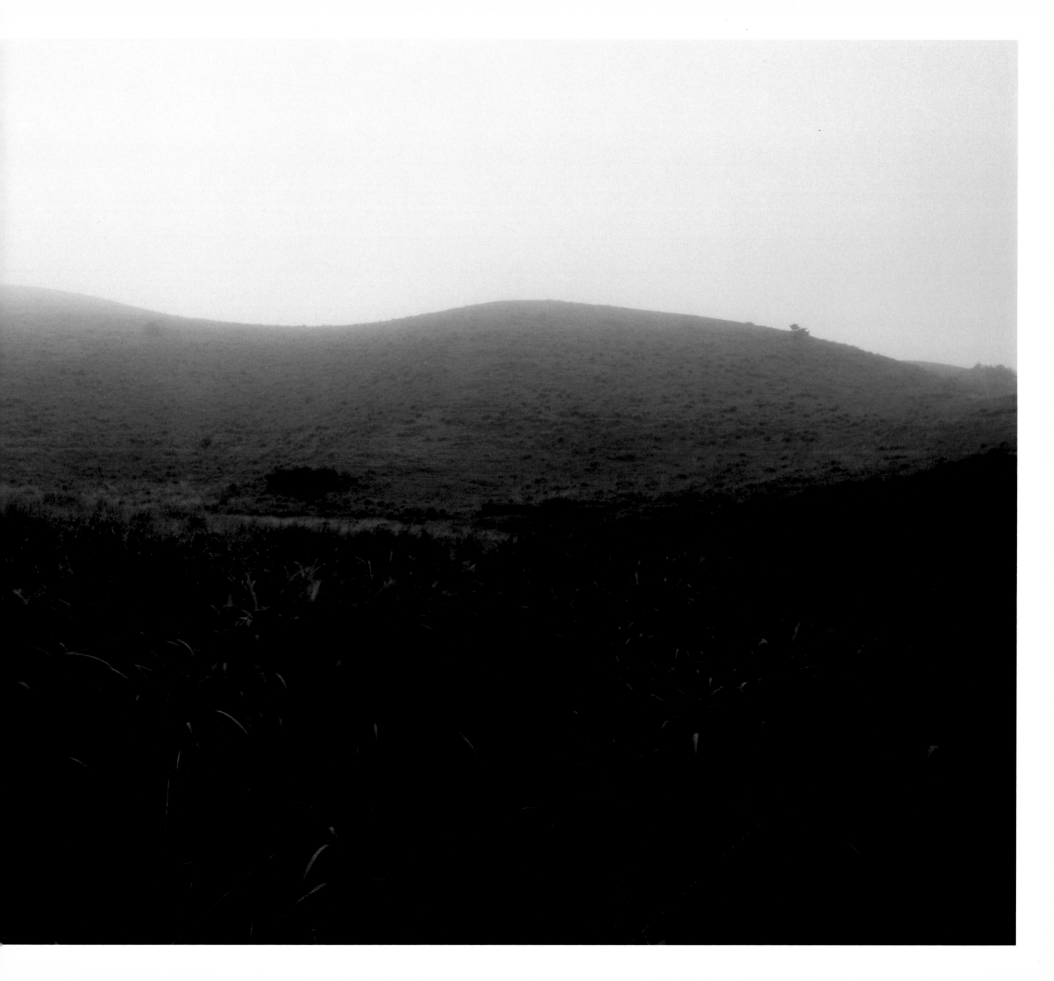

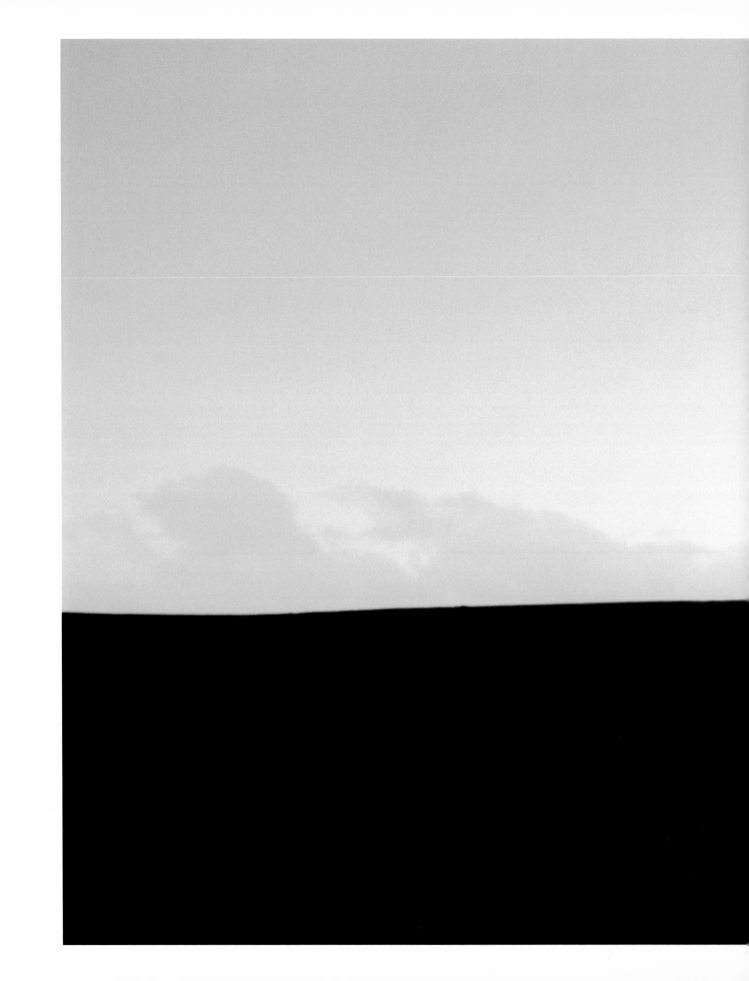

28 om1a-039h, 1999

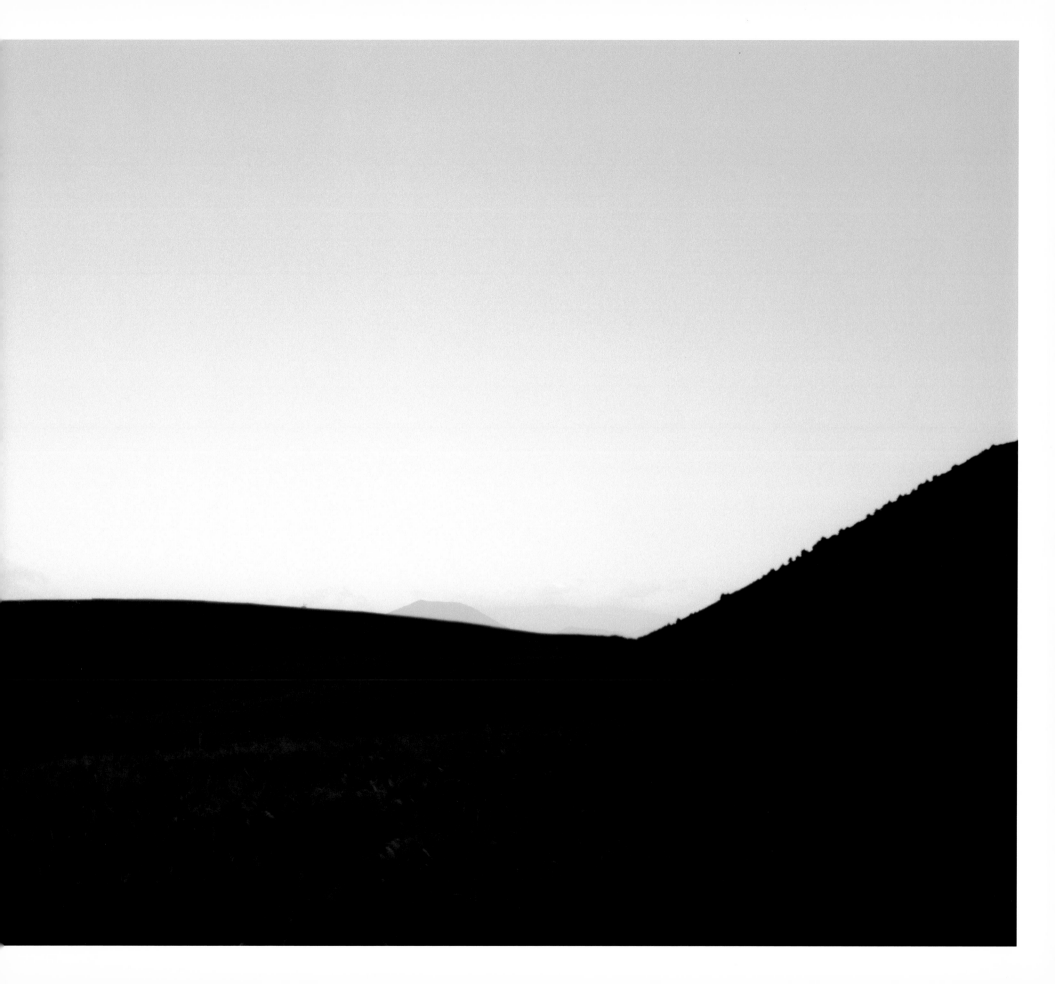

om1a-038v, 2011

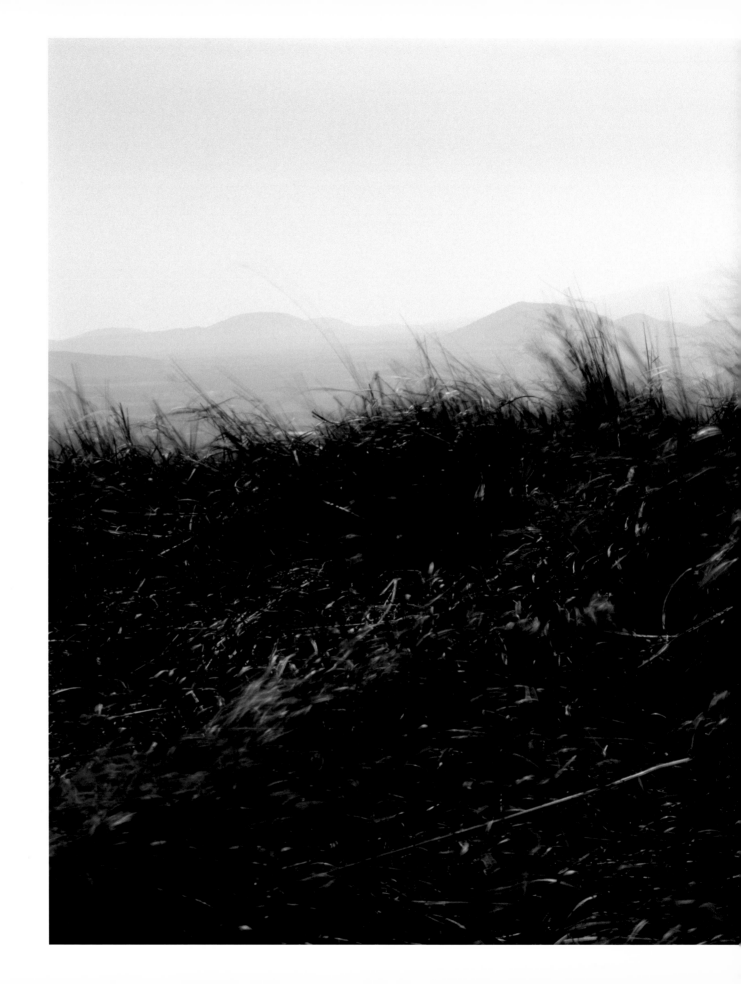

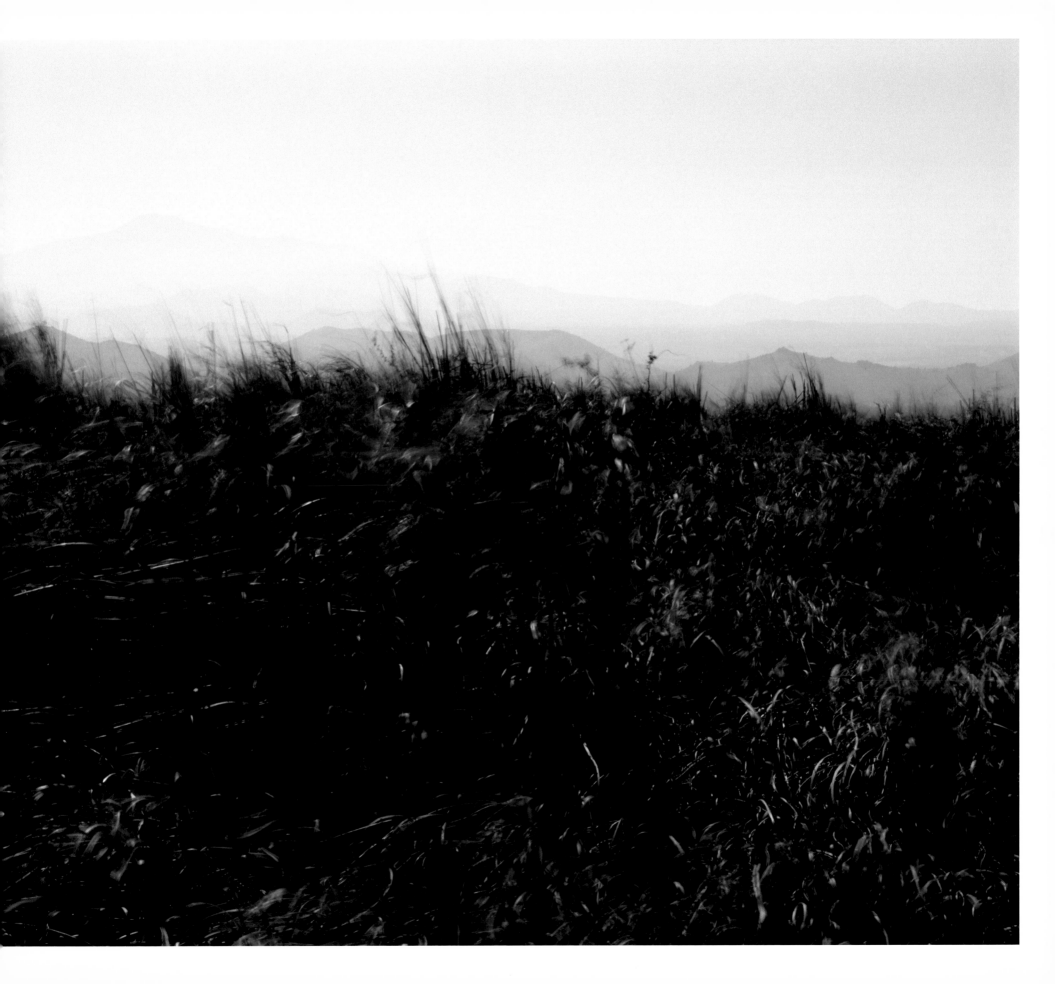

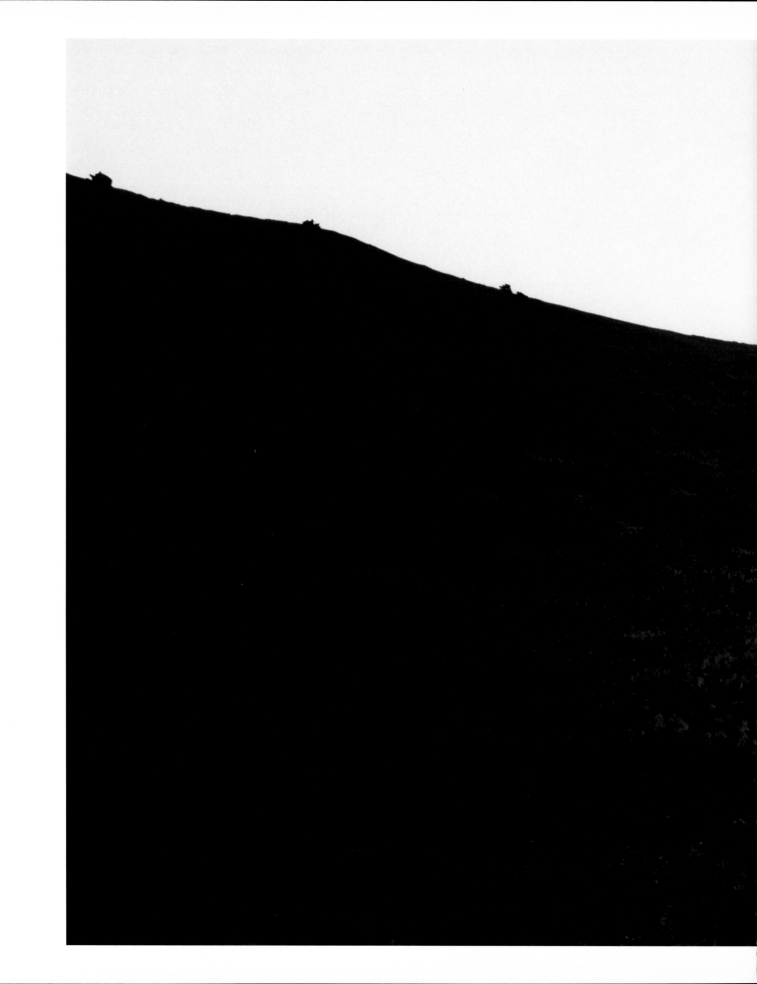

34 om1a-044h, 1999

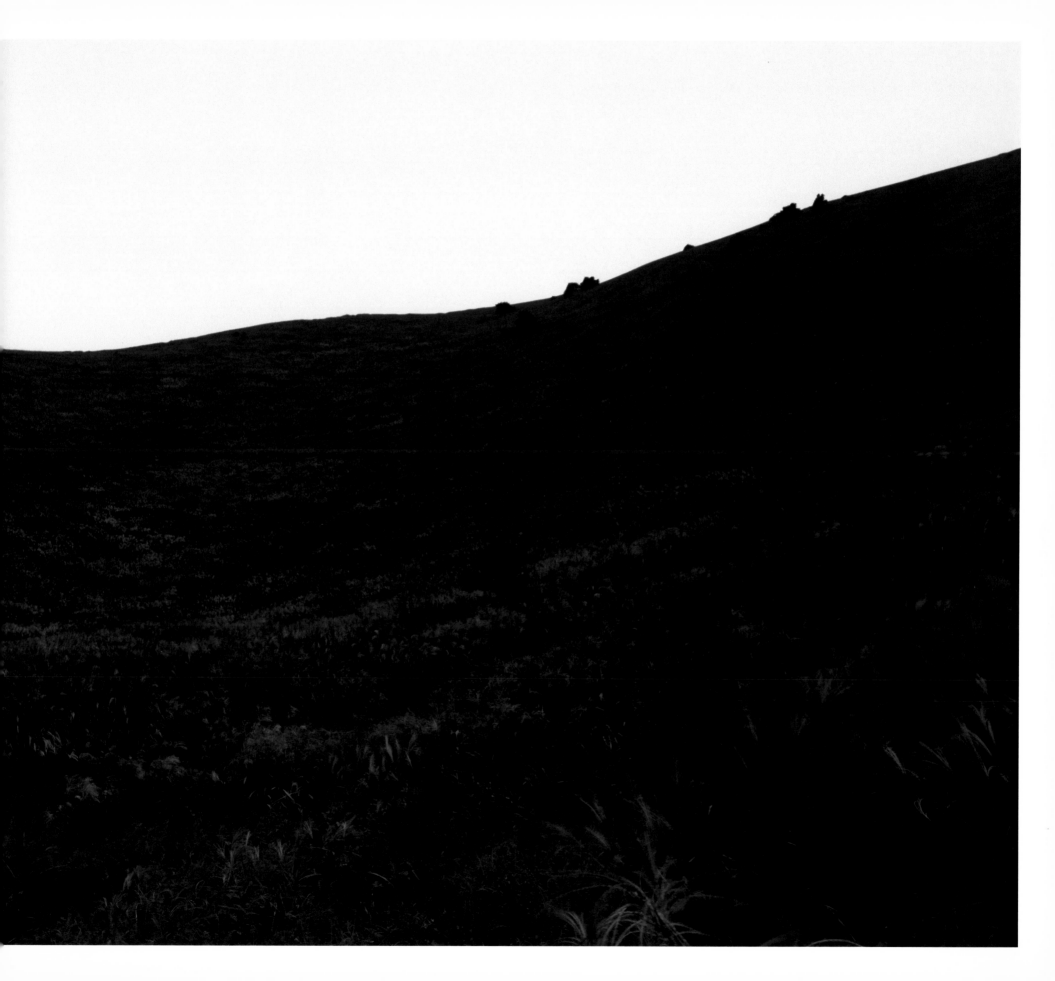

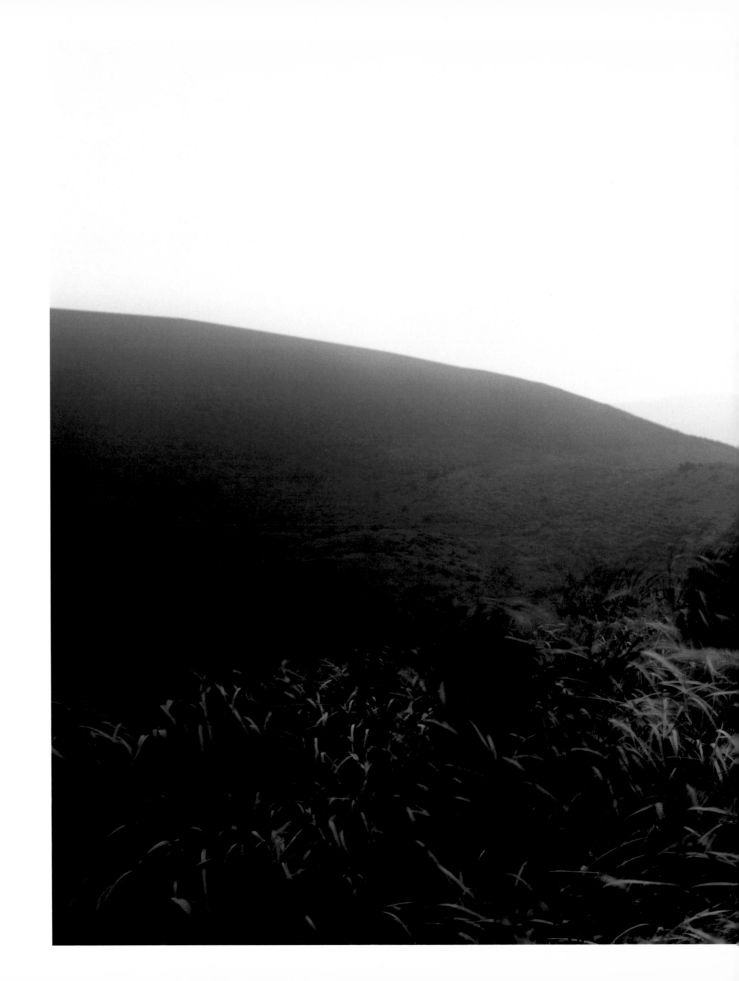

36 om1a-050h, 1999

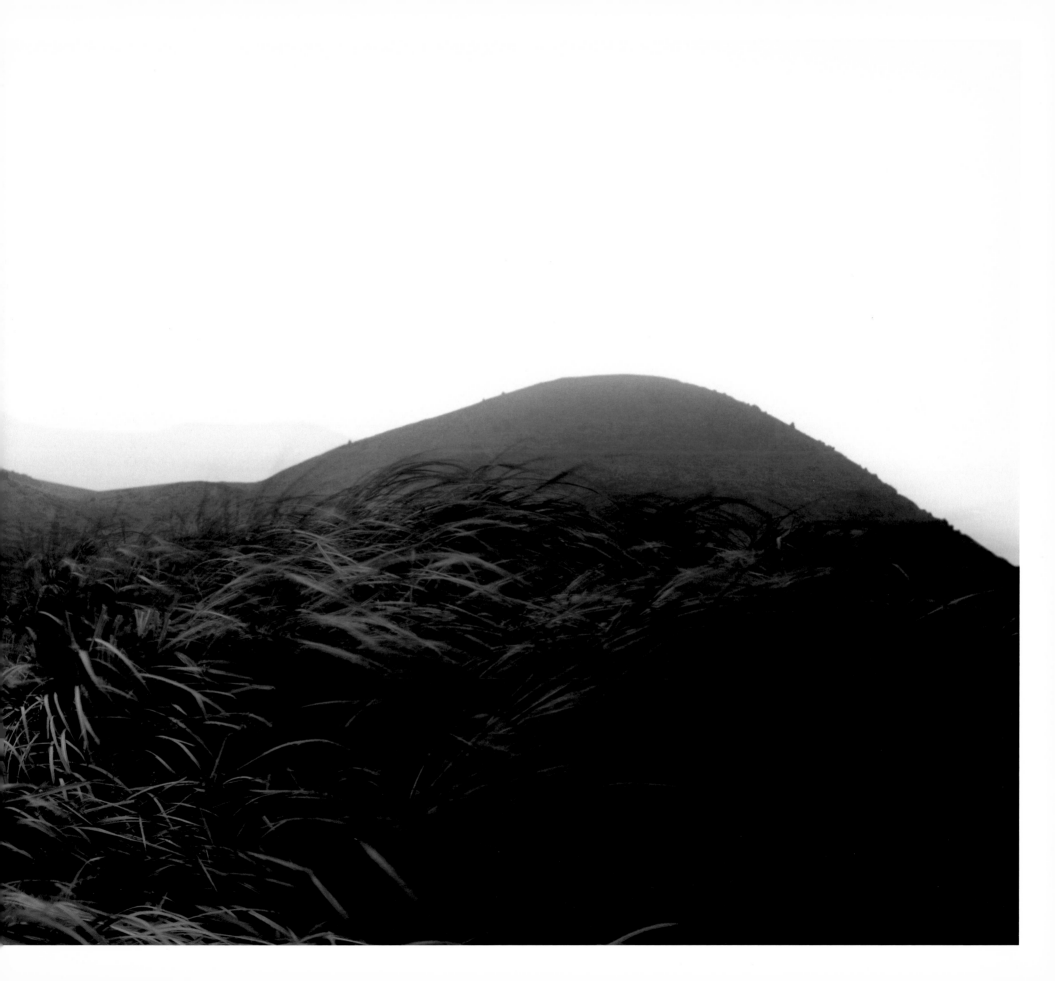

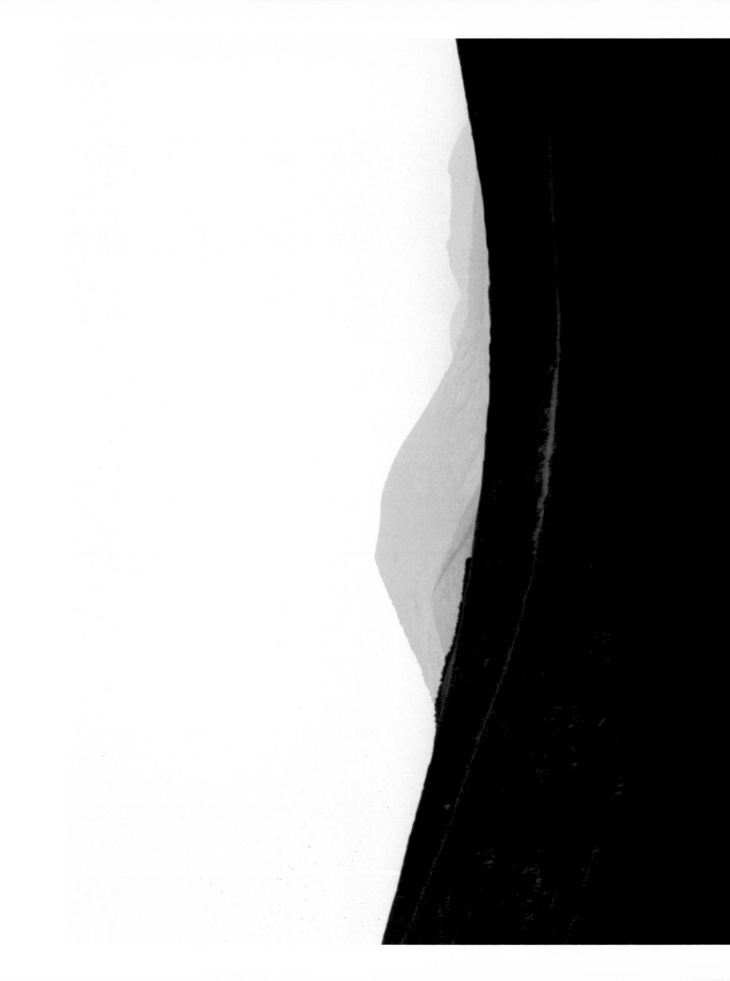

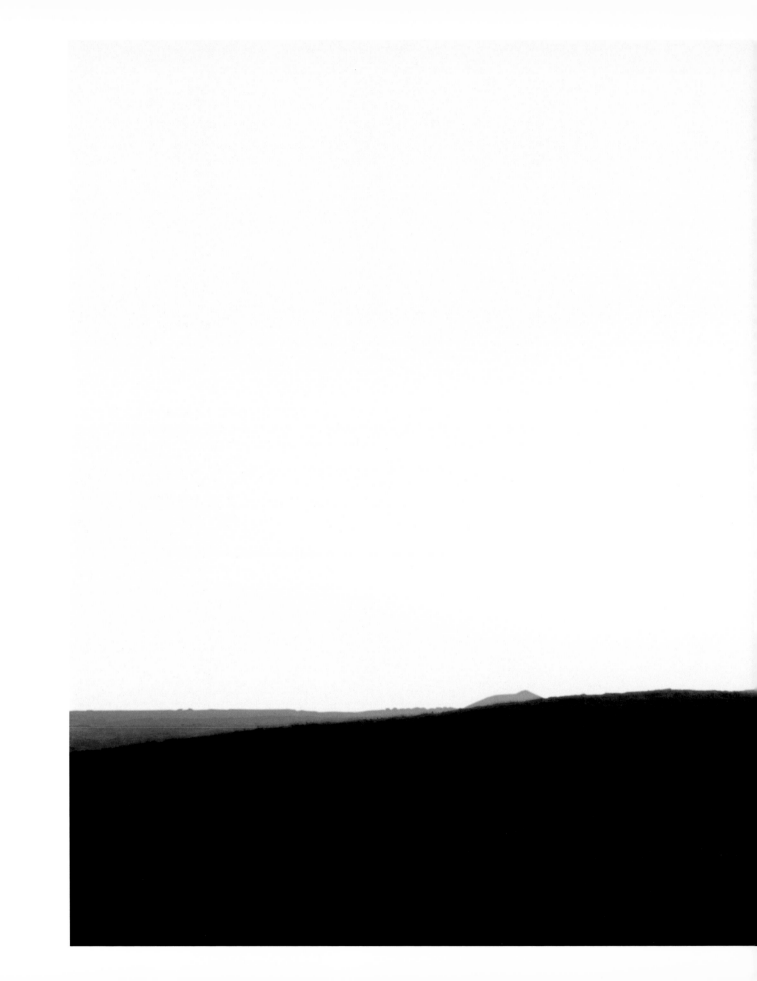

40 om1a-051h, 1999

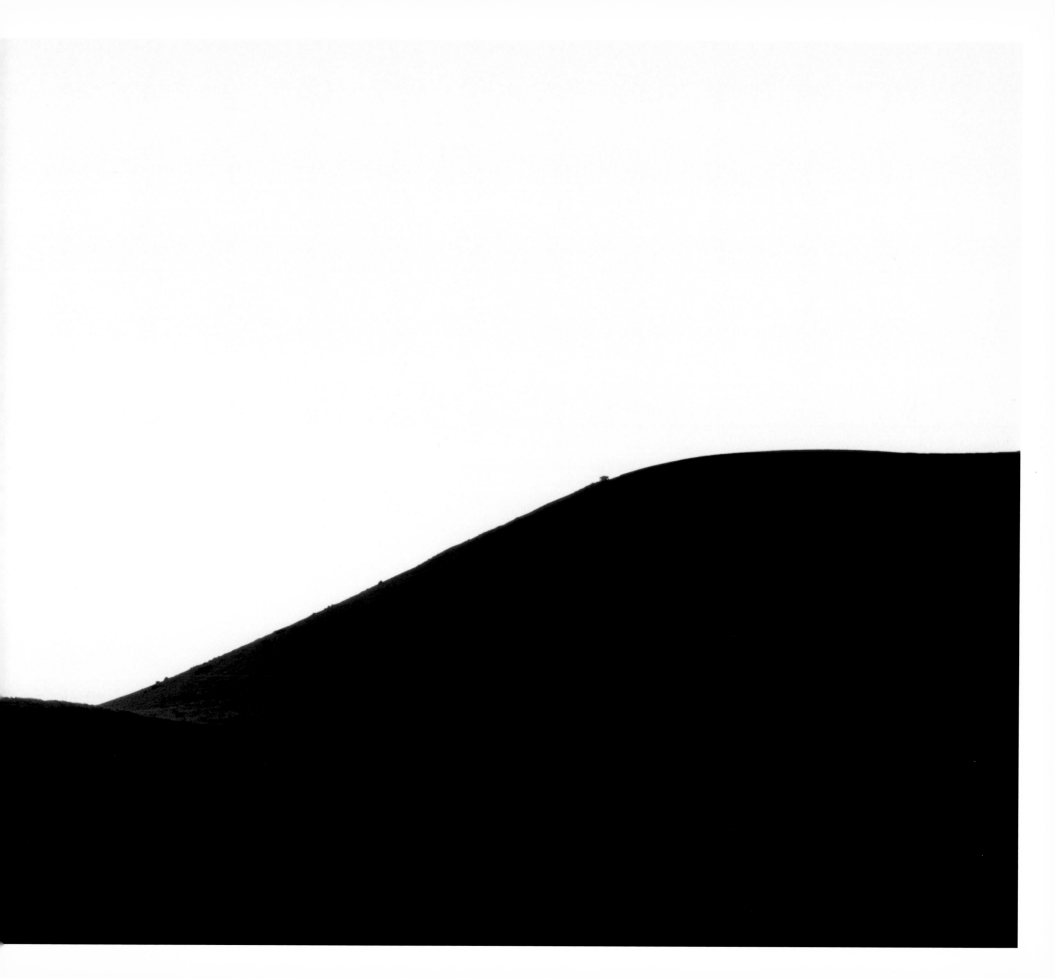

om1a-053v, 2007

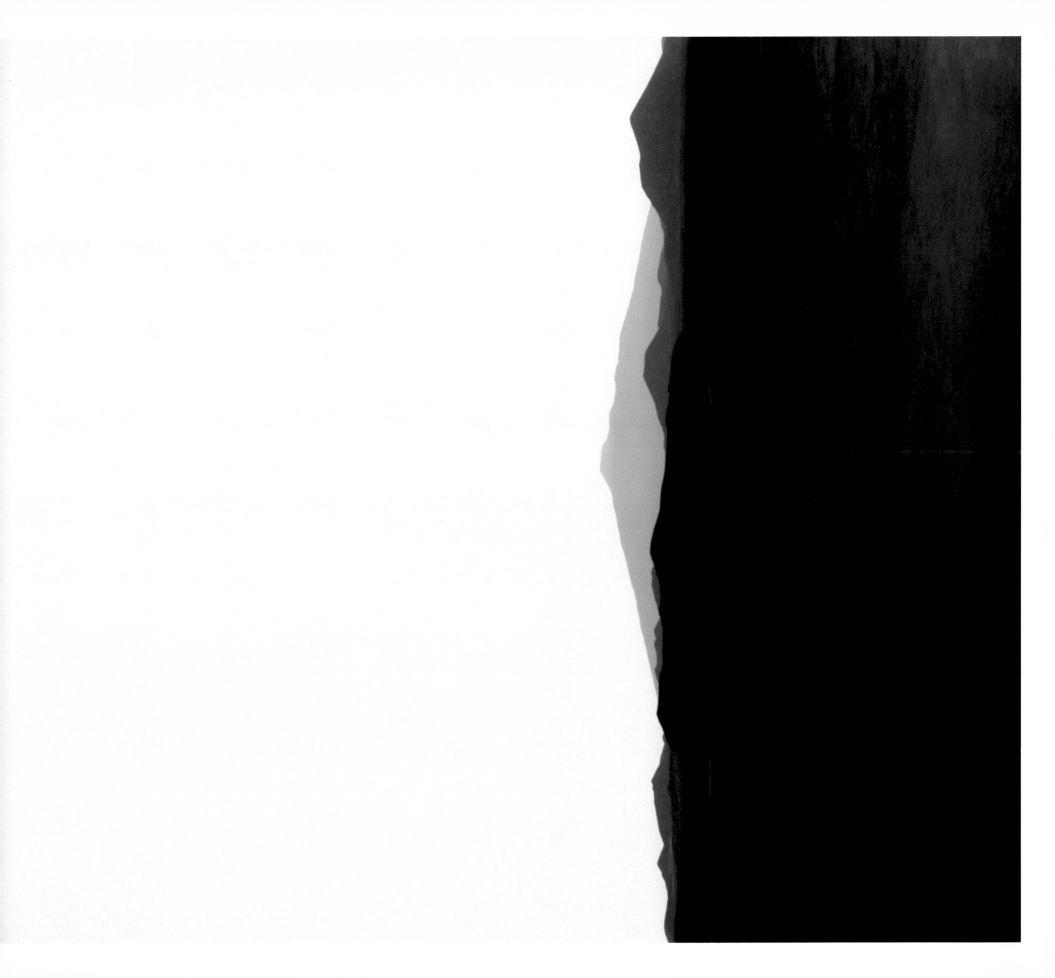

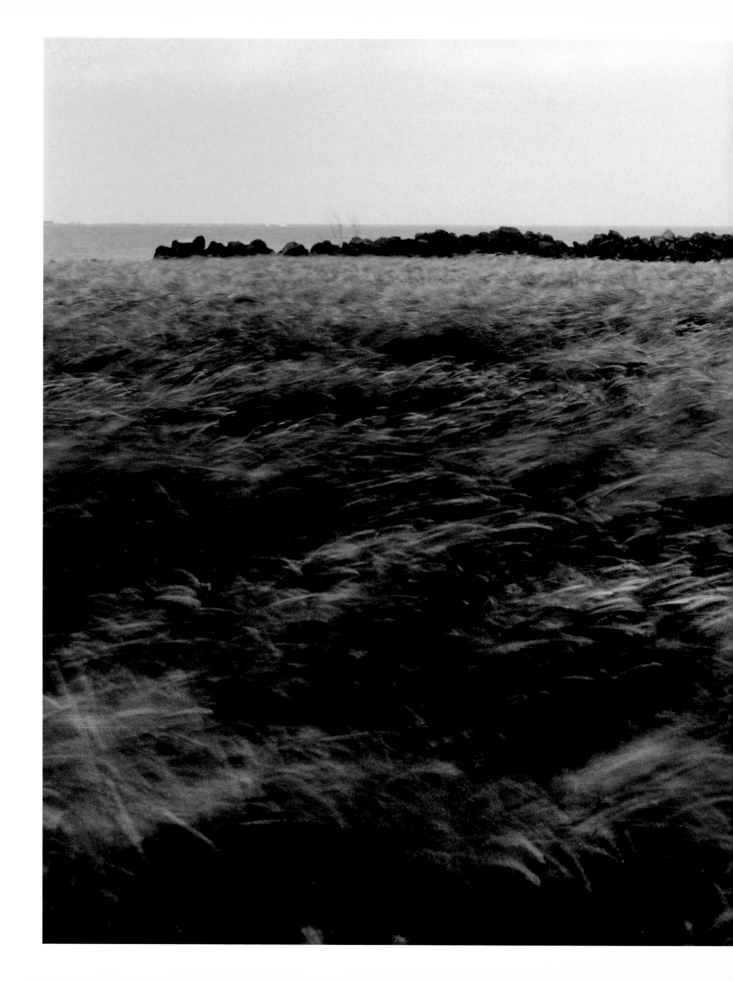

plt1a-029h, 2002

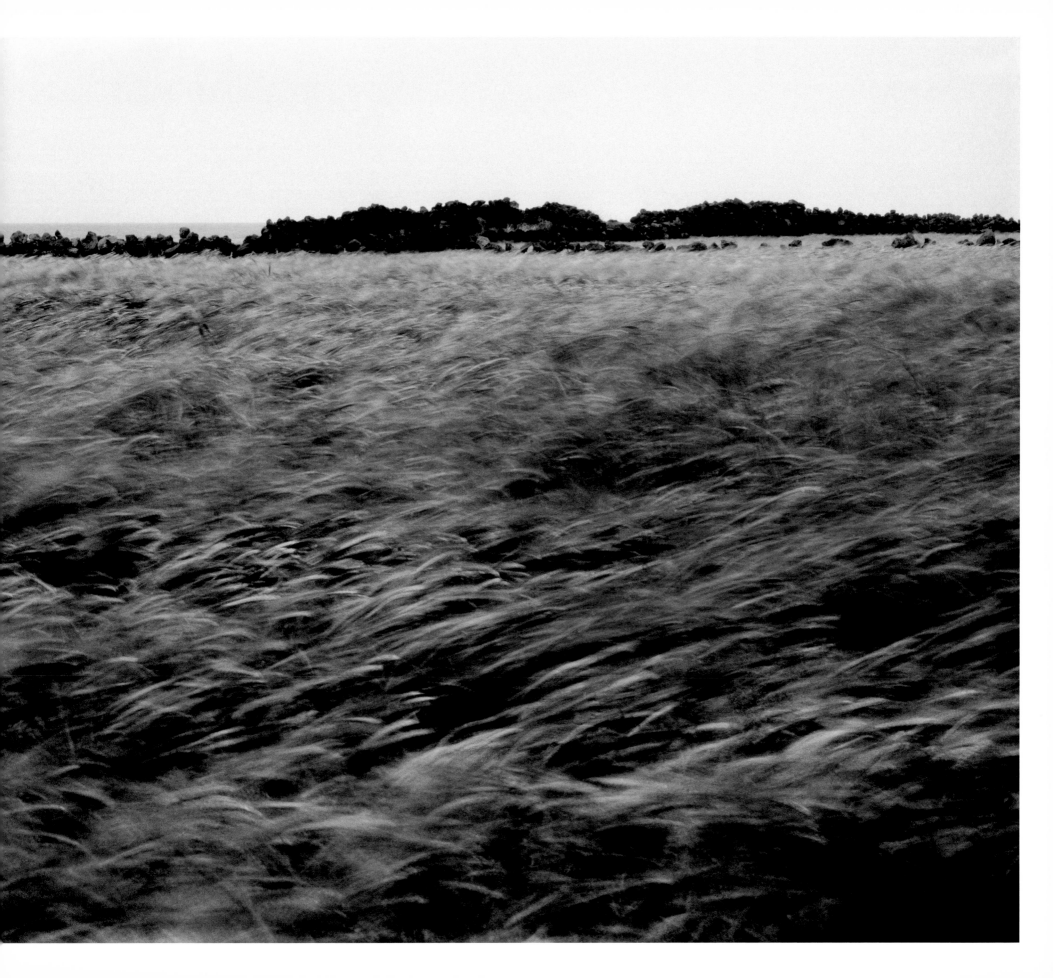

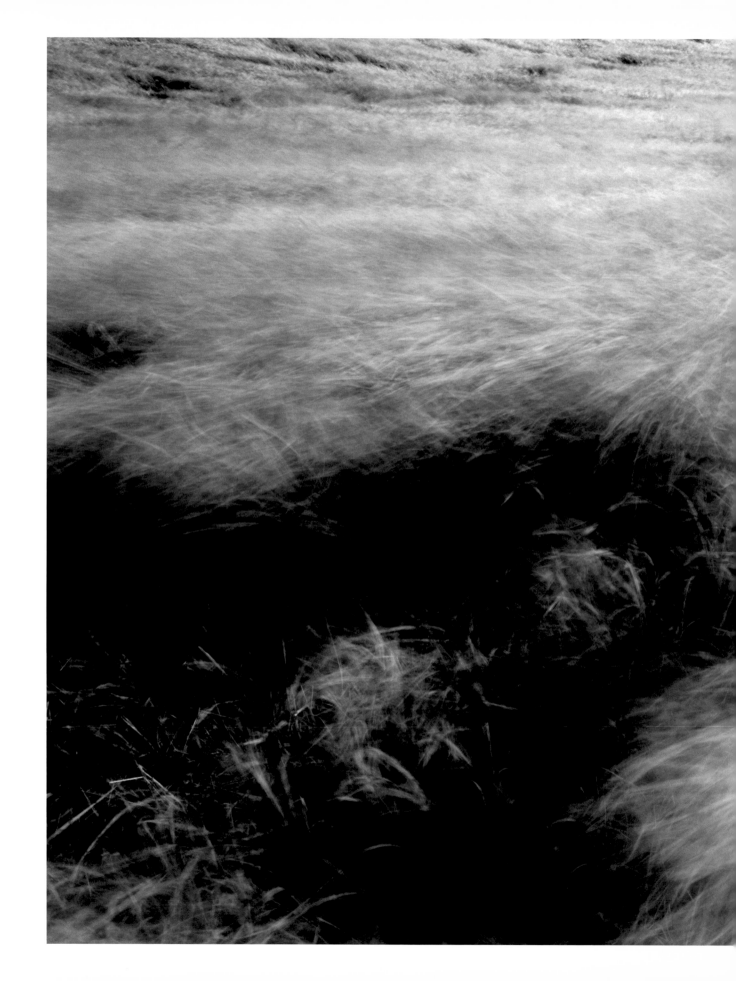

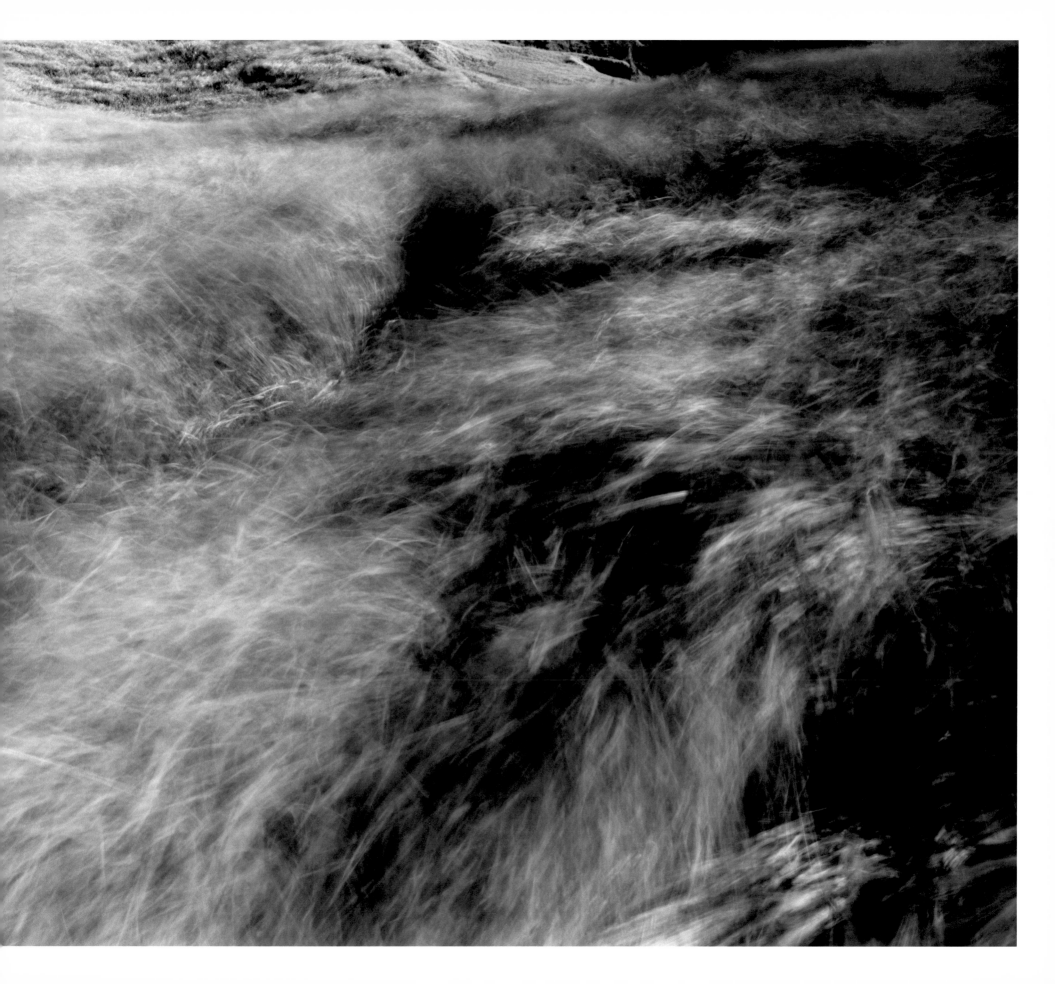

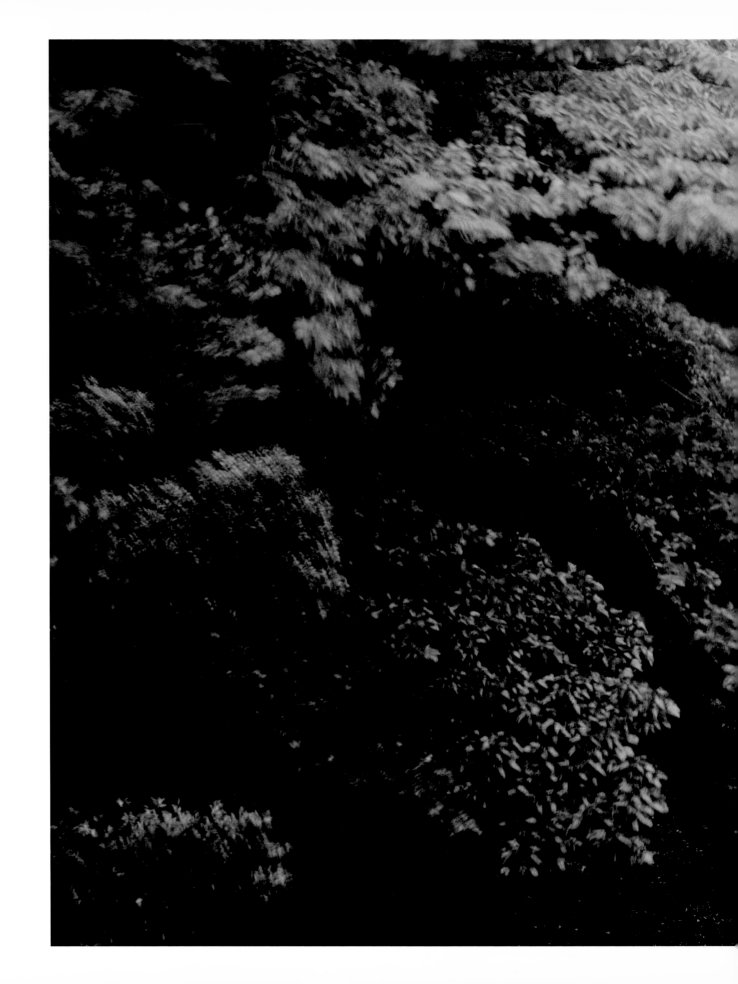

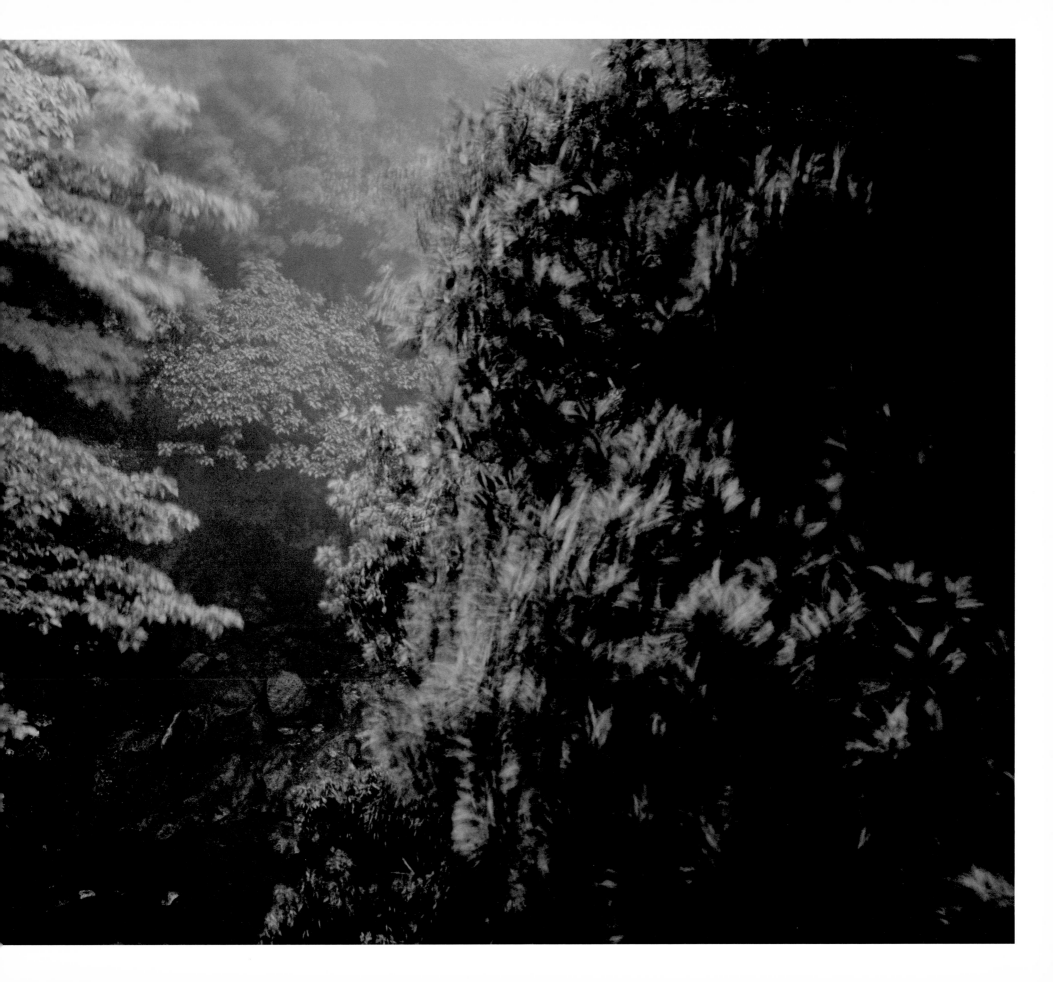

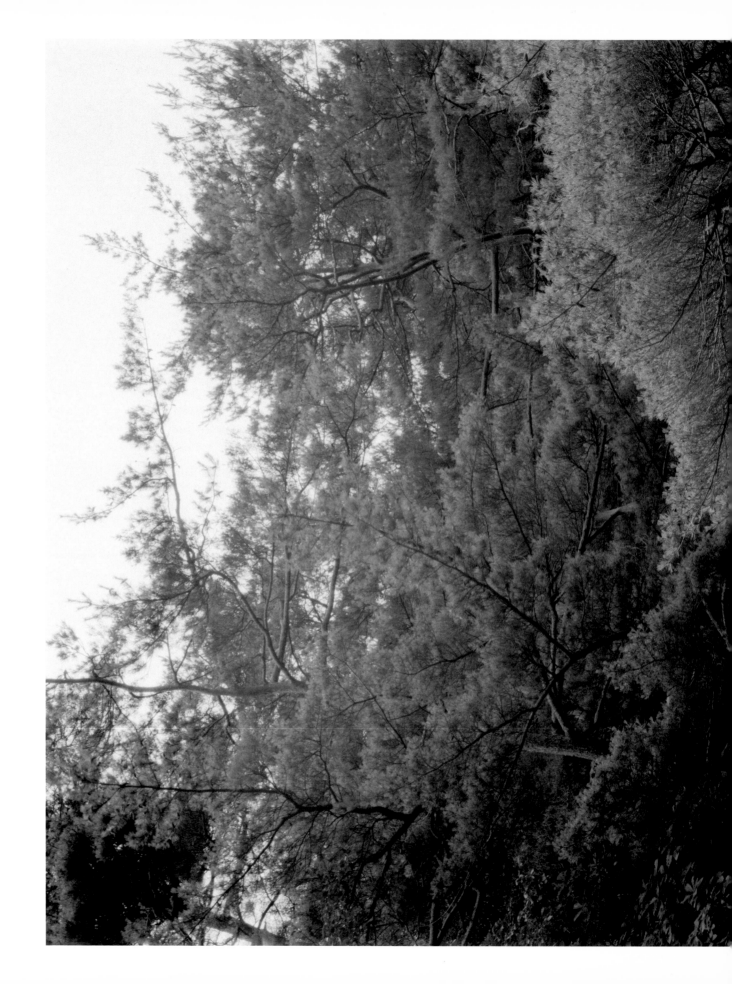

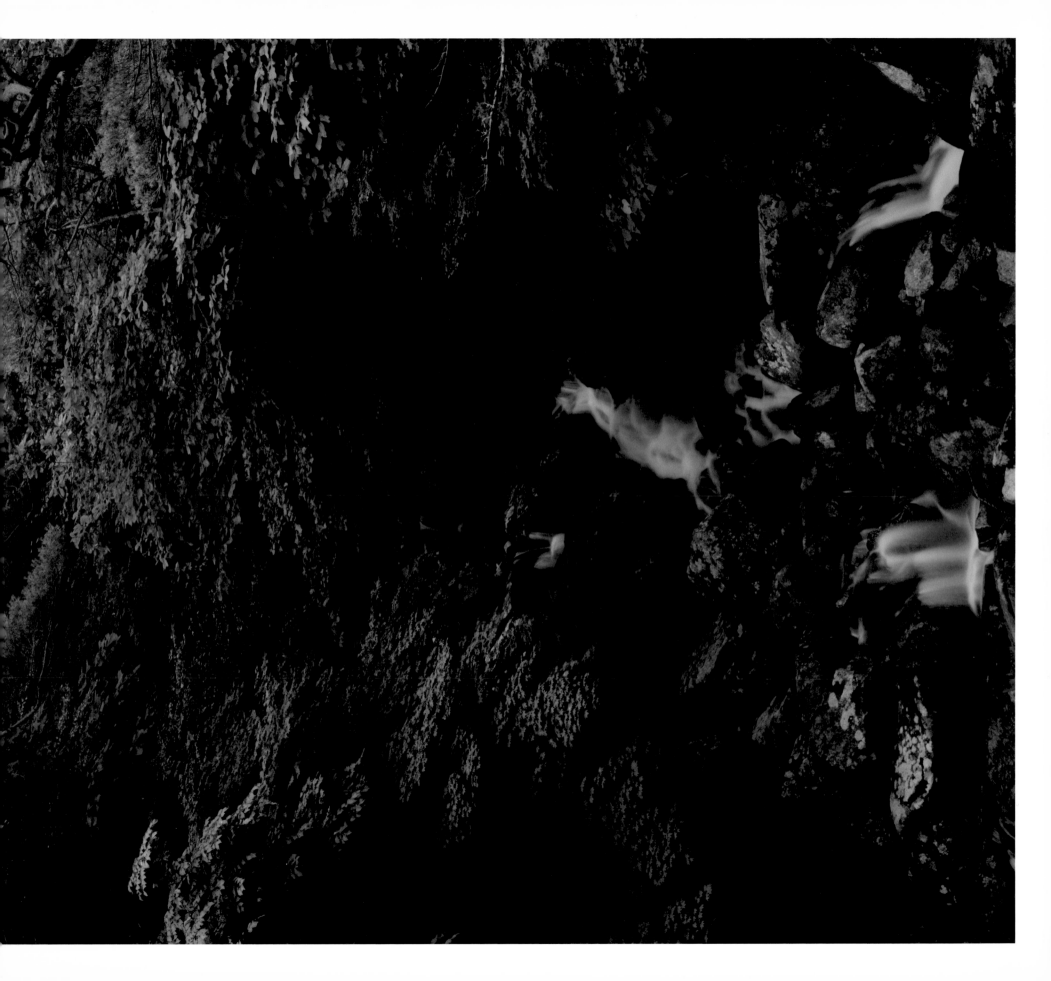

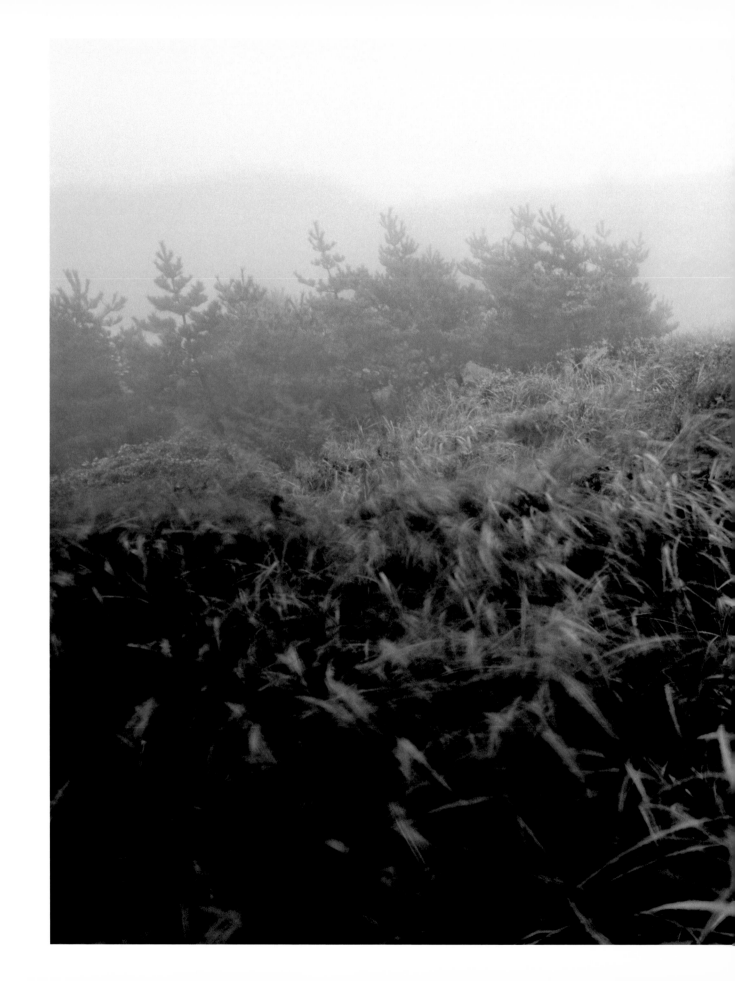

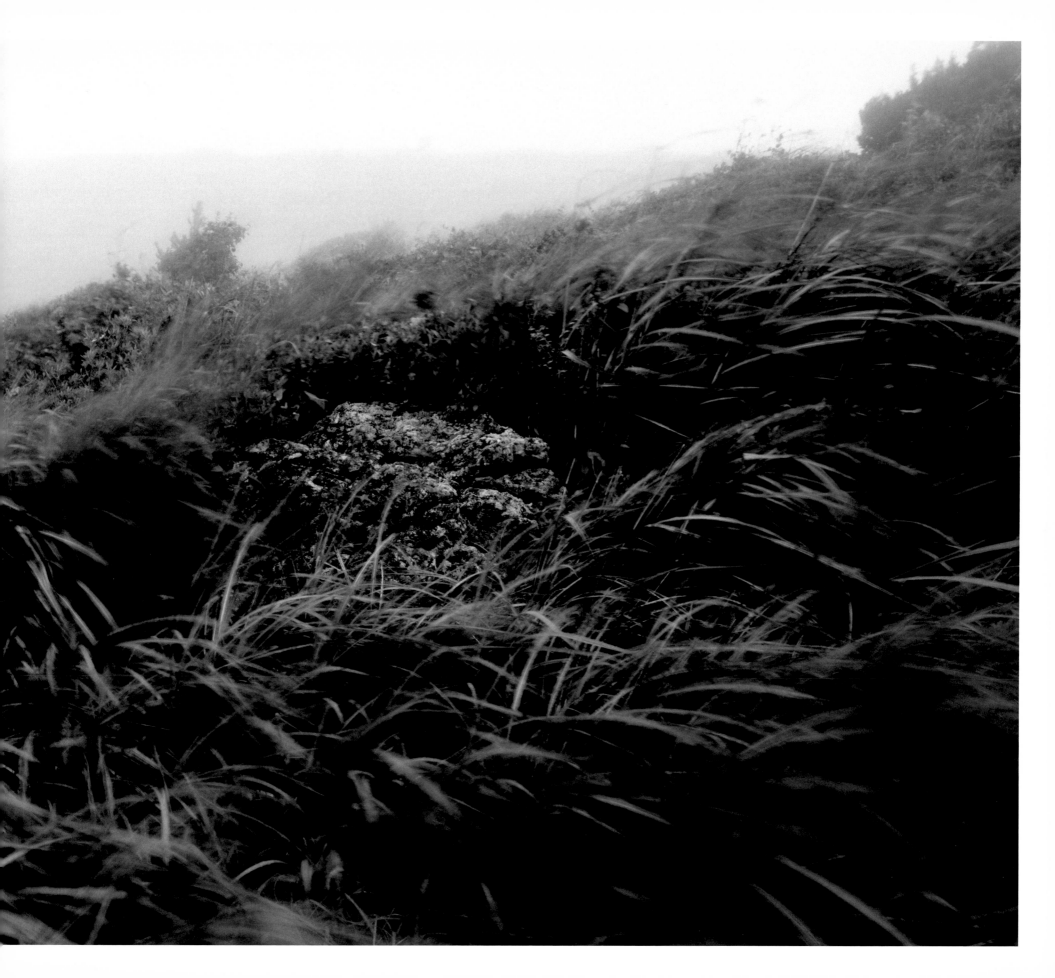

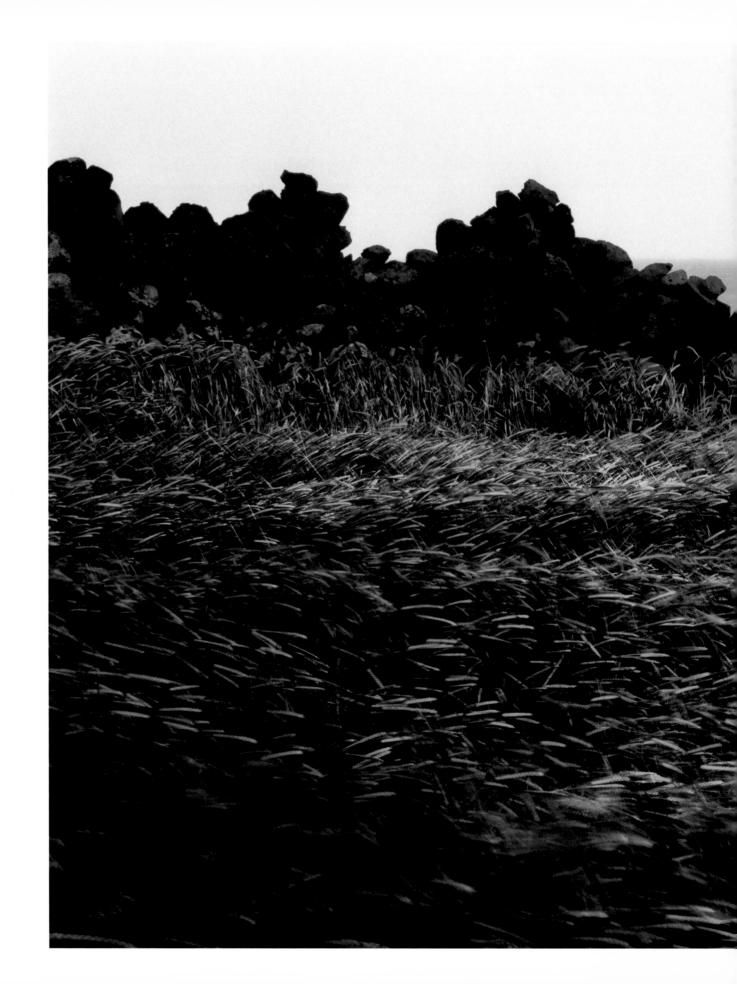

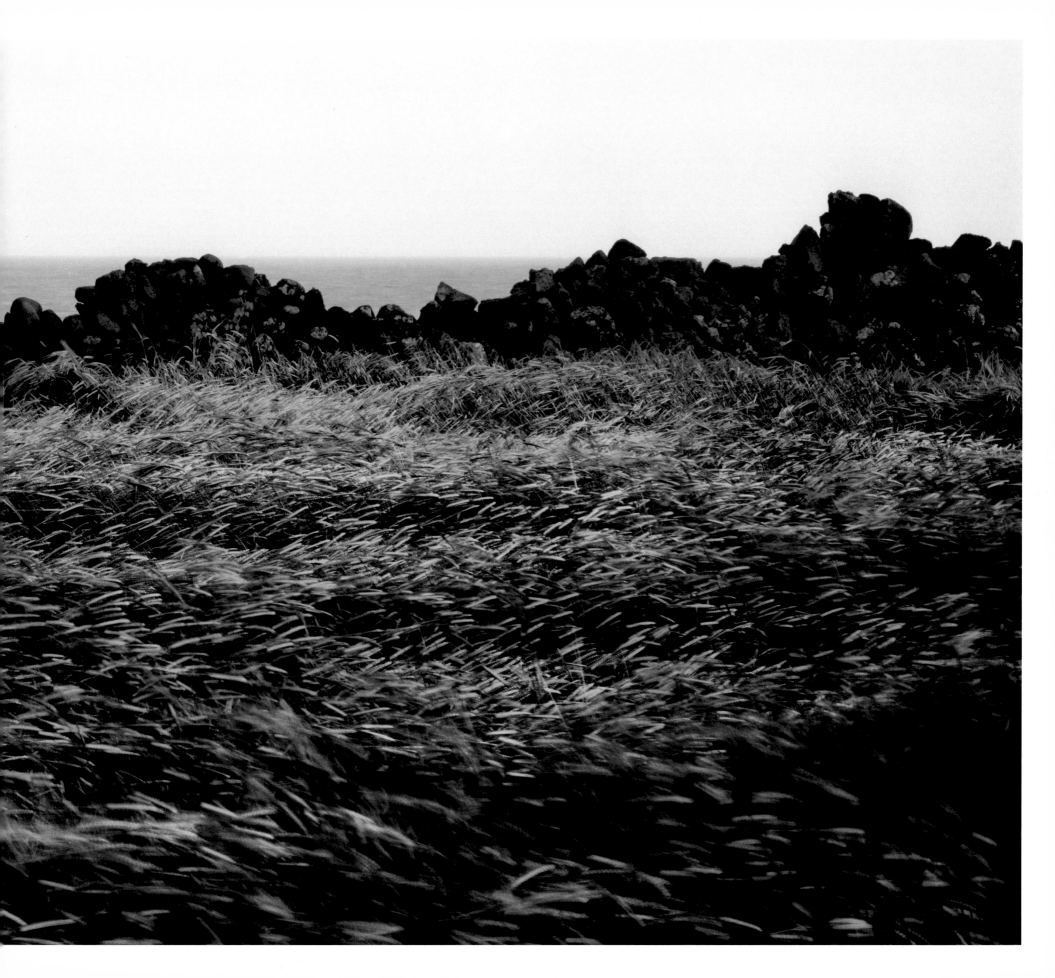

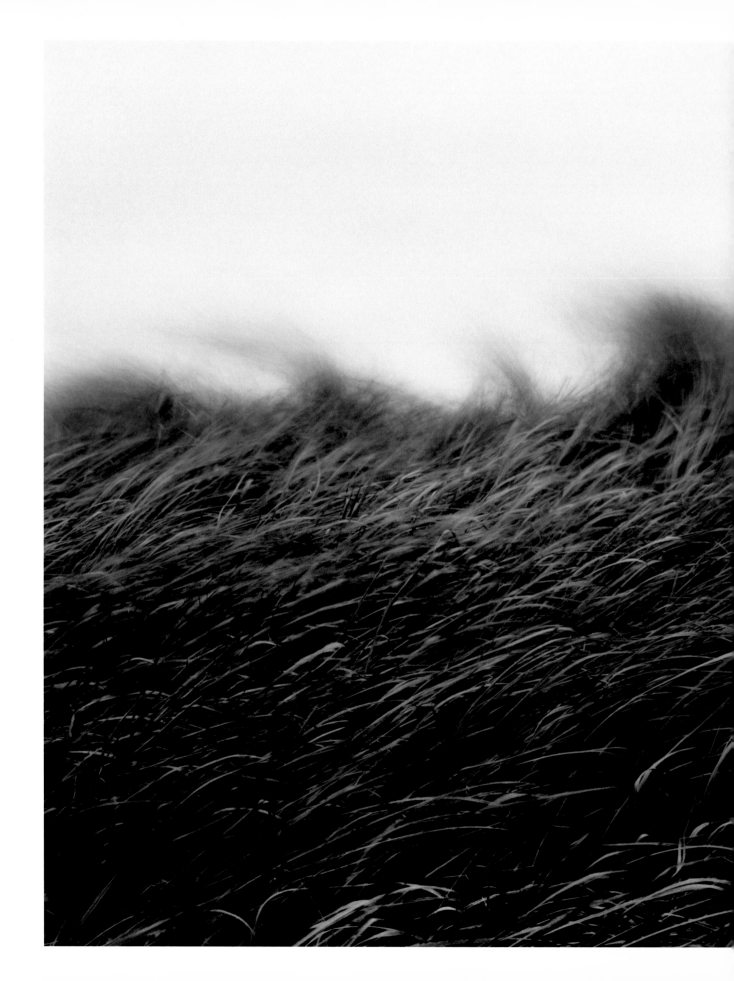

plt1a-043h, 2002

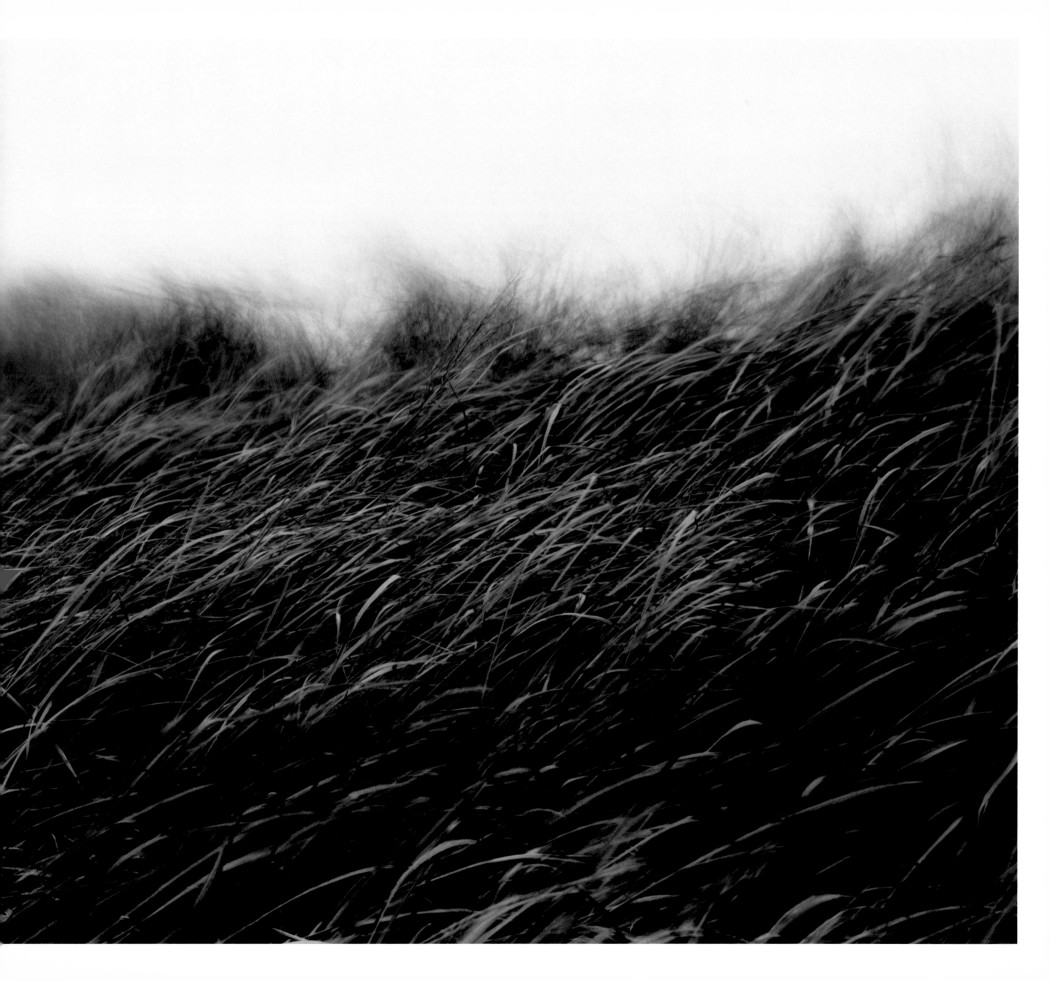

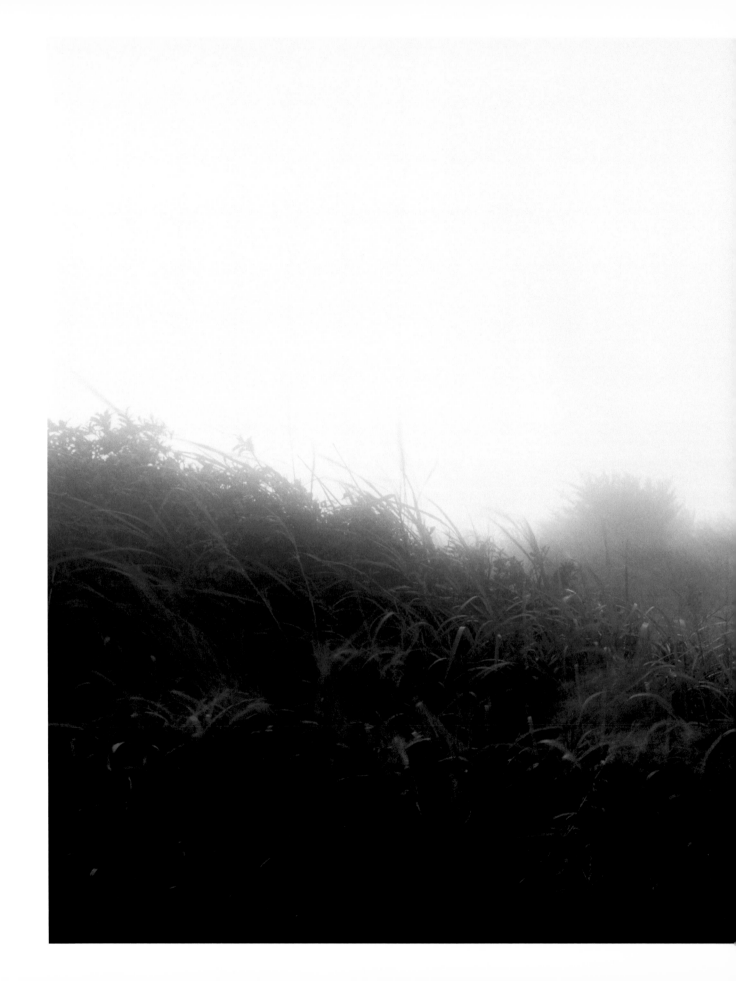

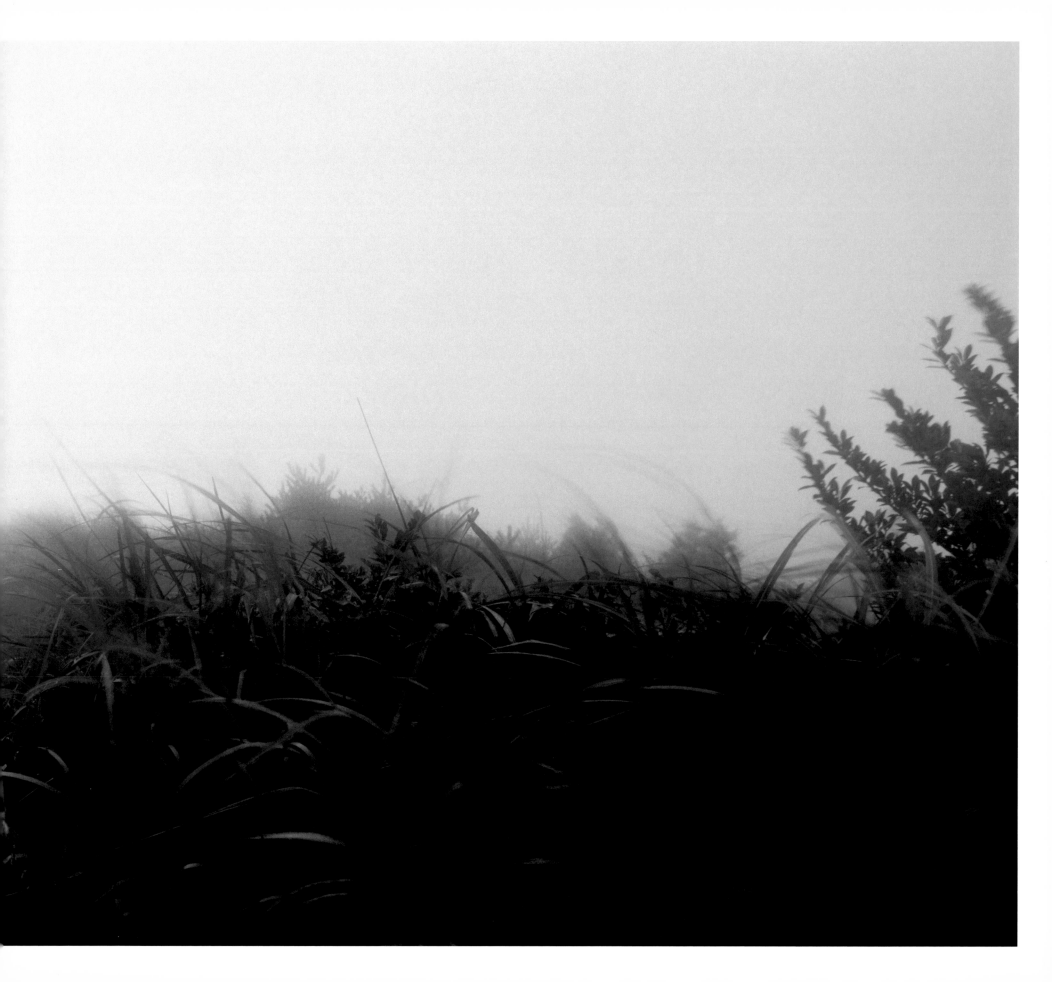

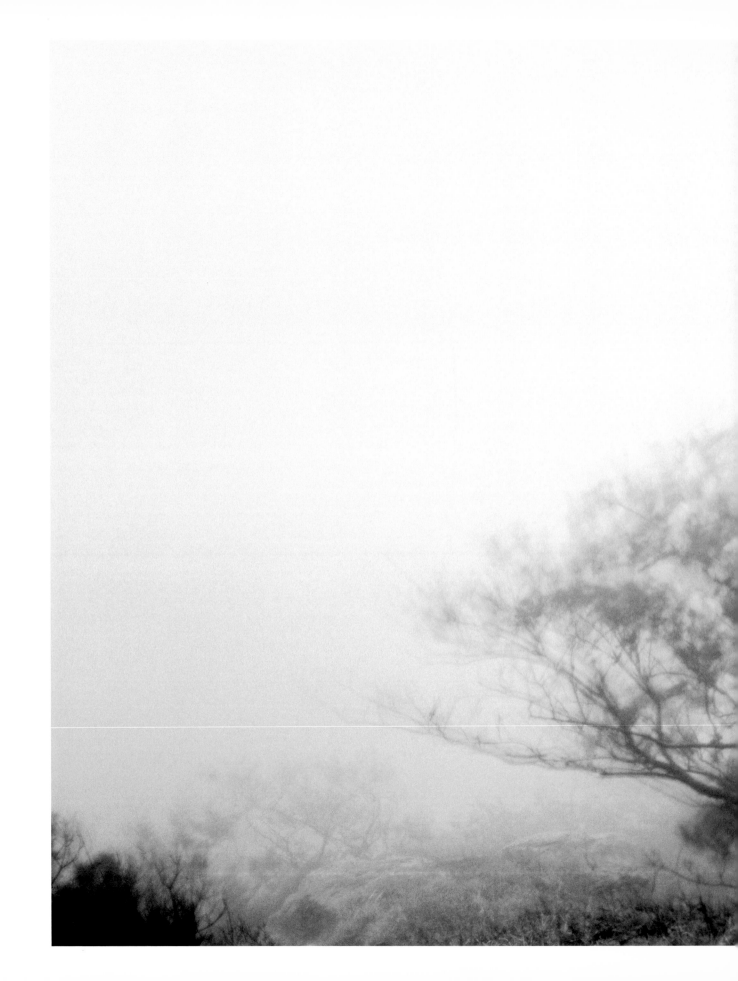

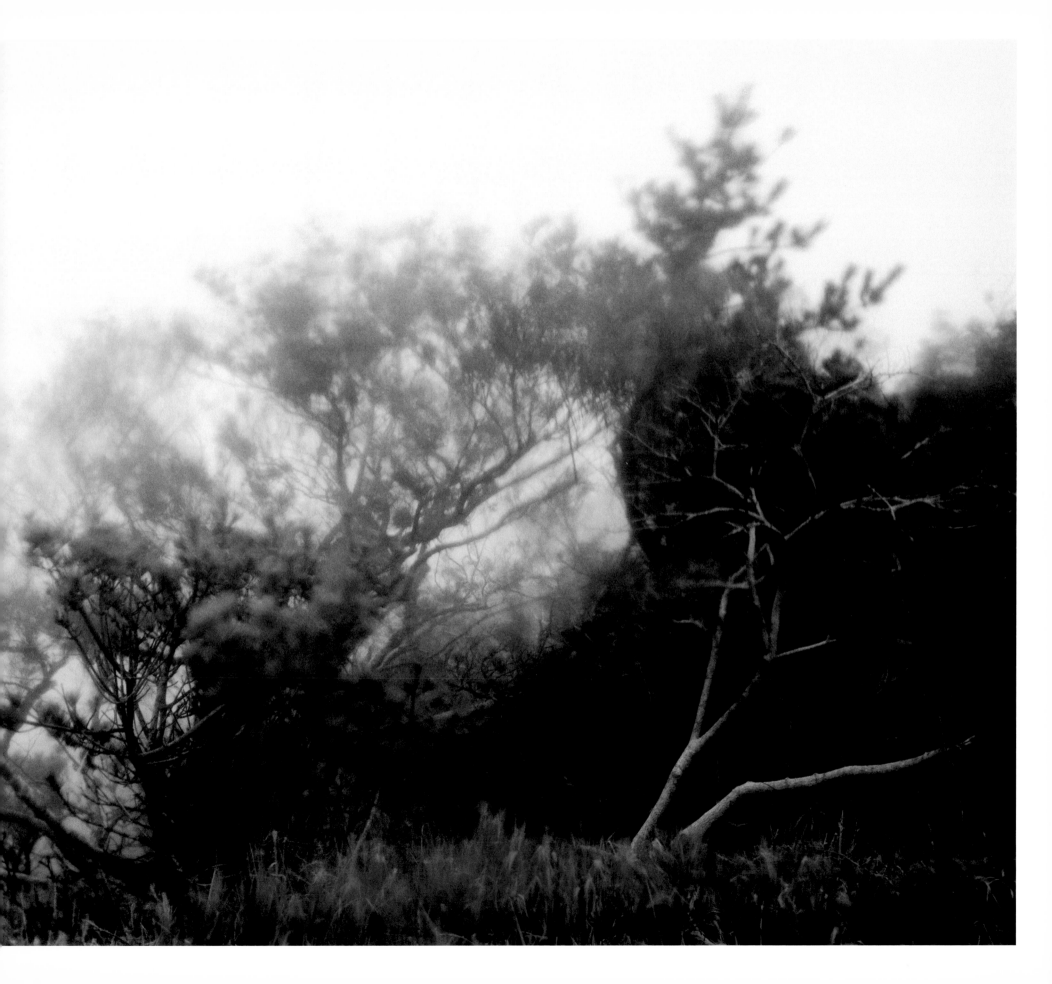

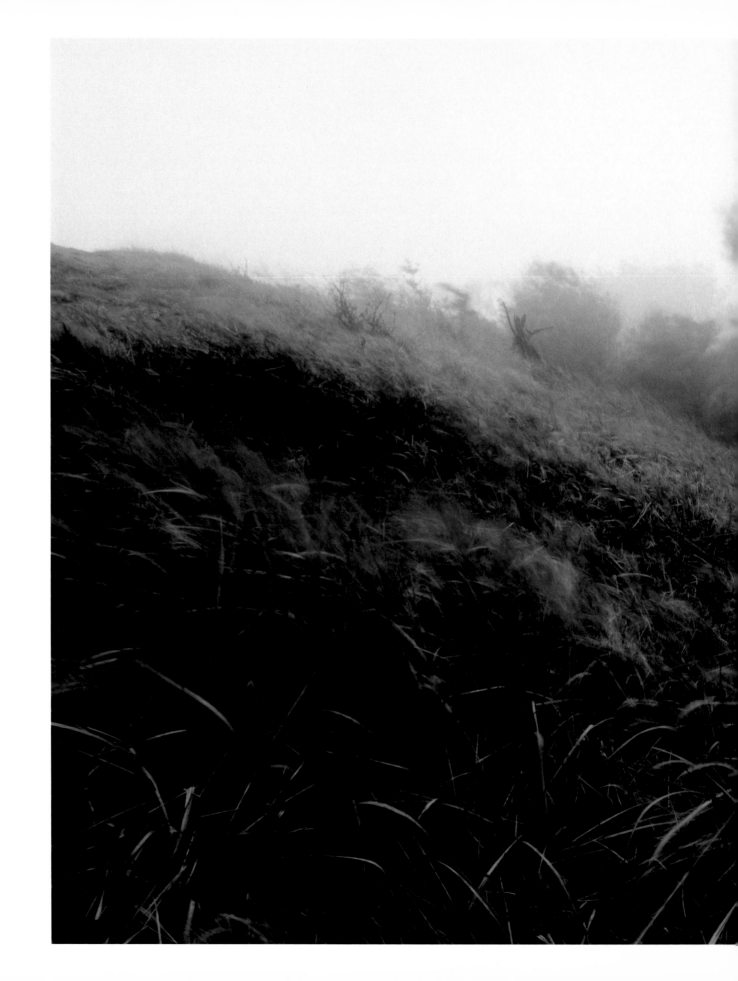

plt1a-040h, 2012

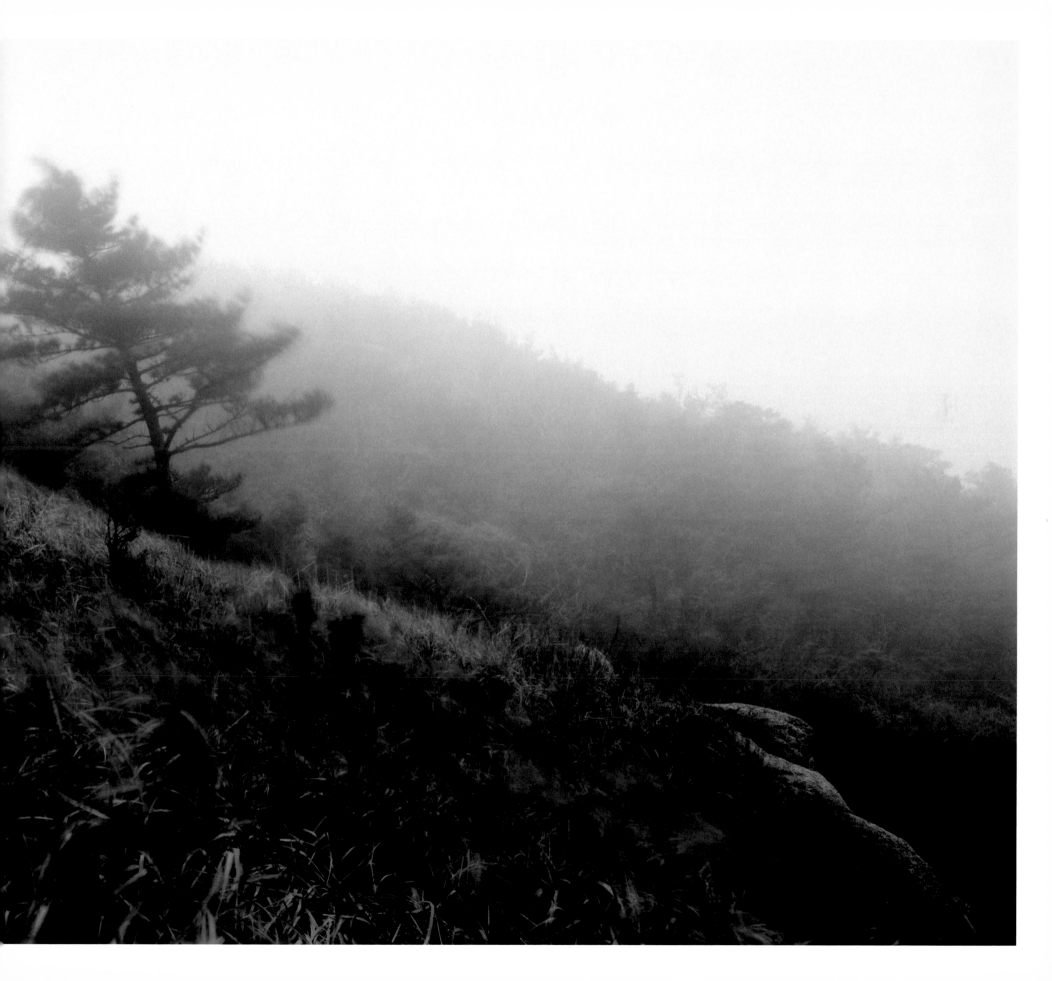

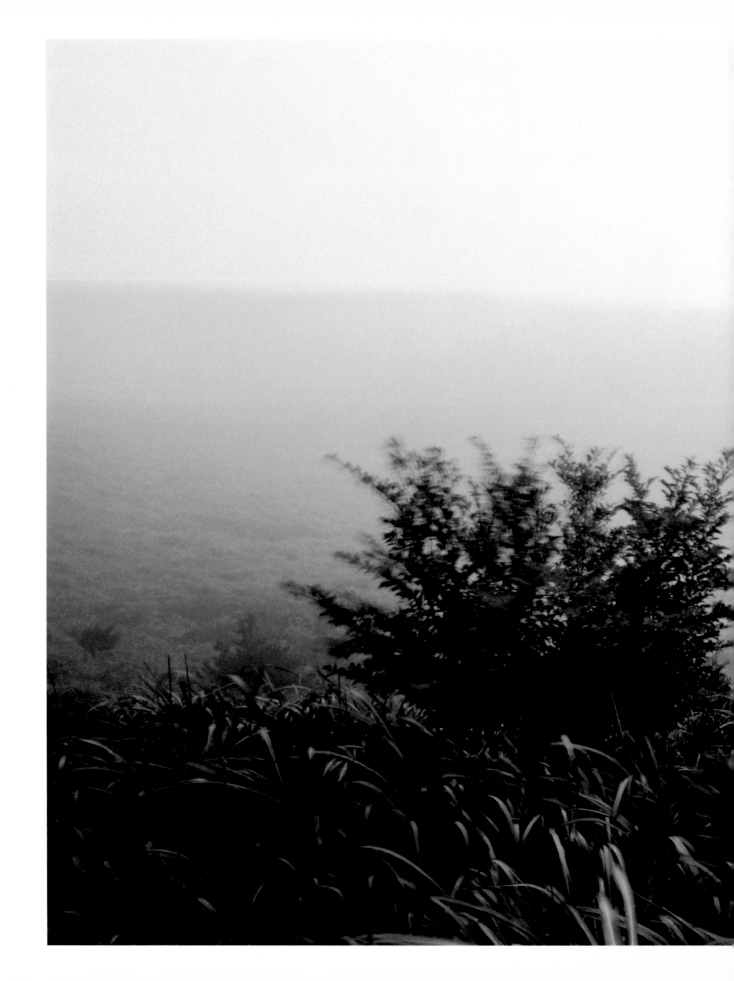

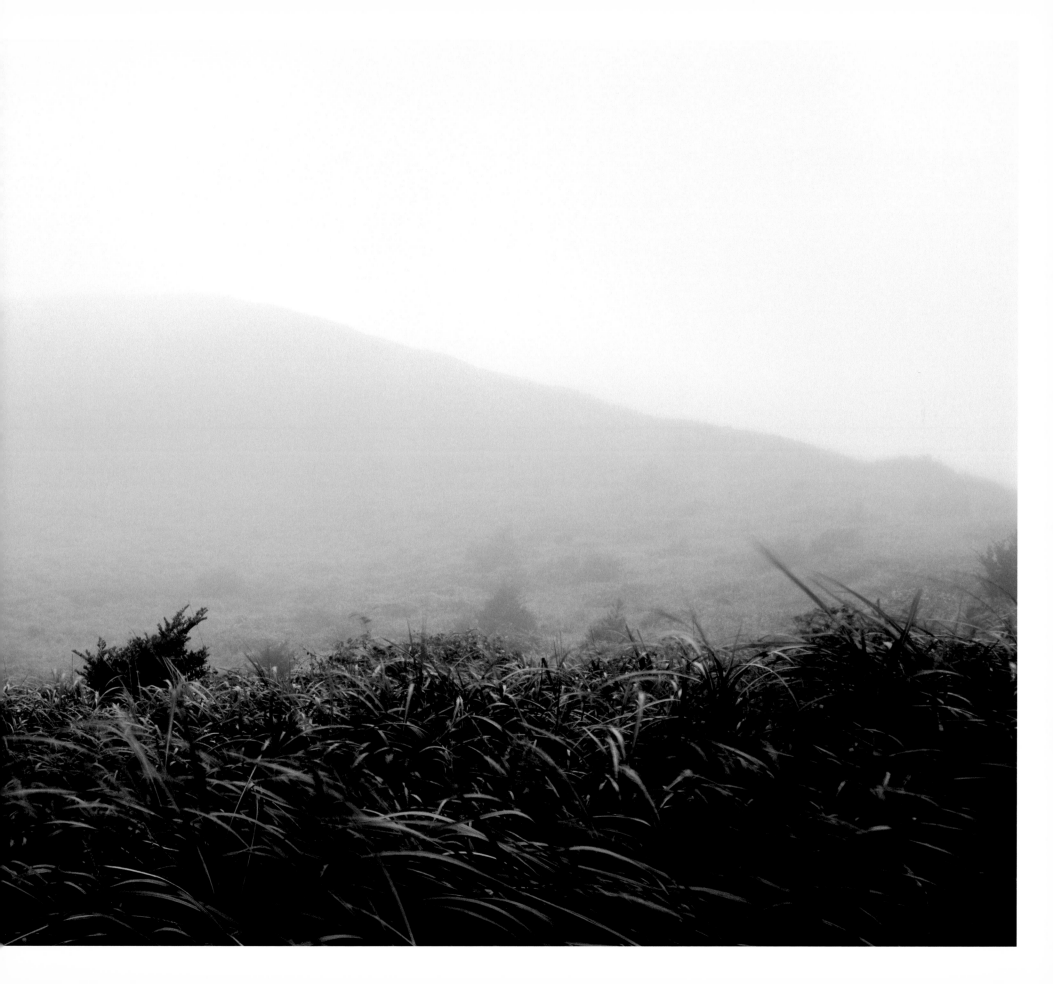

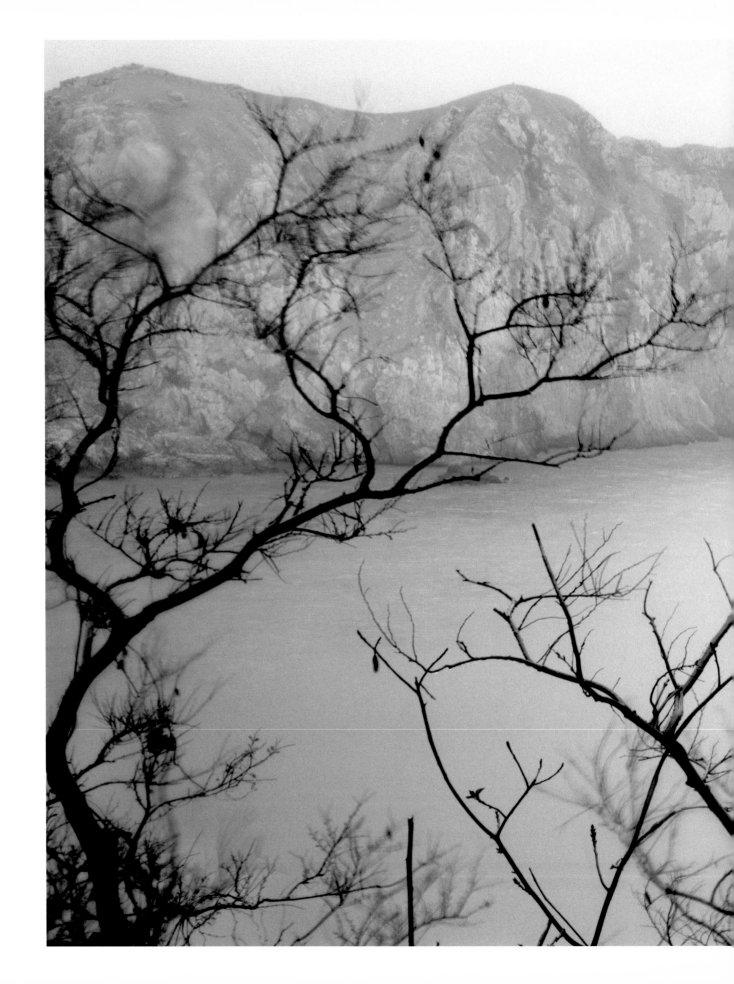

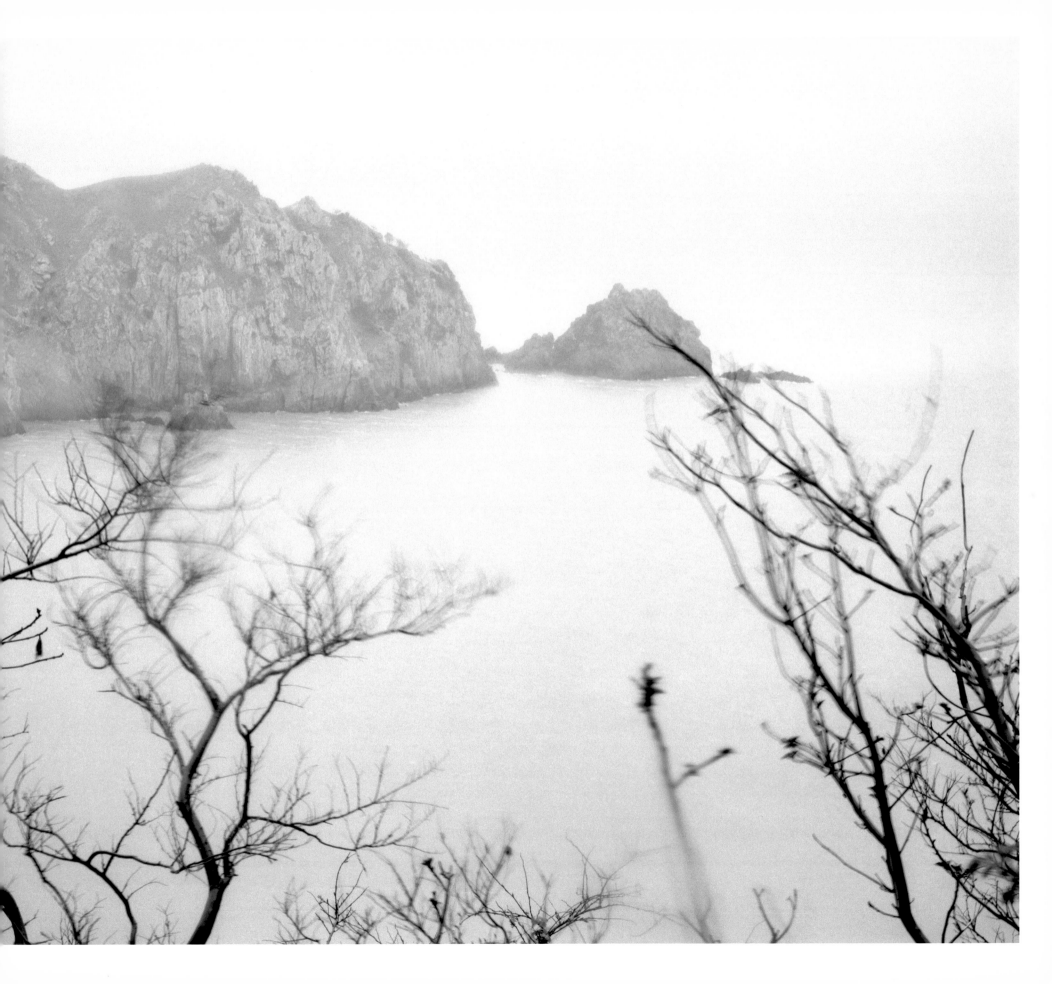

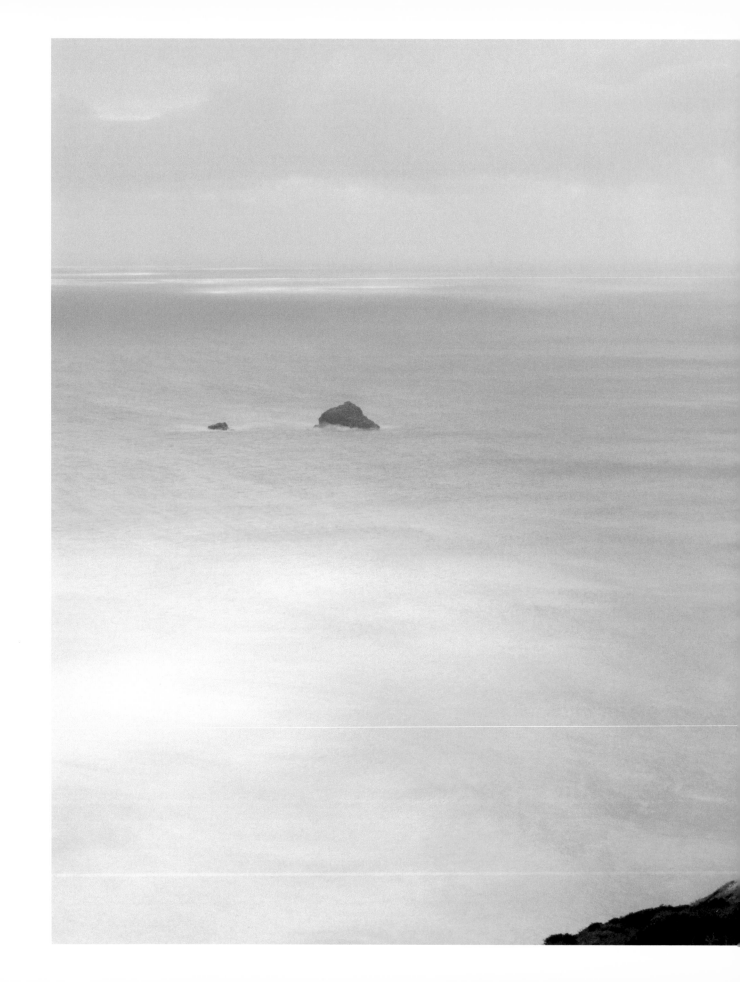

68 sea1a-064h, 2012

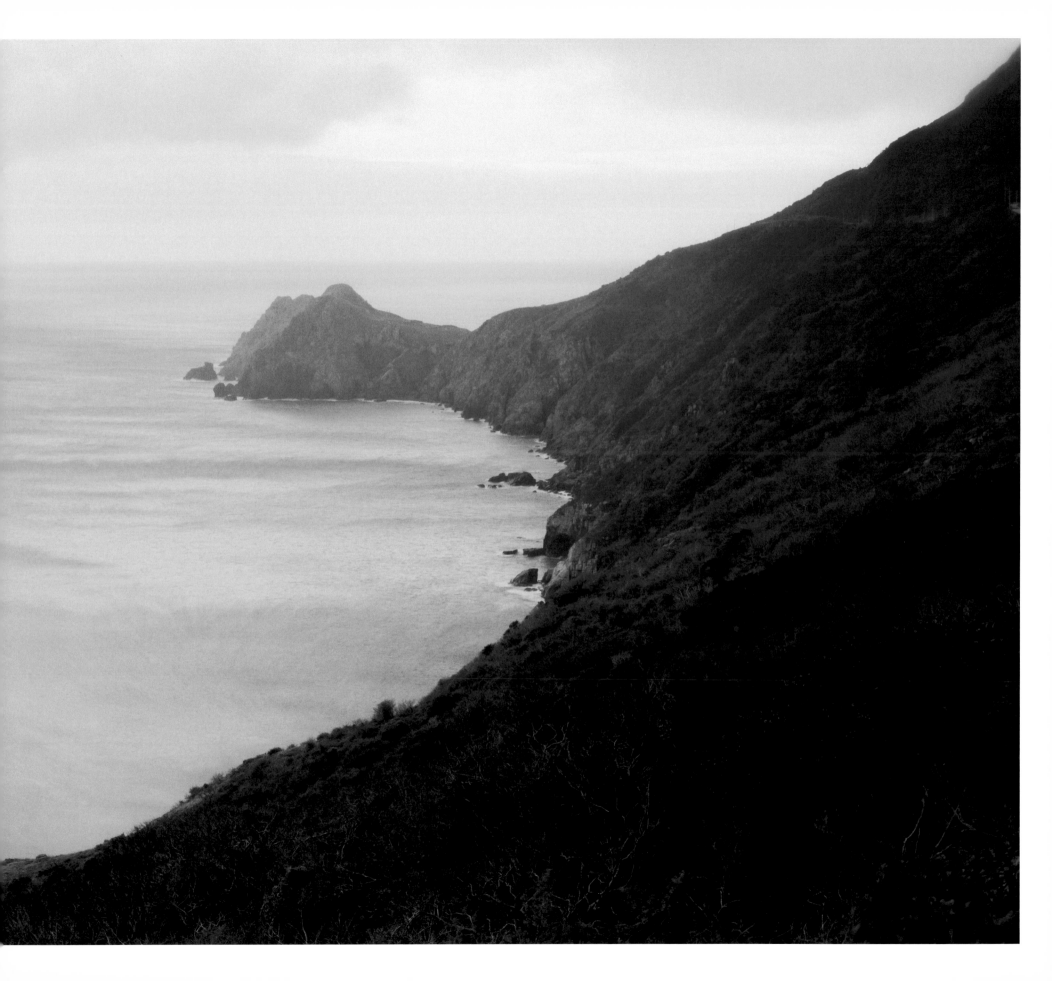

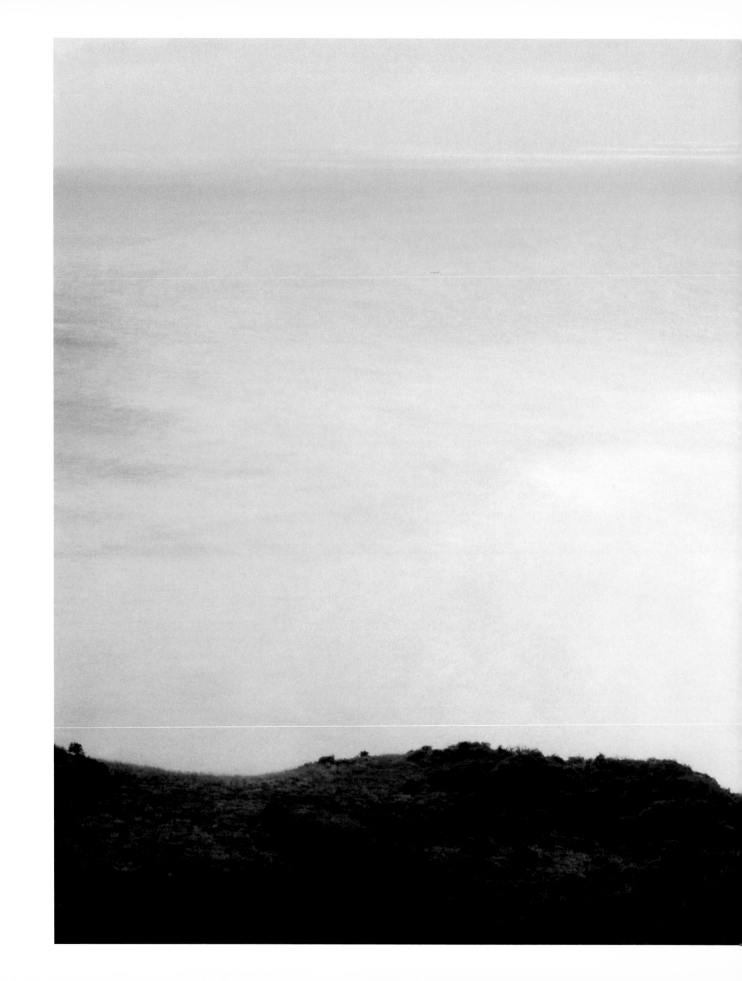

70 sea1a-066h, 2012

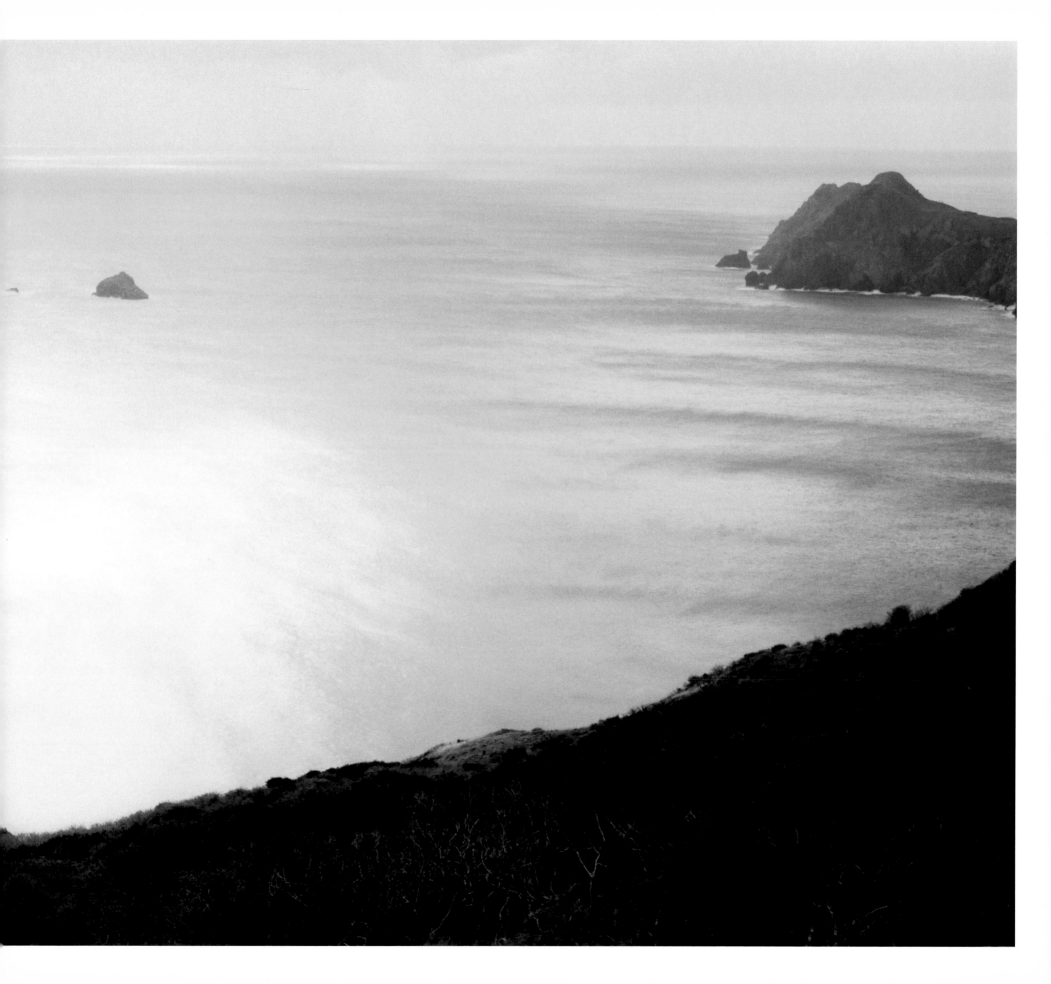

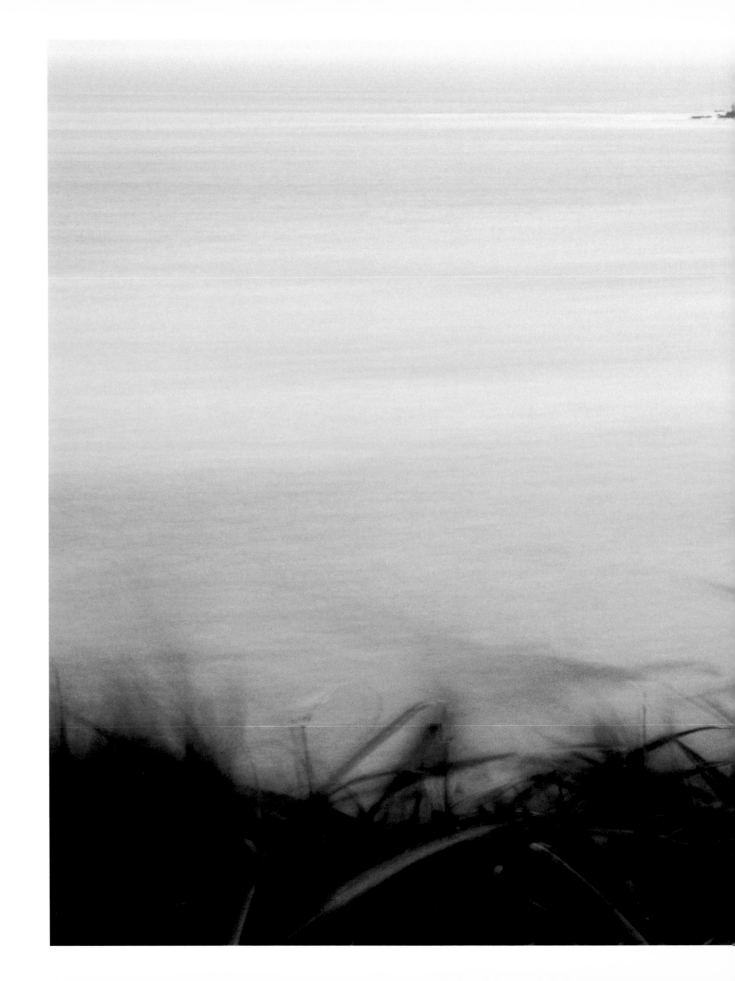

72 sea1a-063h, 2012

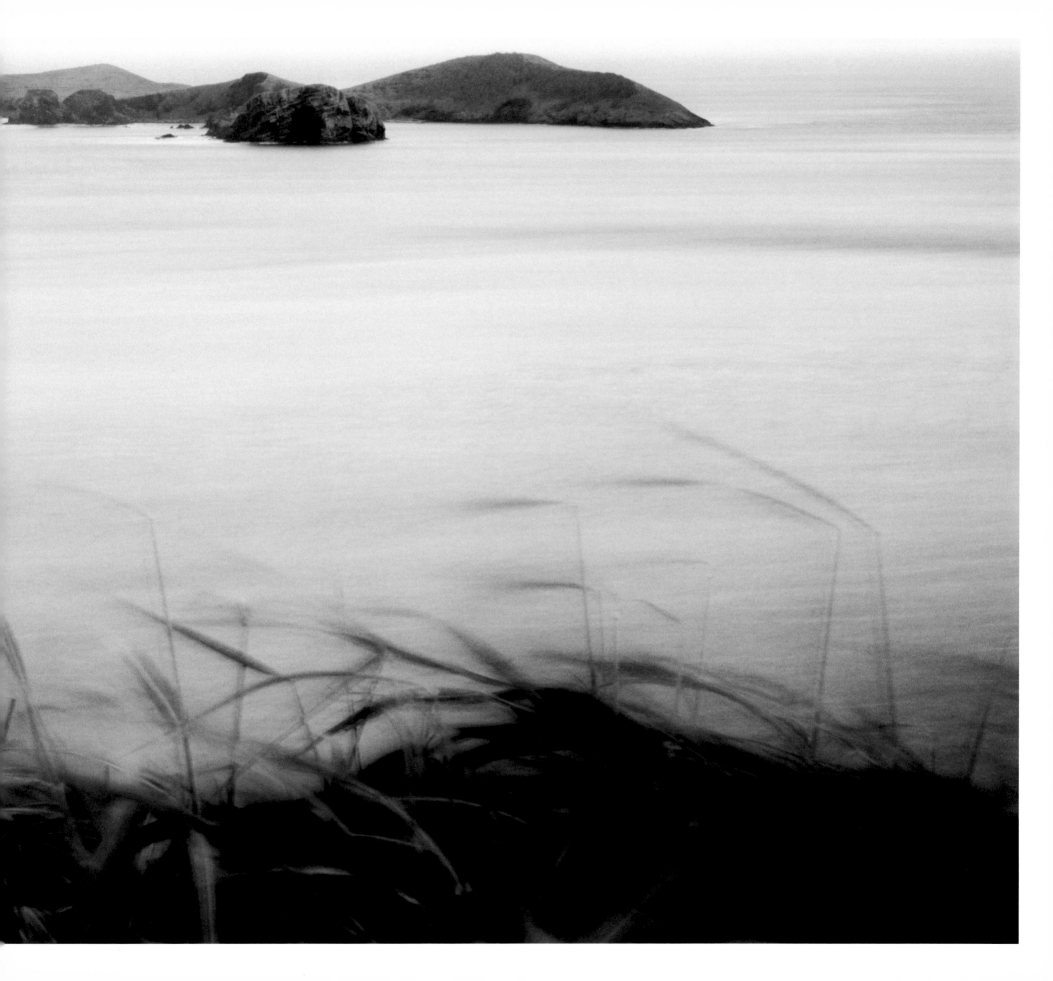

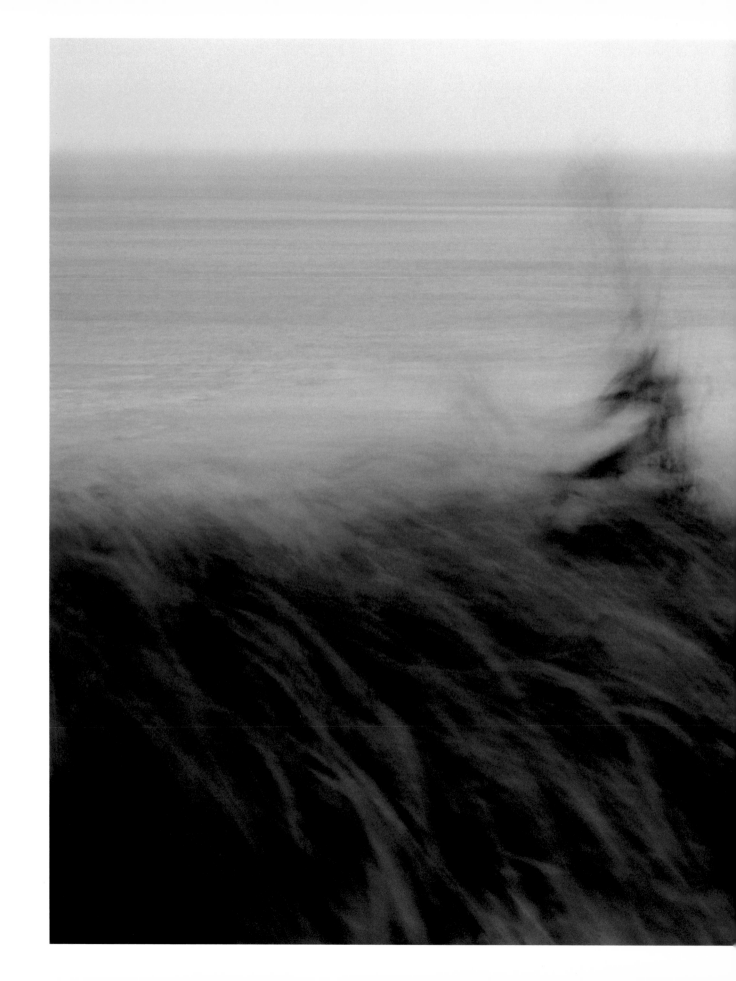

74 sea1a-061h, 2012

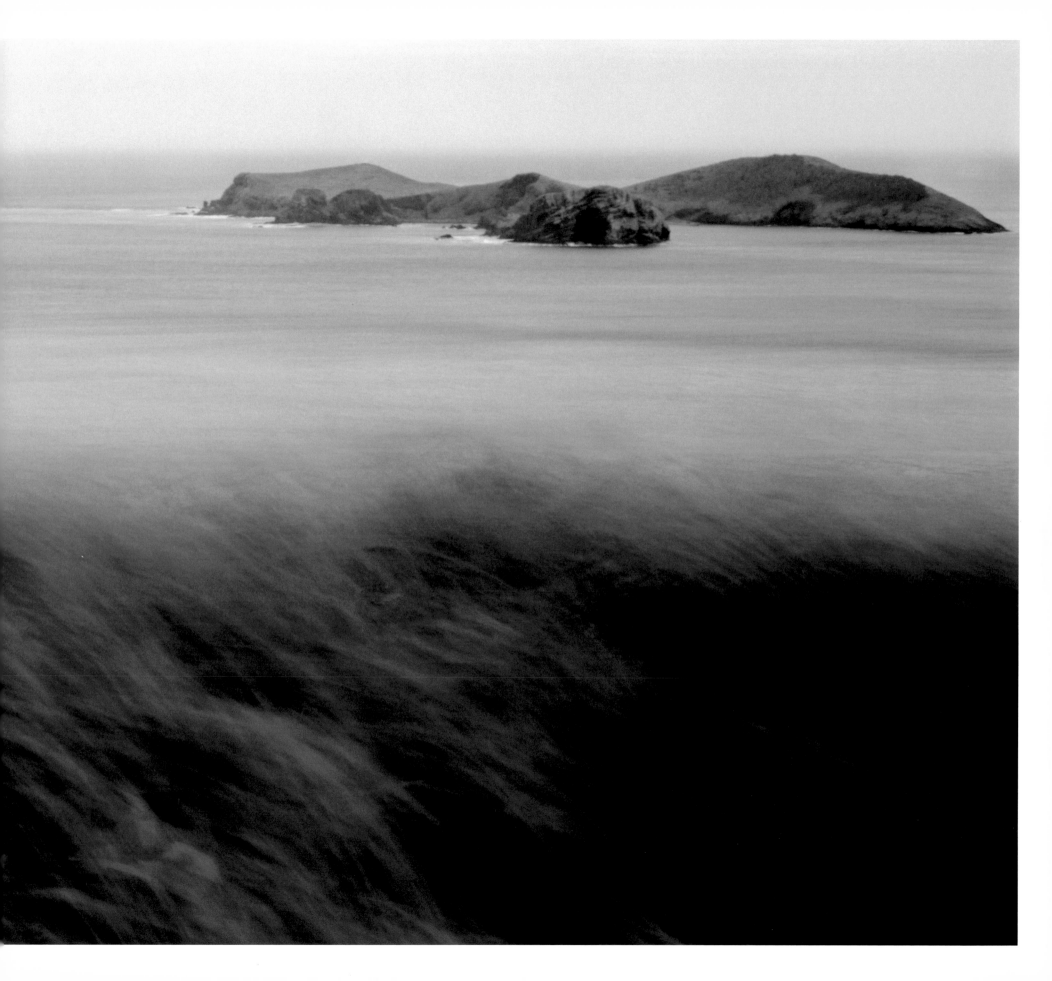

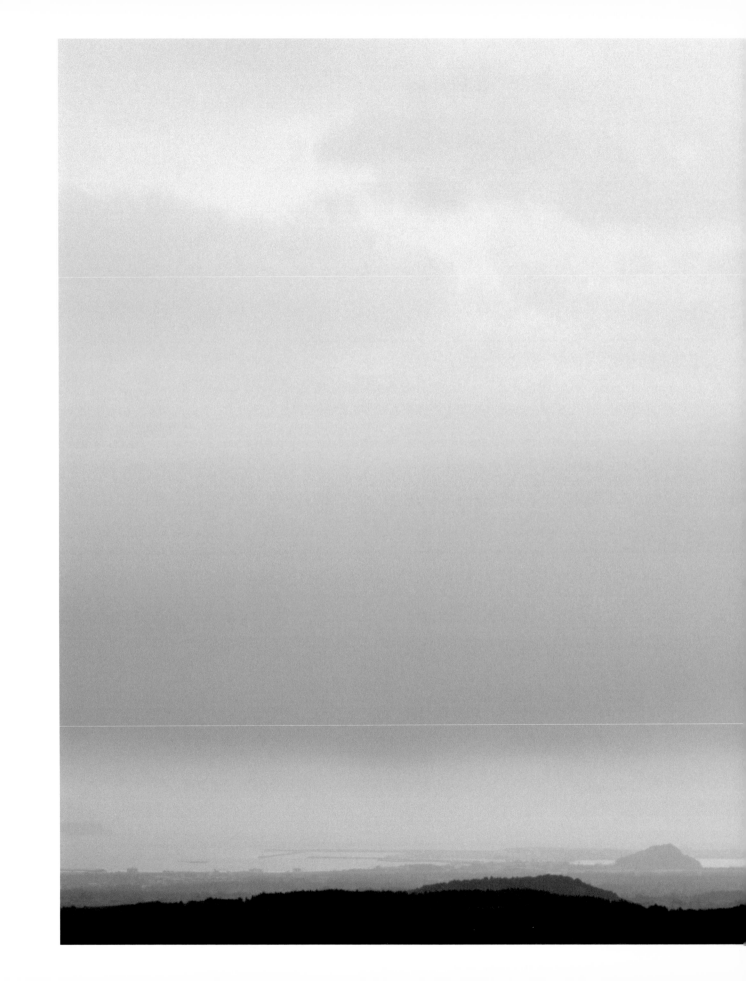

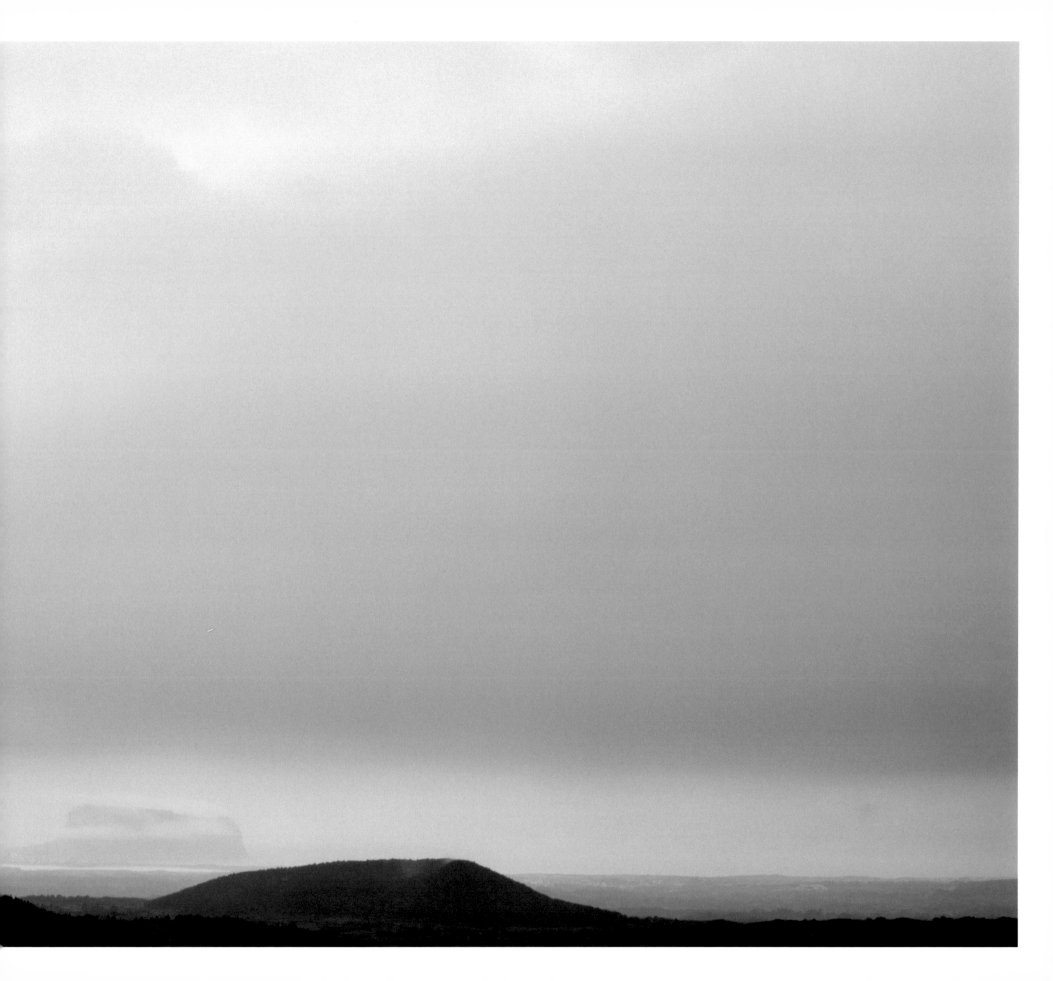

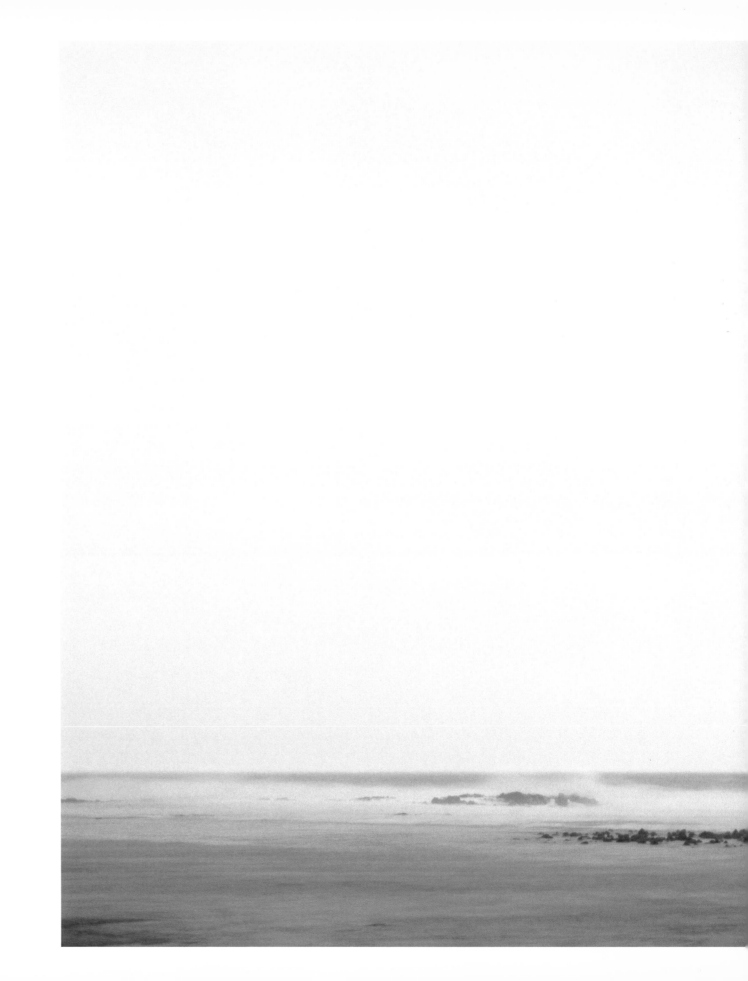

78 sea1a-071h, 1999

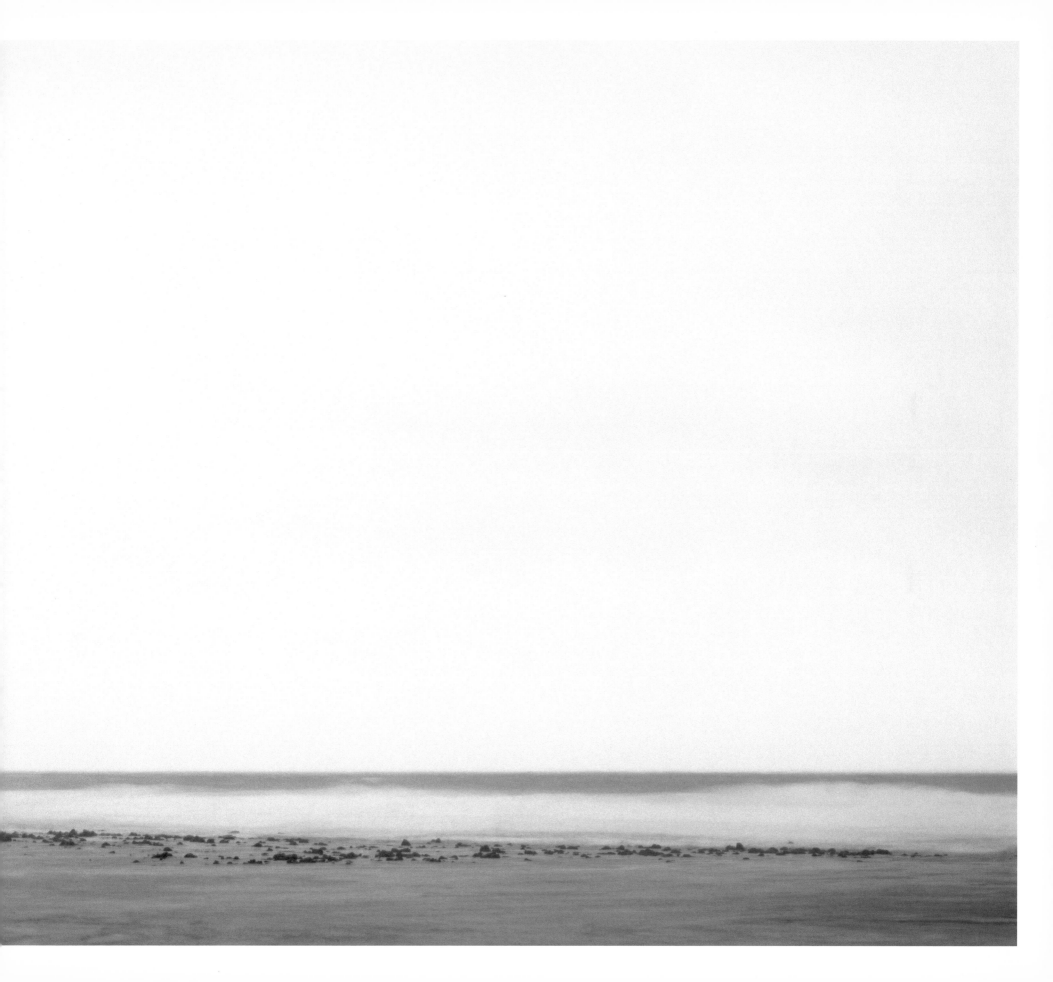

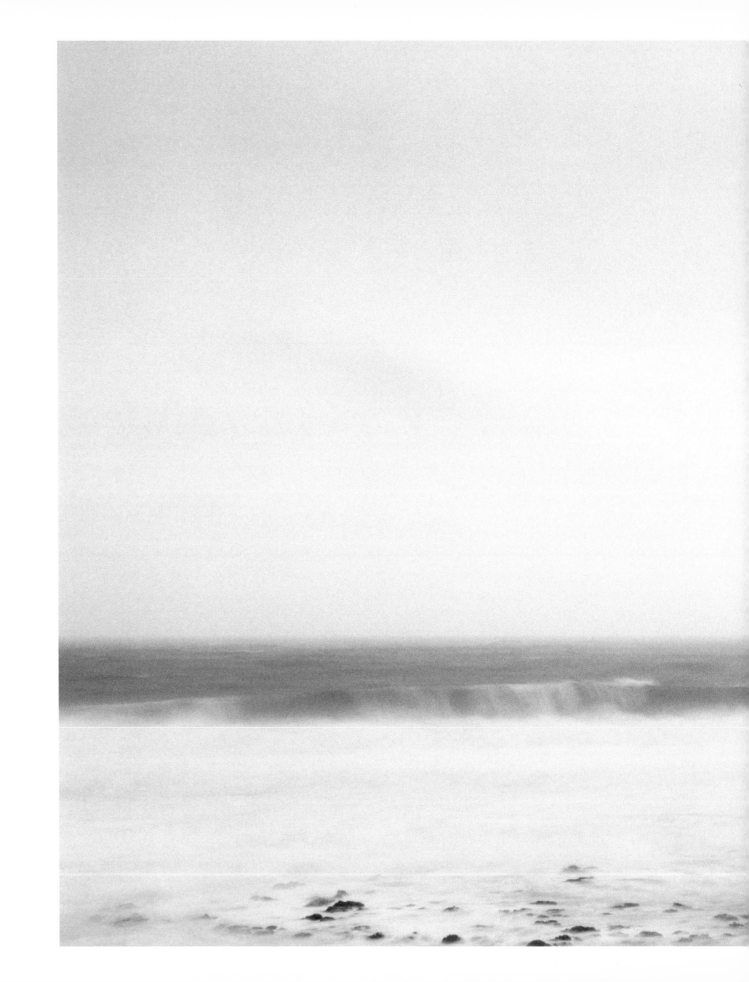

sea1a-072h, 2002

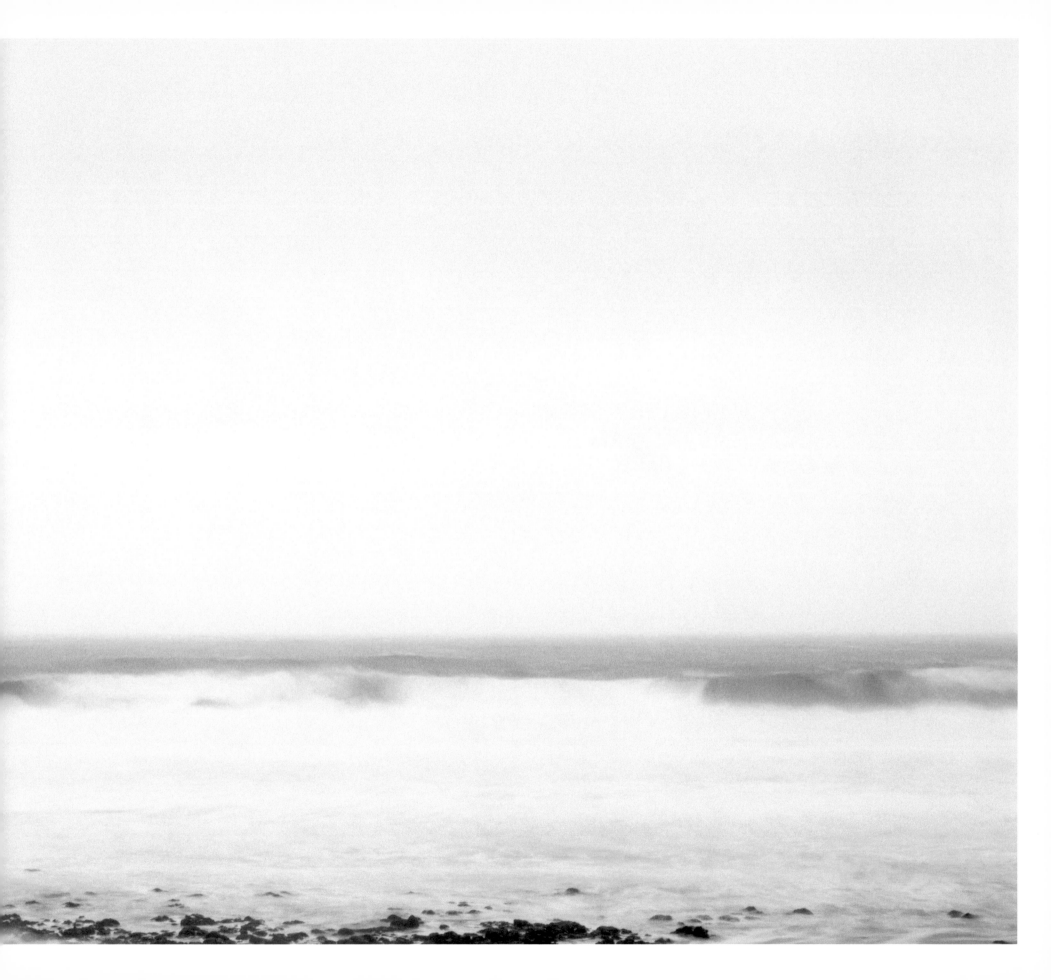

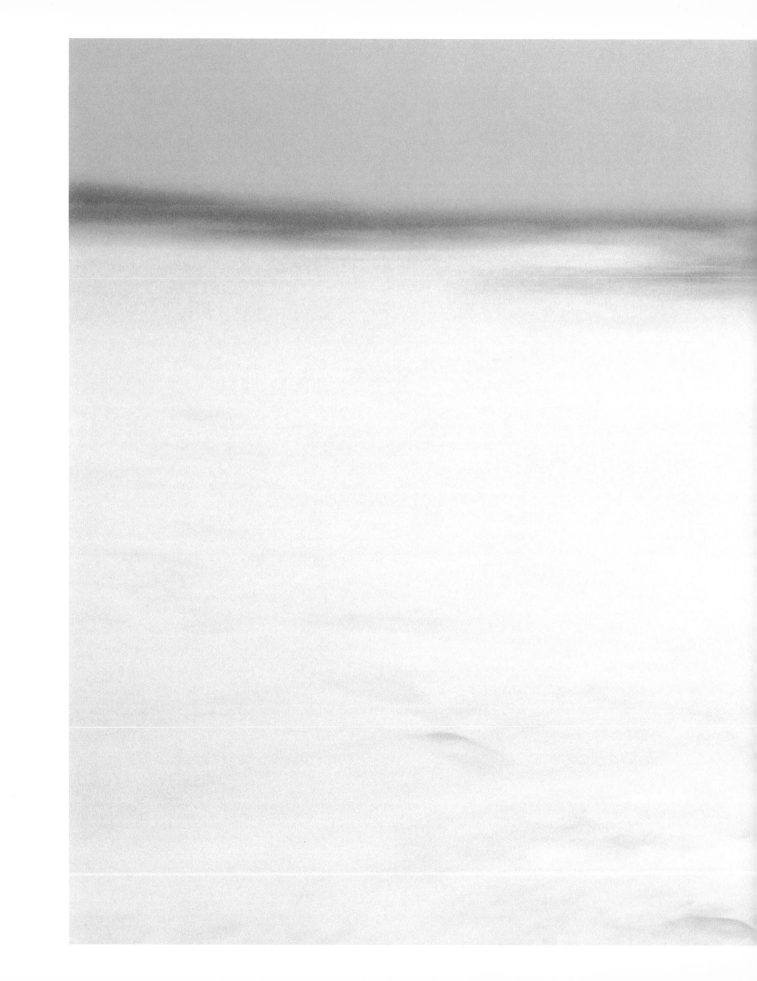

82 sea1a-073h, 2002

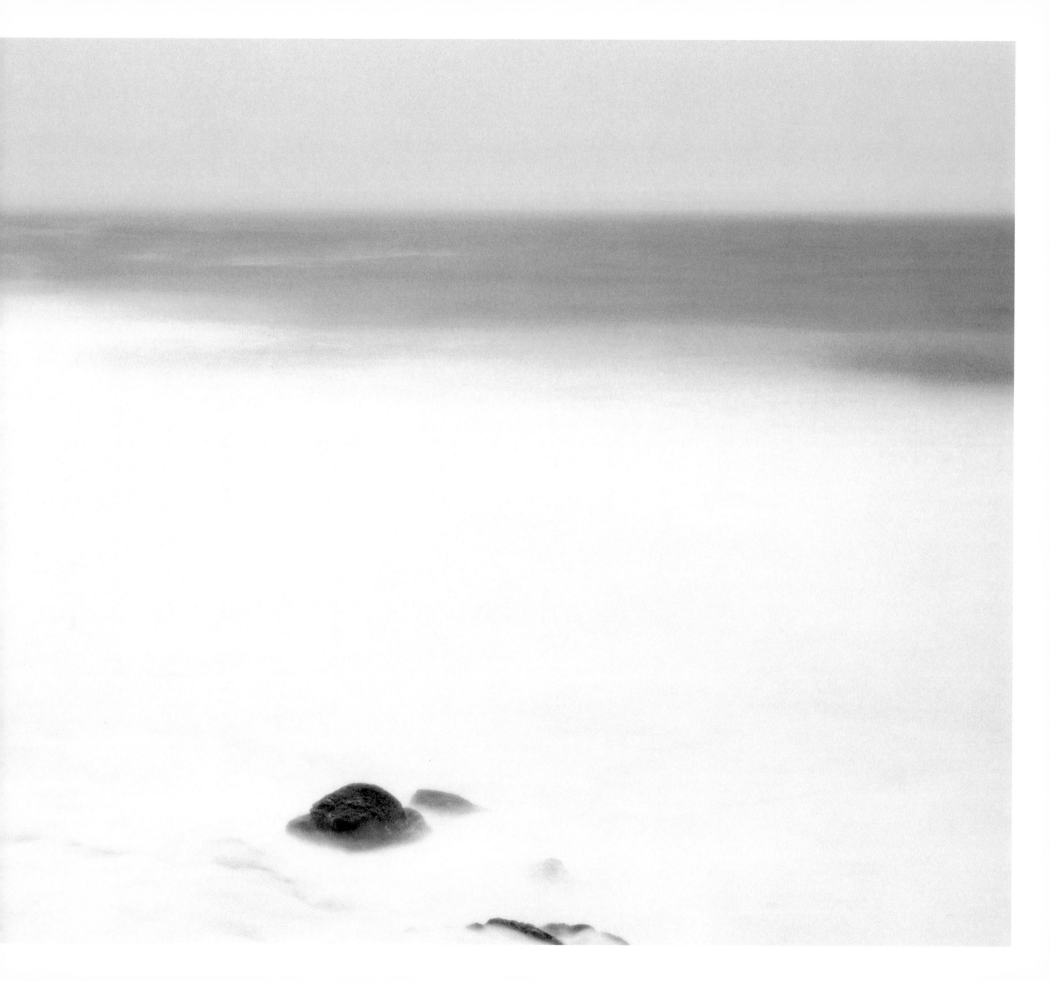

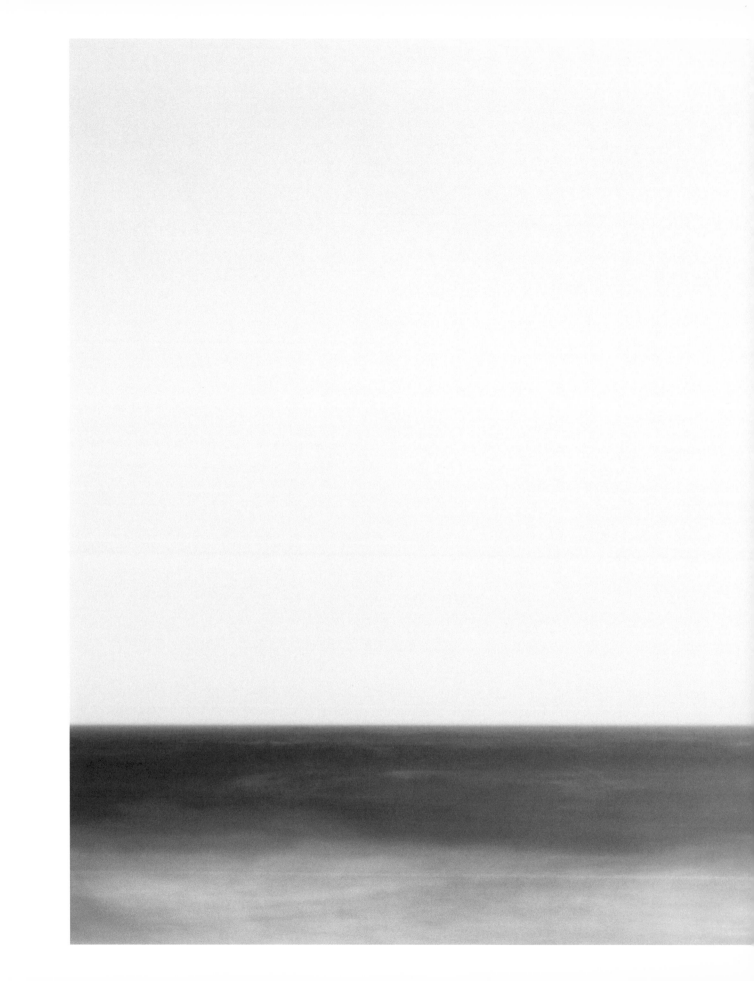

84 sea1a-079h, 2009

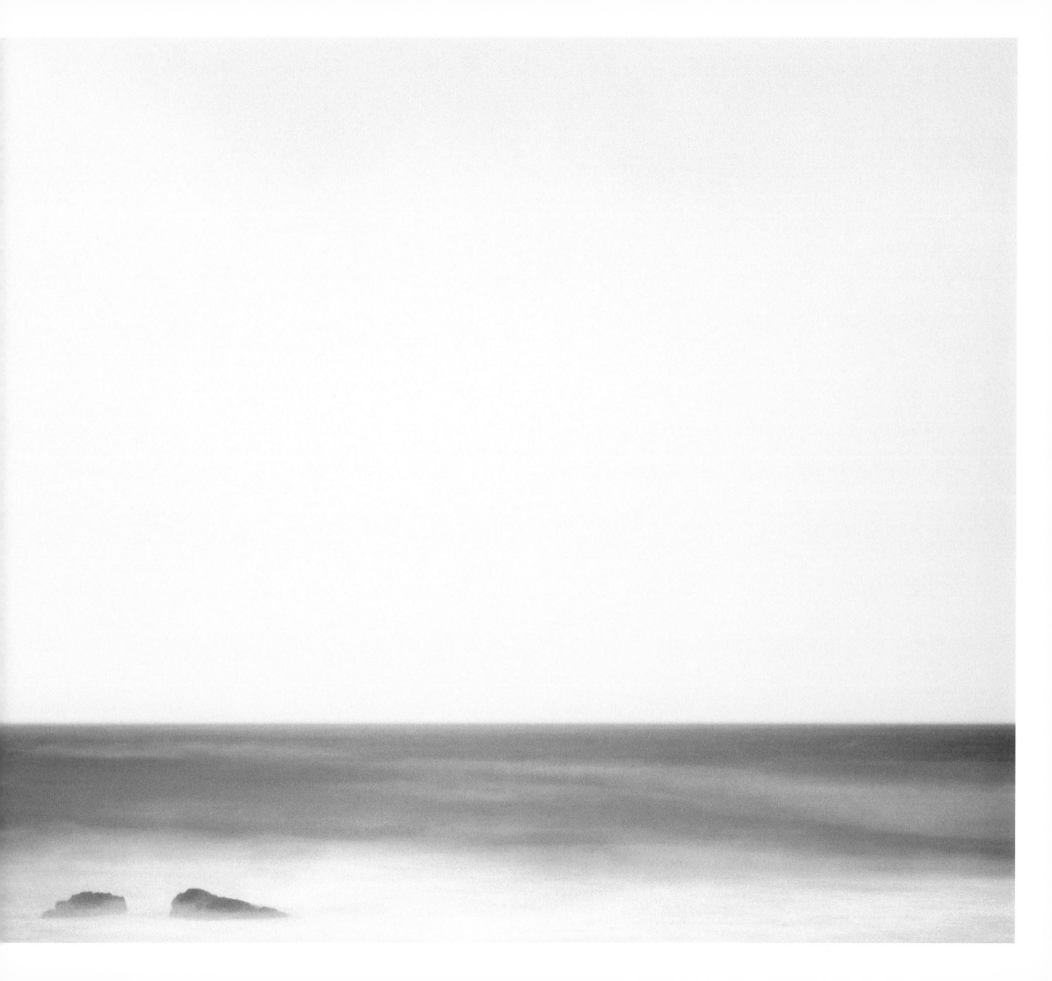

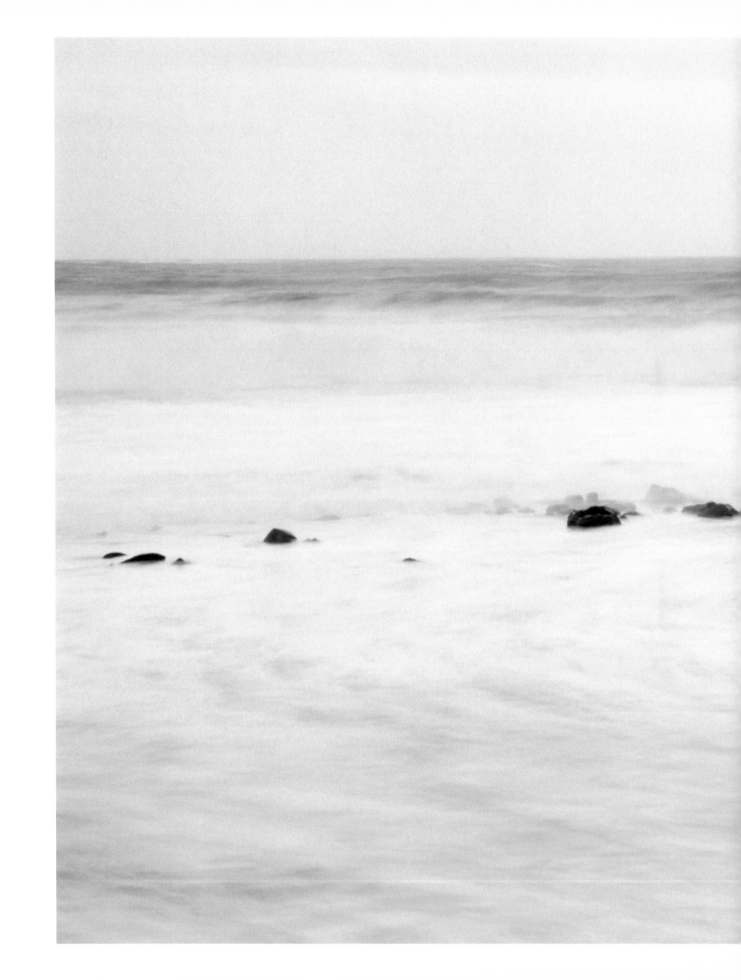

sea1a-082h, 2012

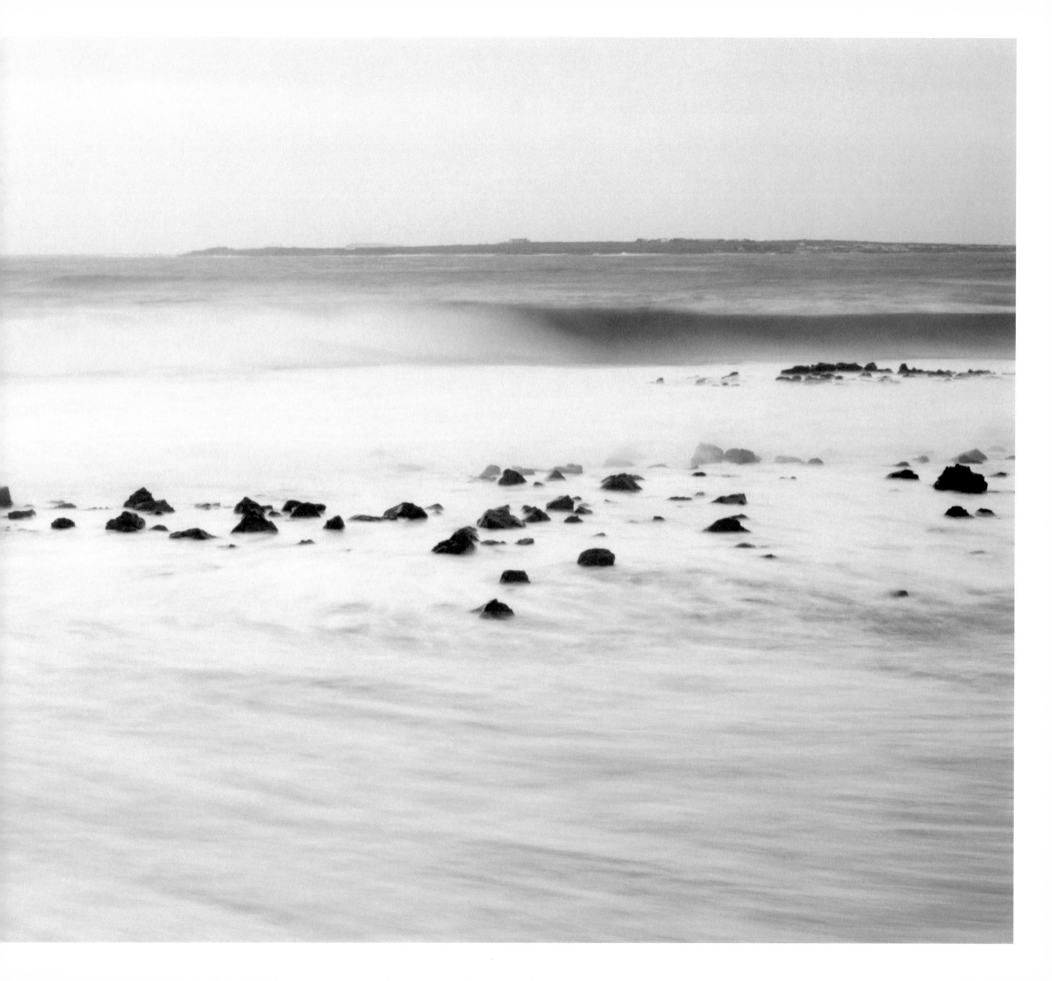

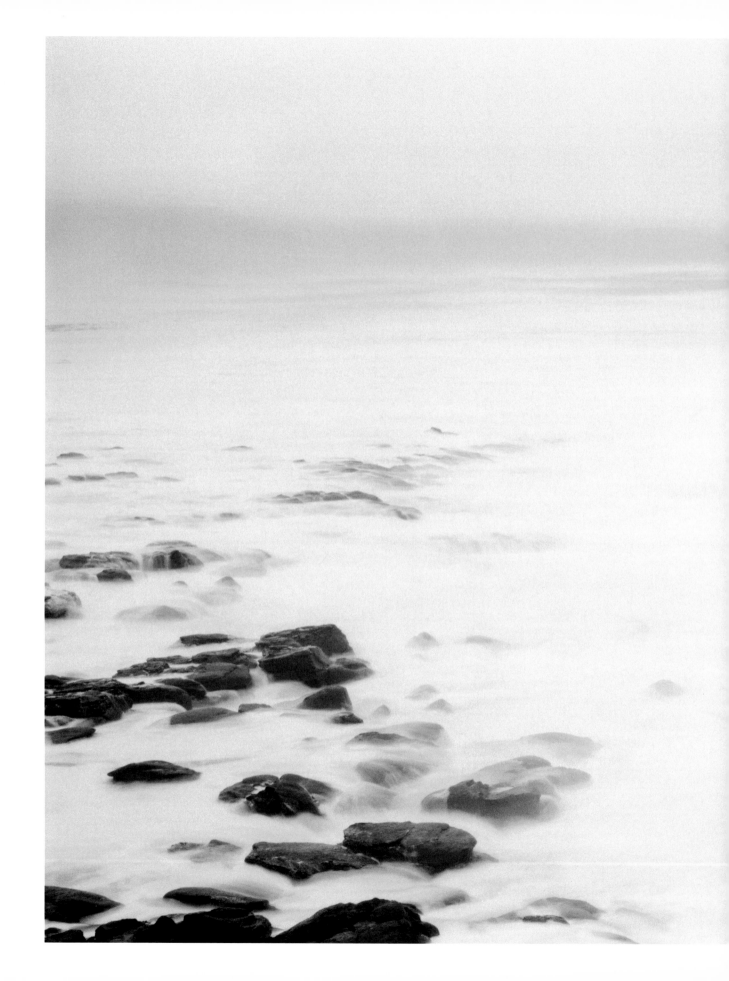

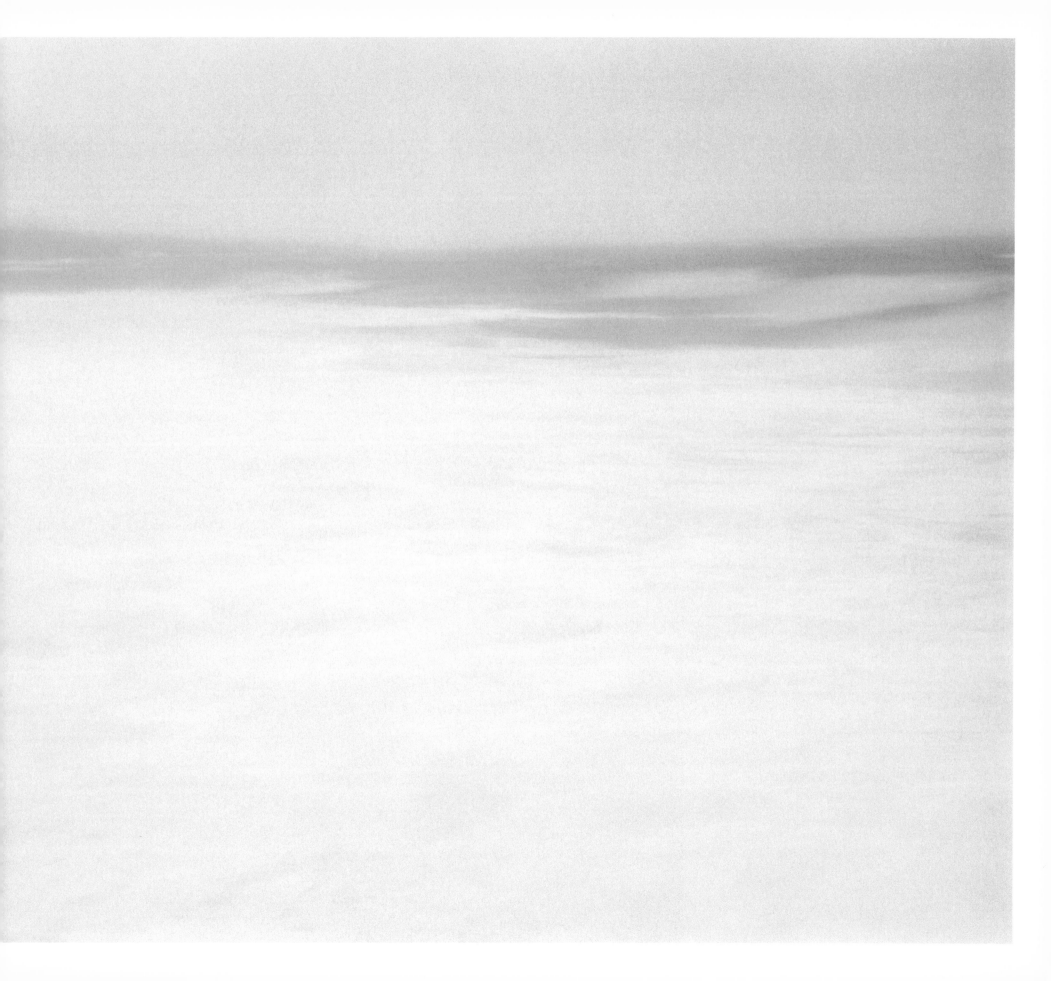

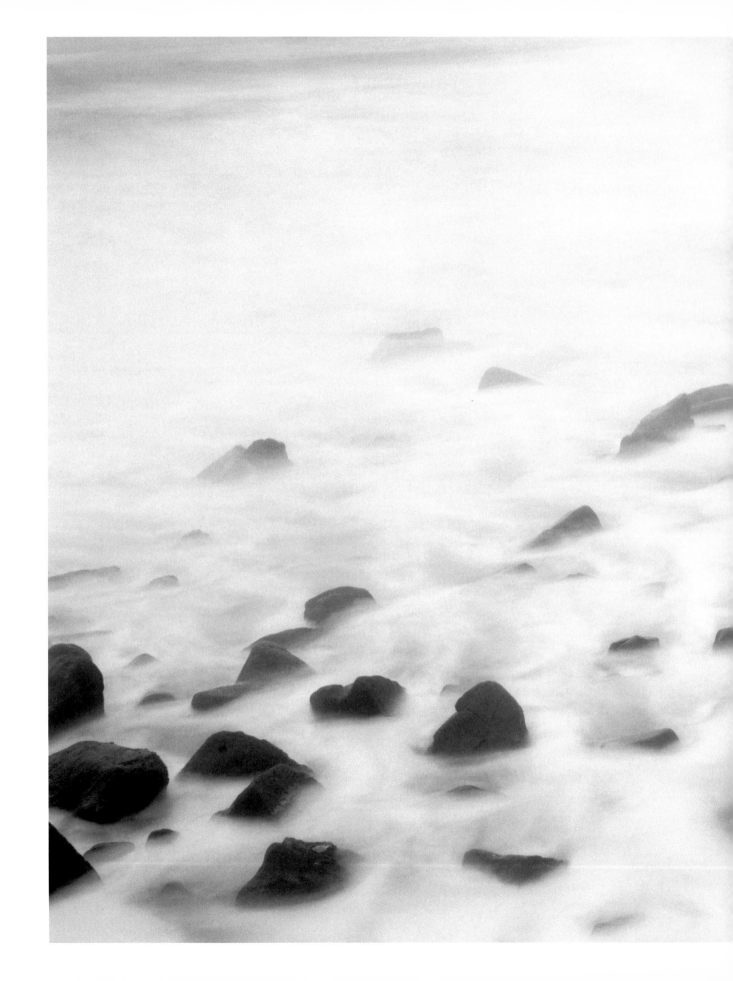

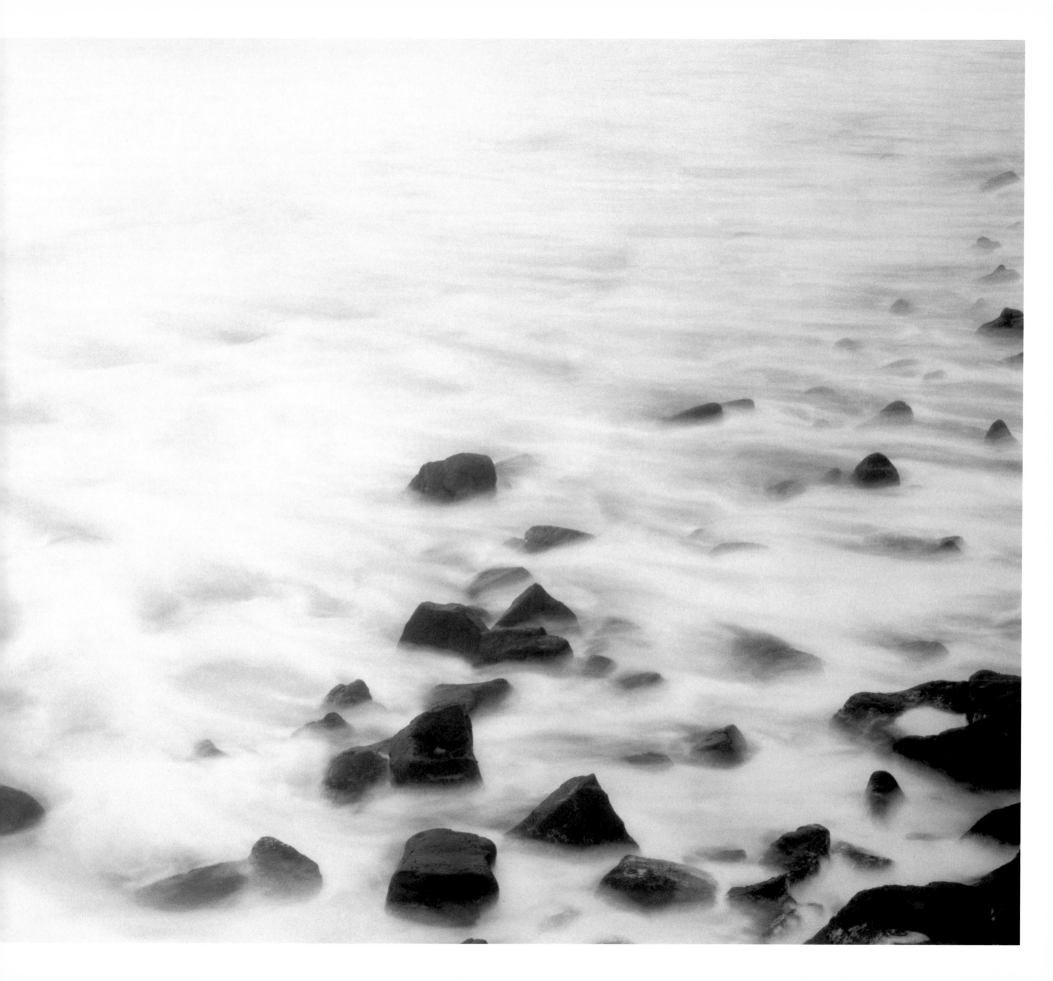

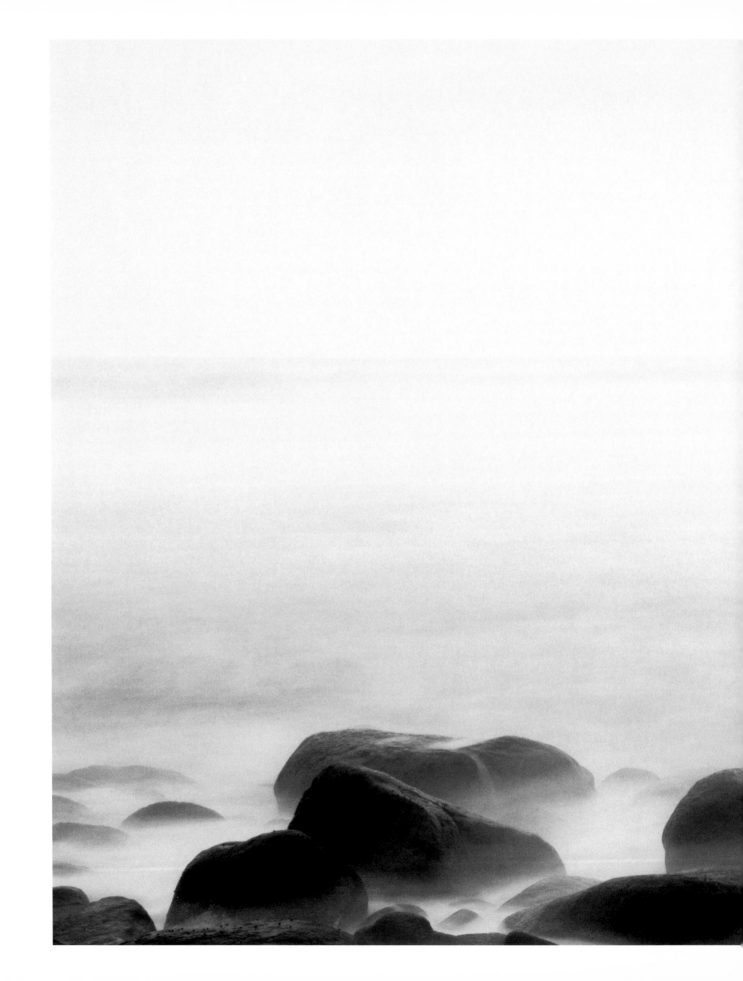

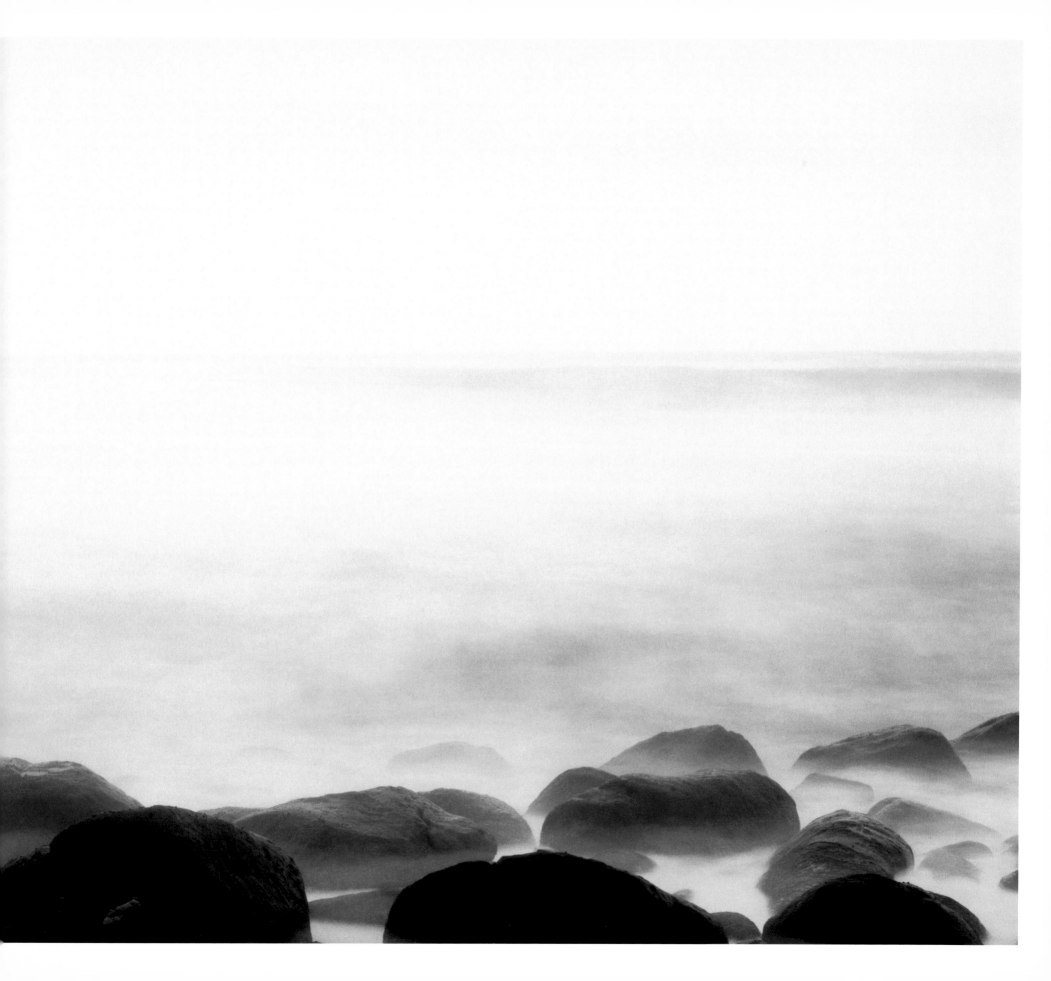

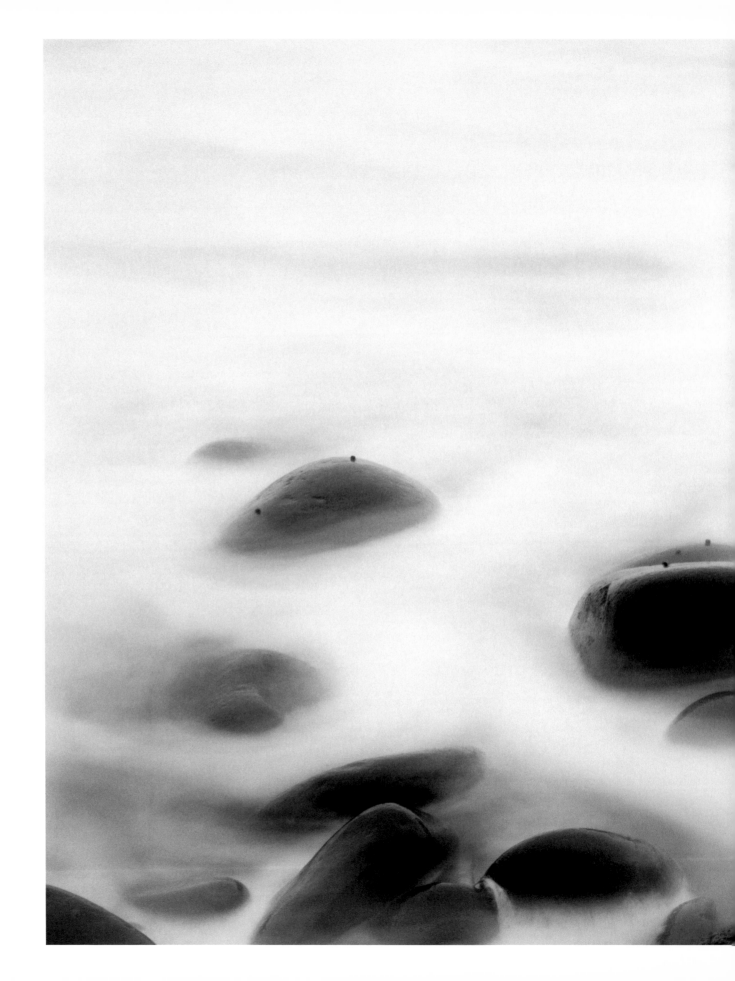

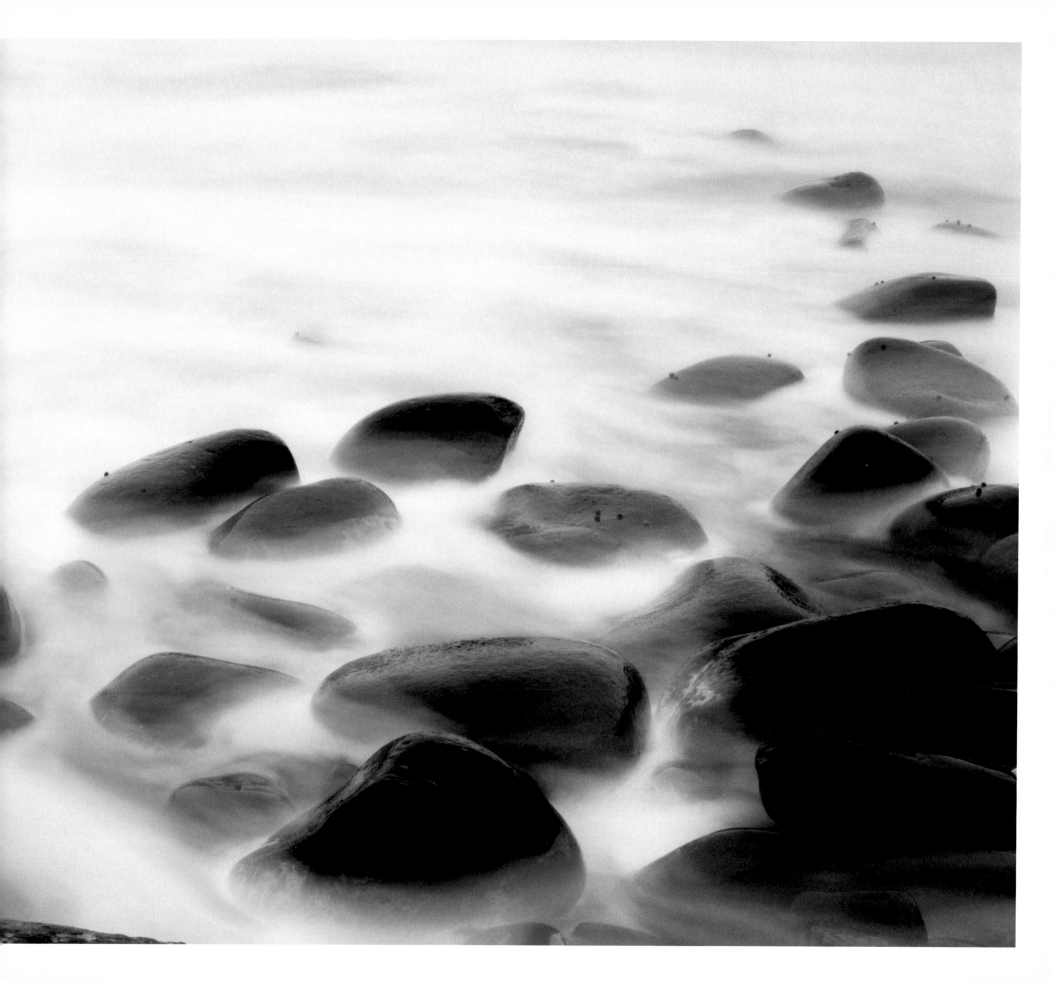

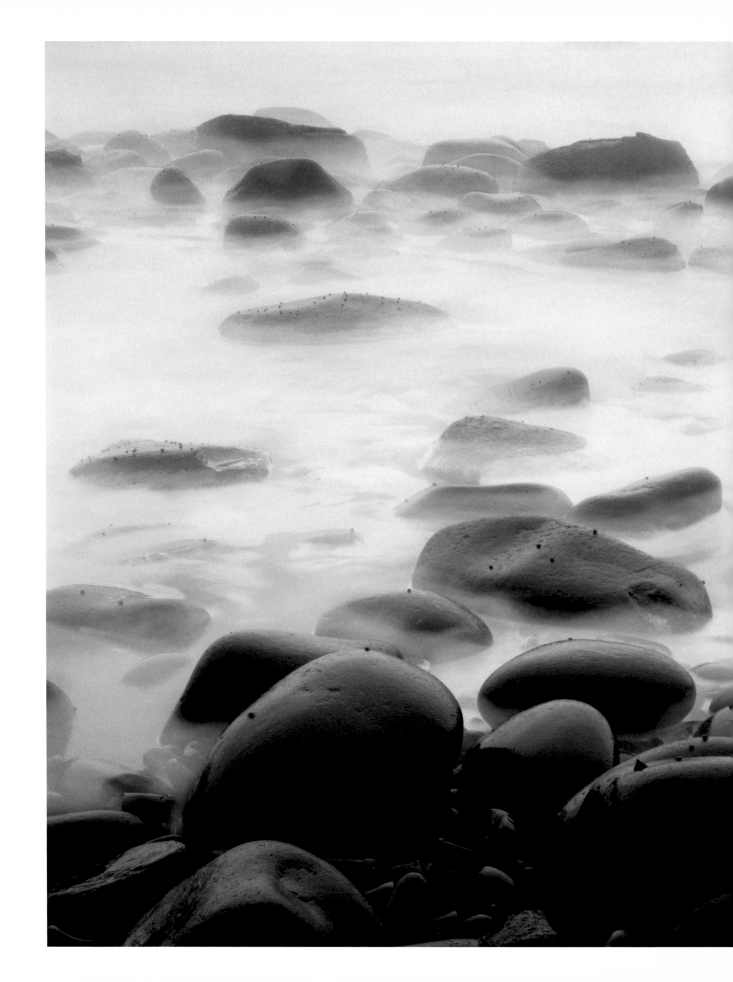

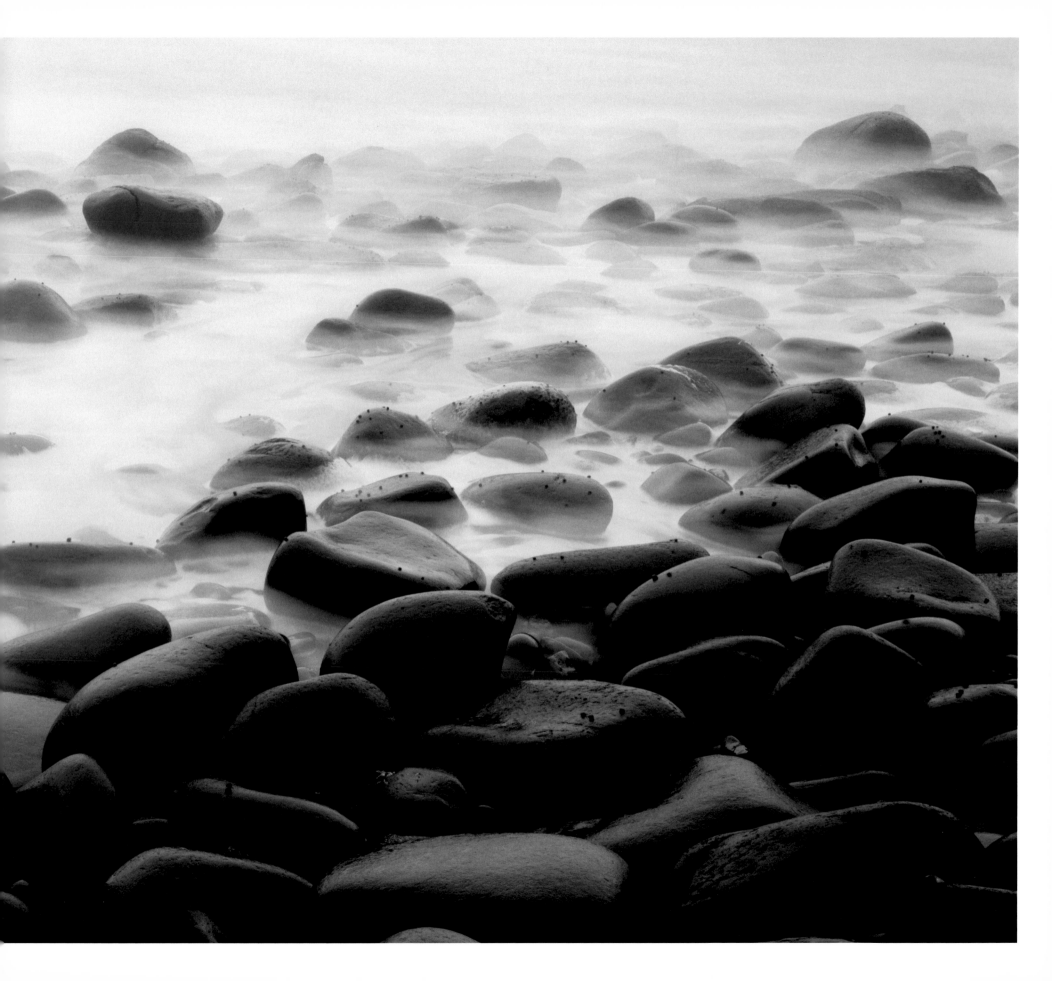

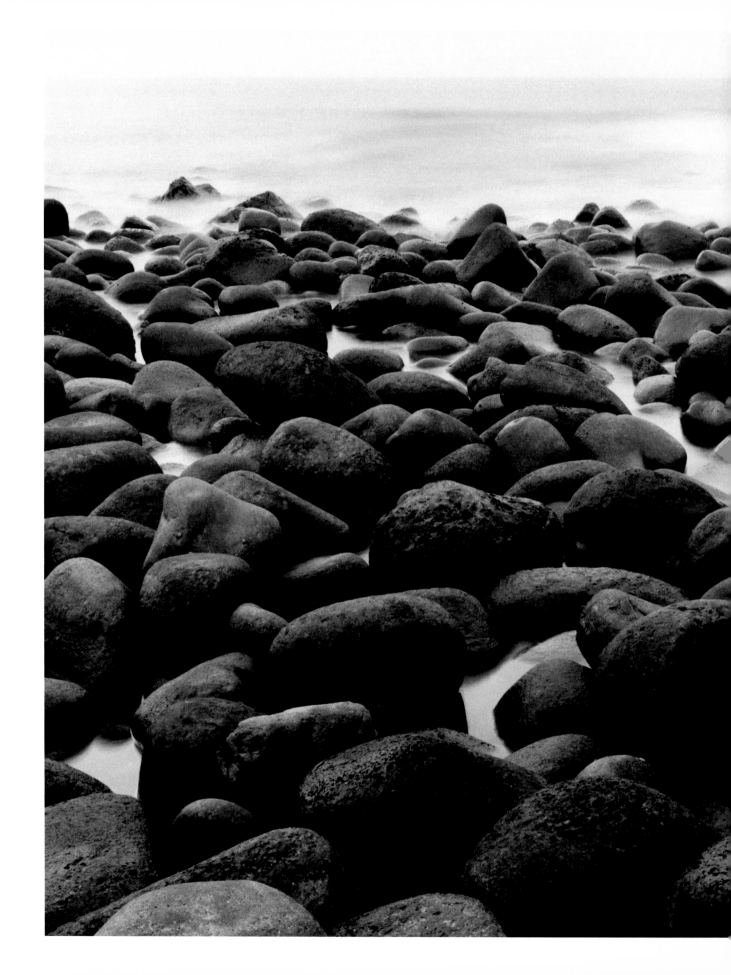

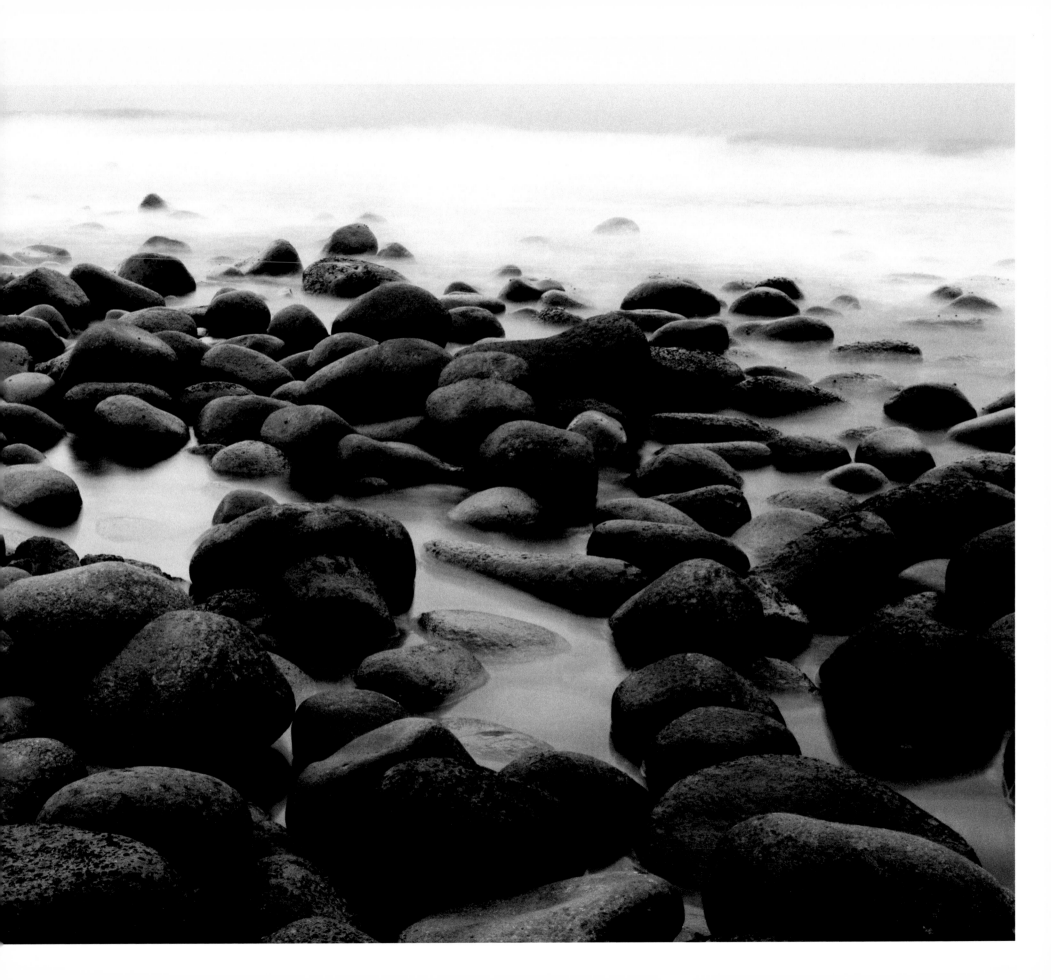

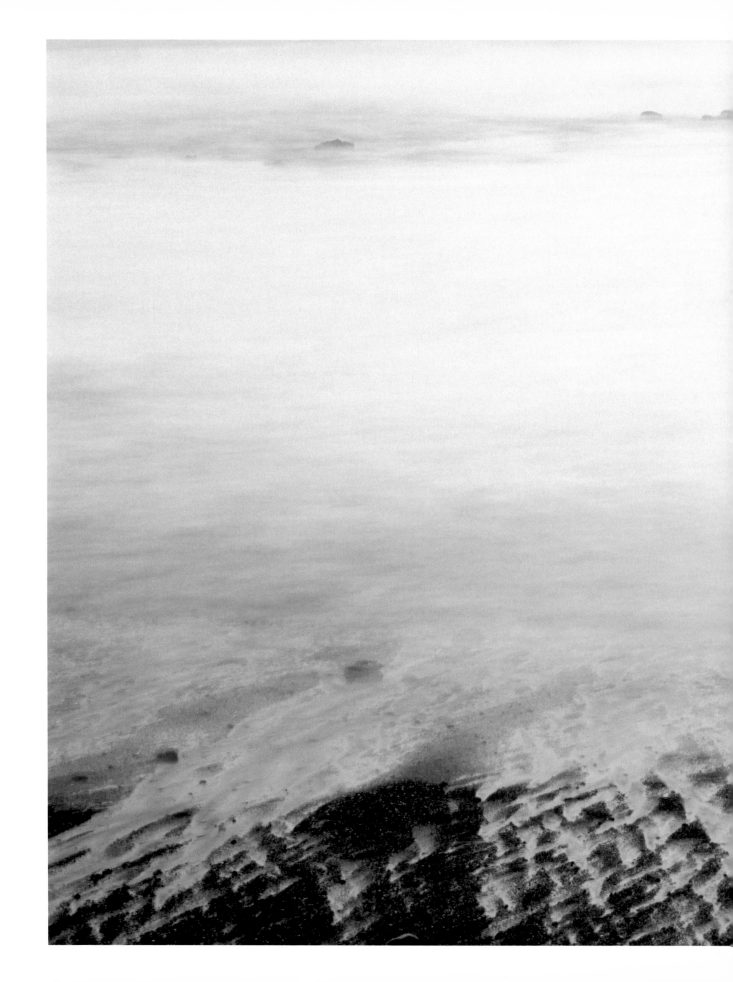

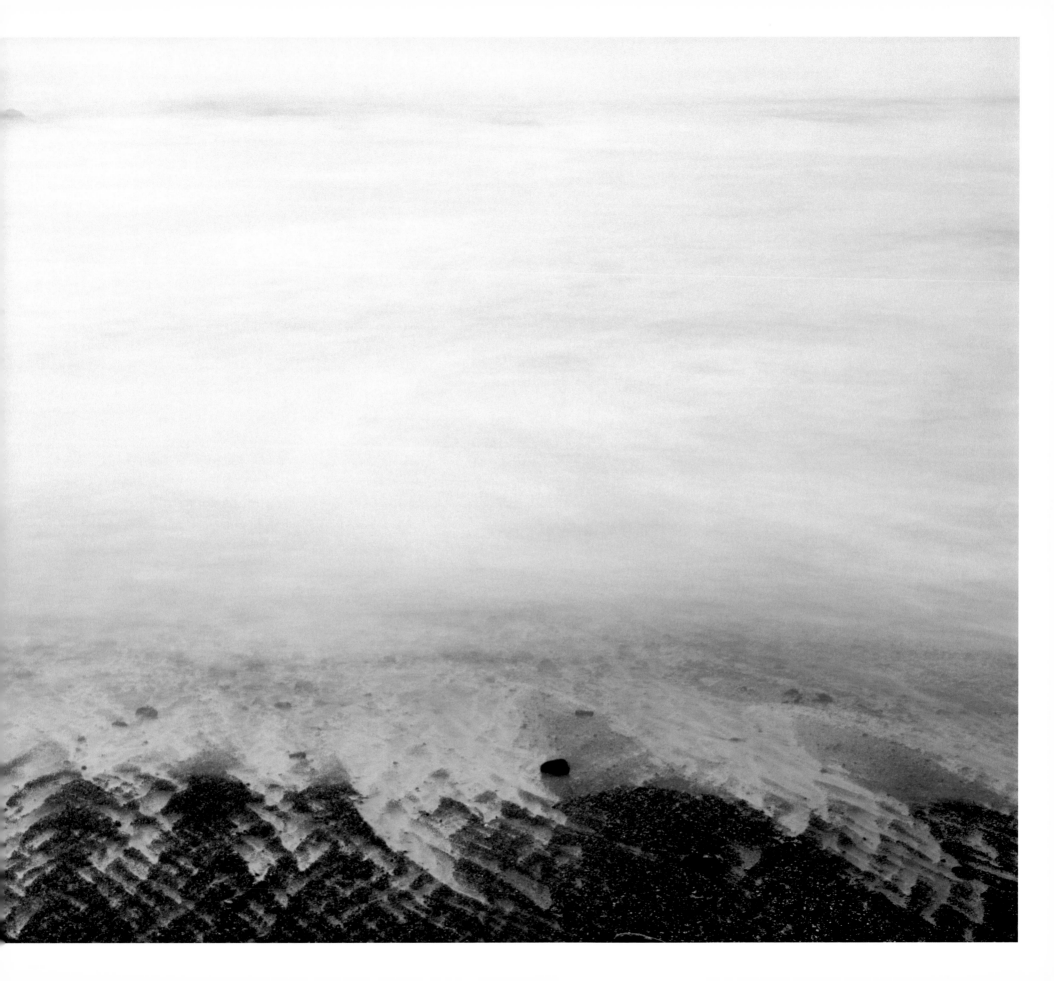

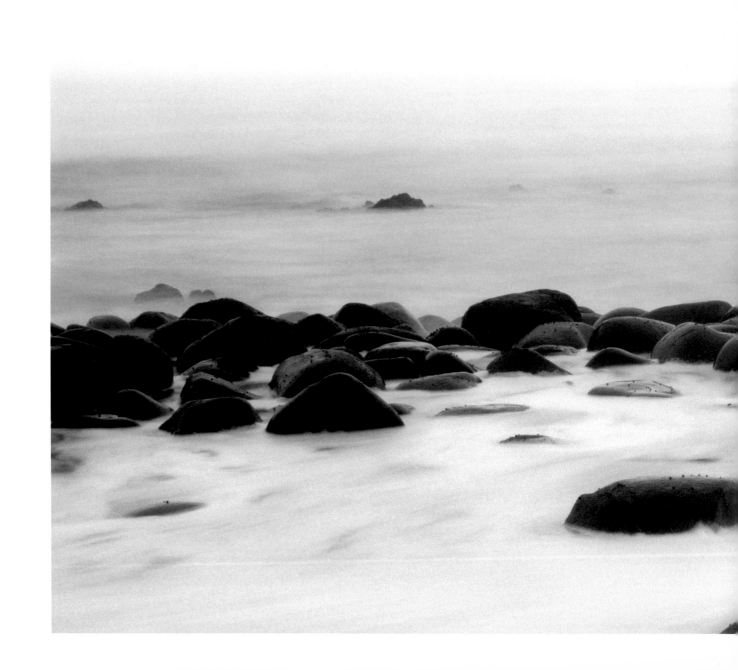

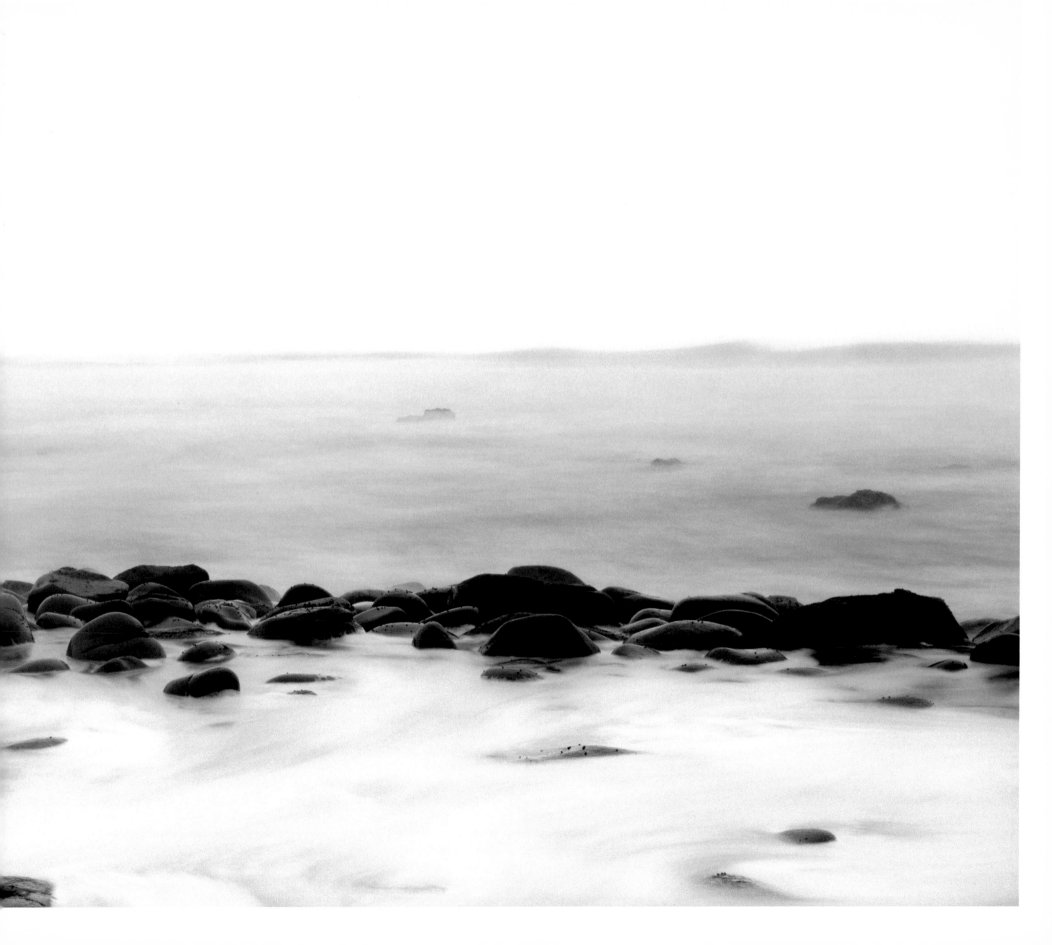

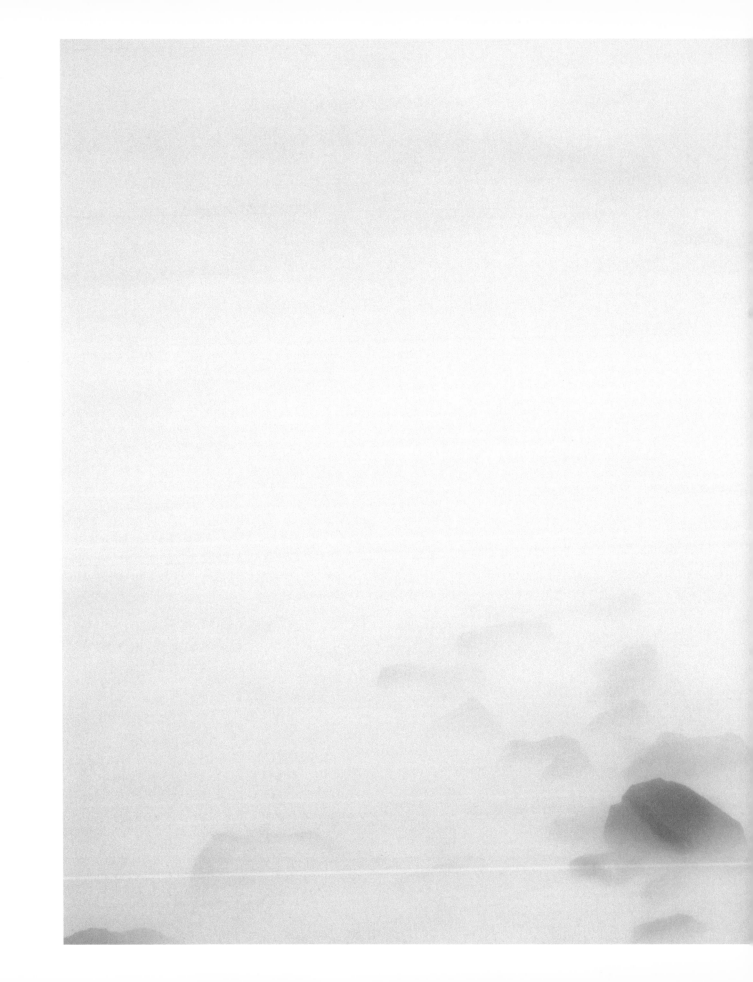

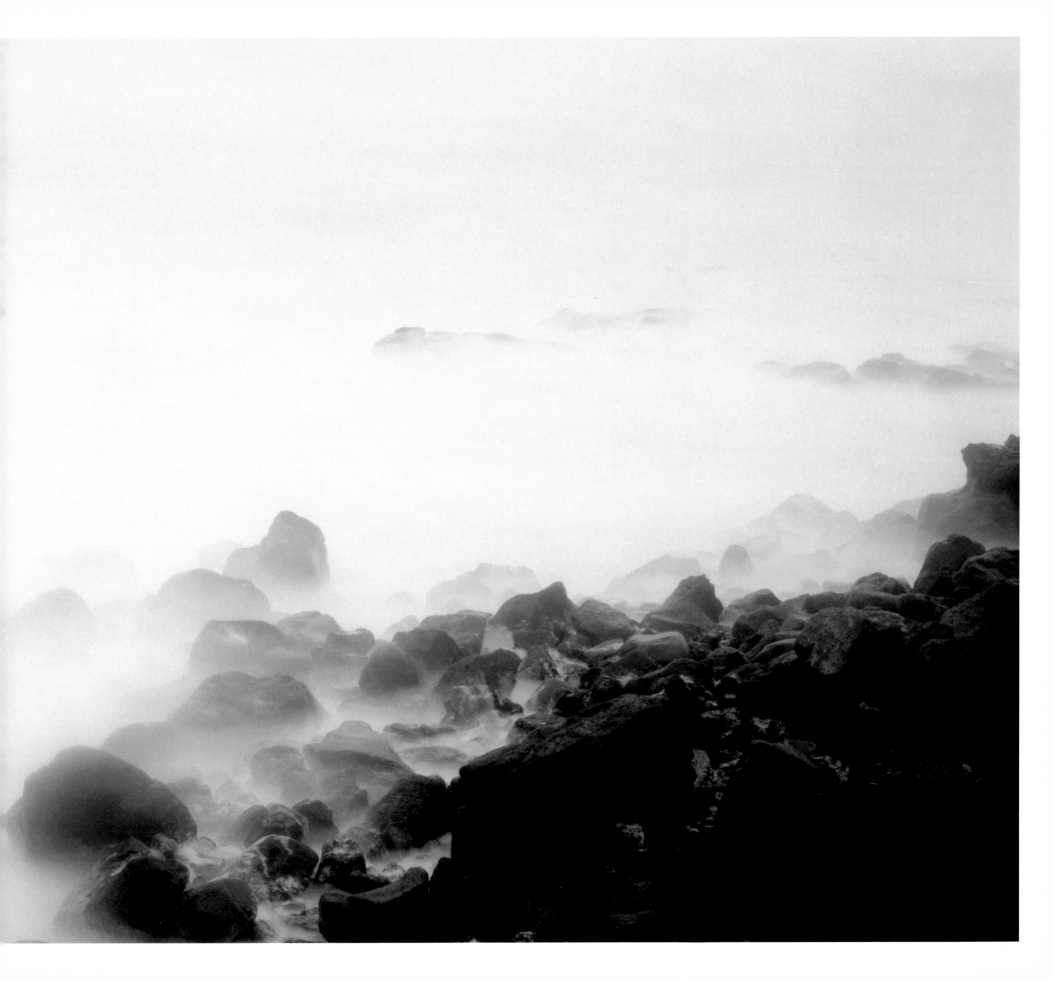

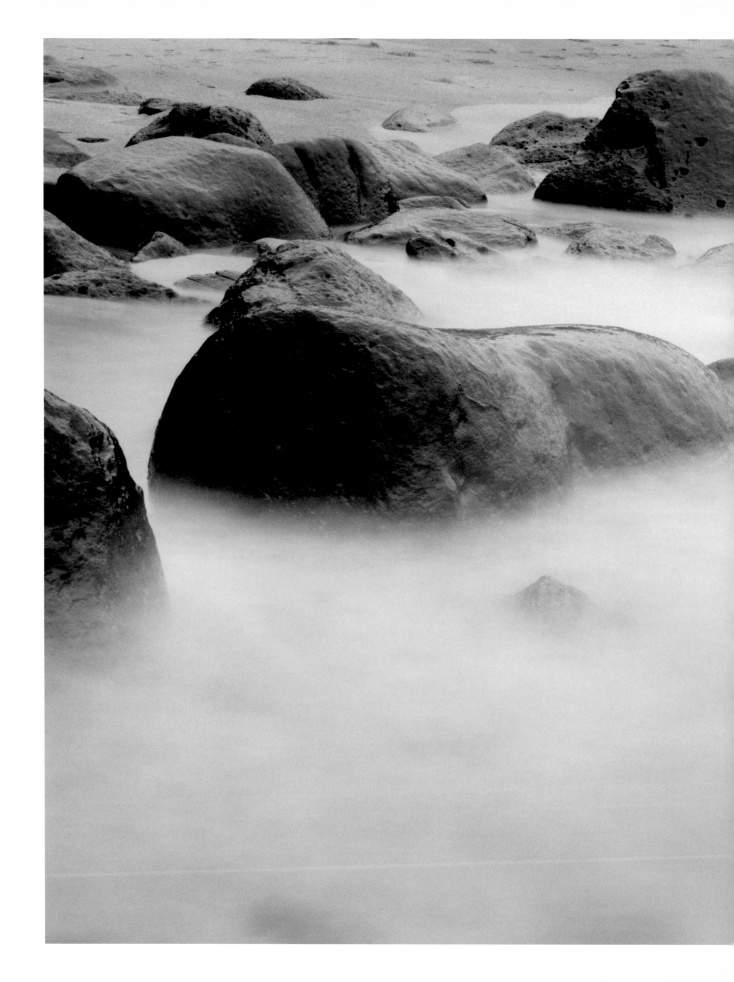

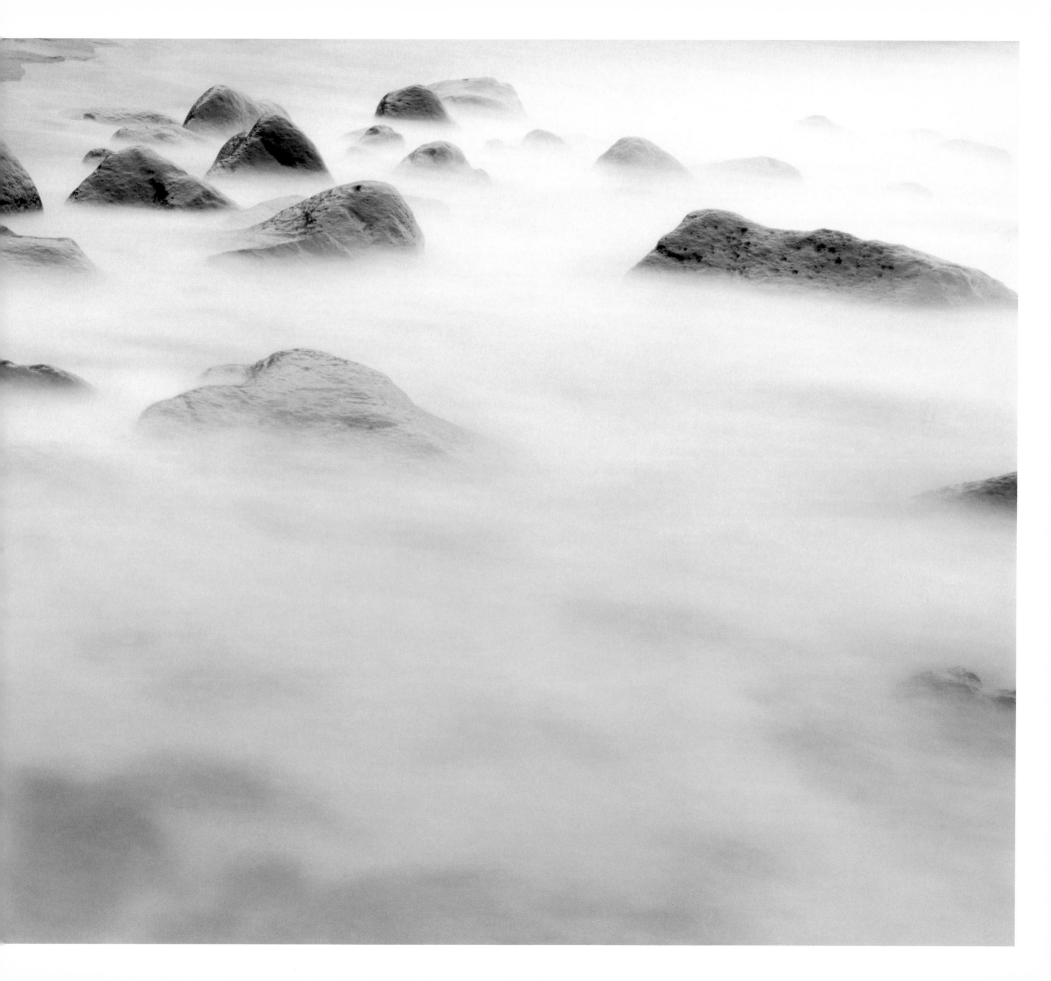

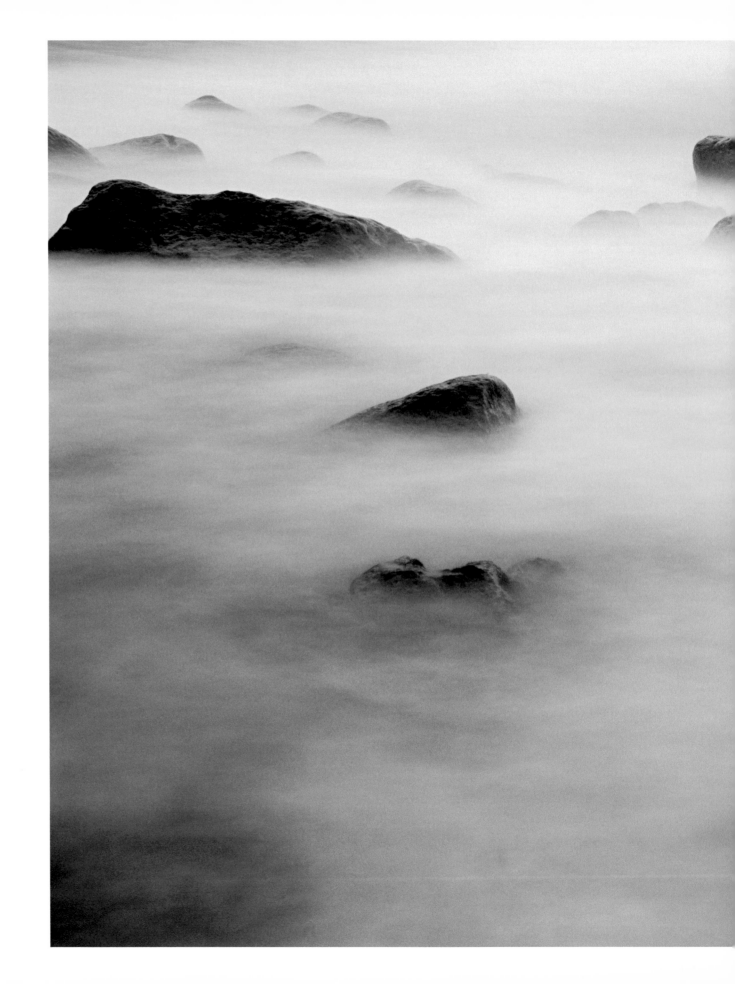

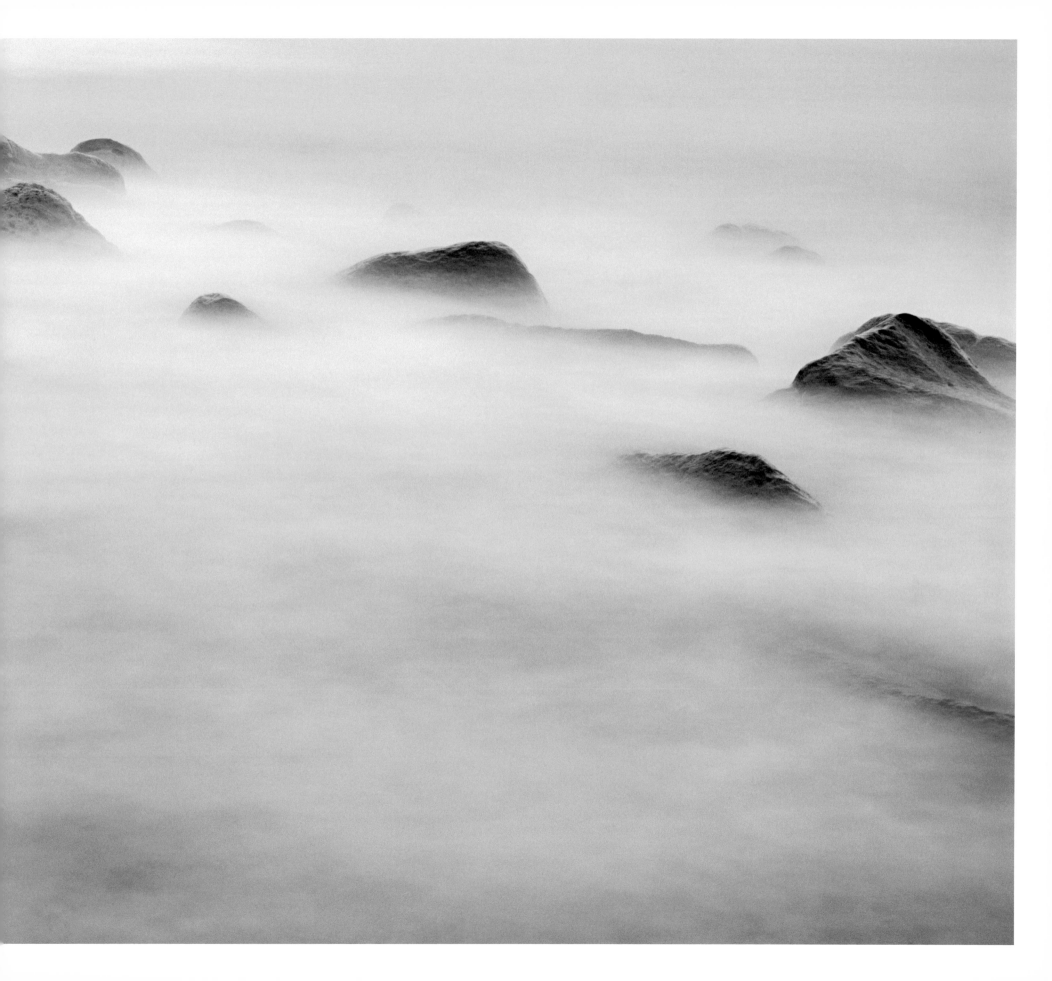

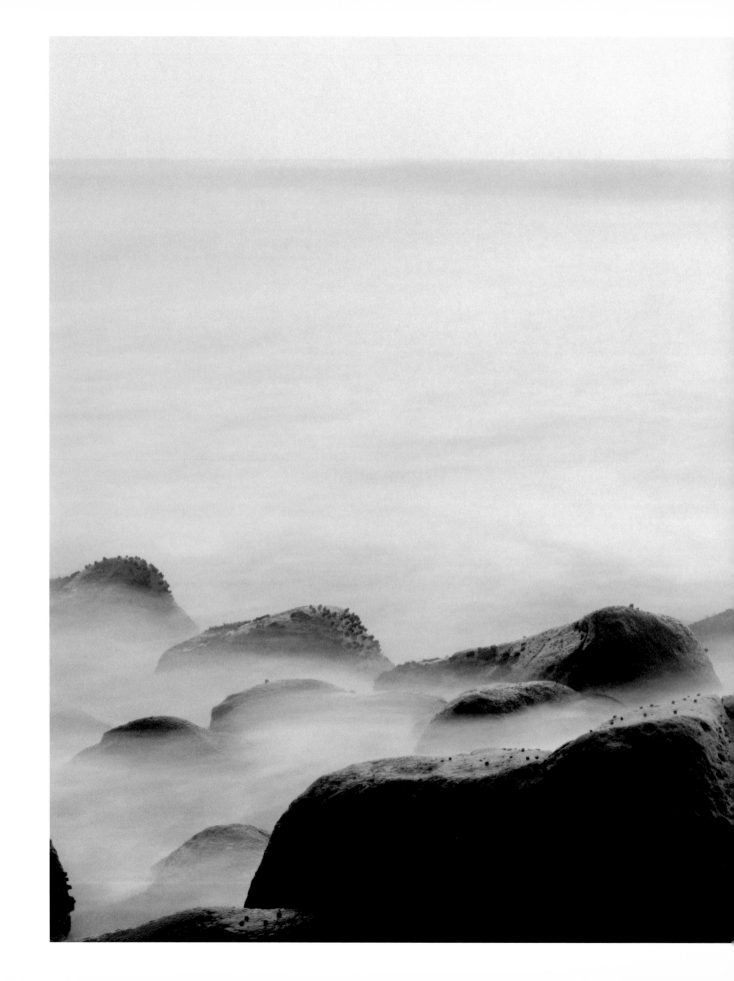

110 sea1a-074h, 1999

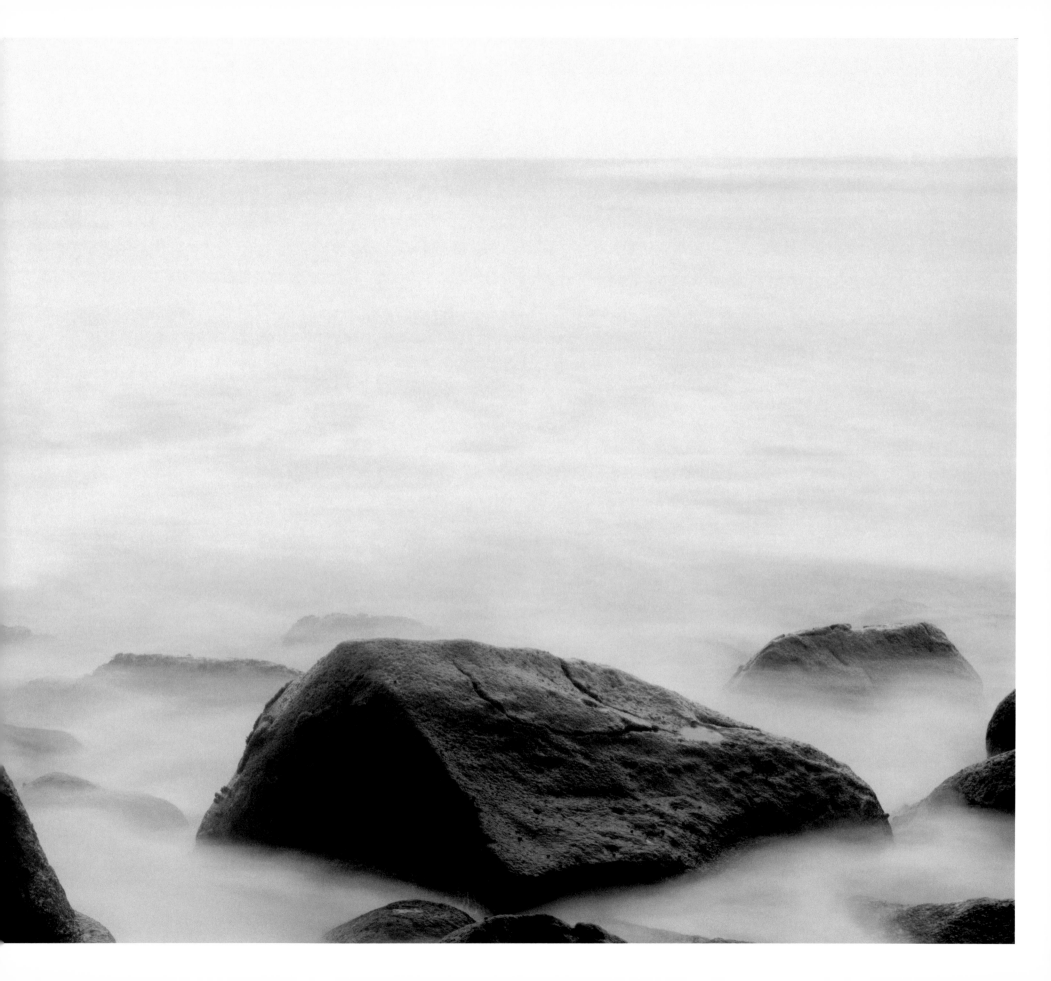

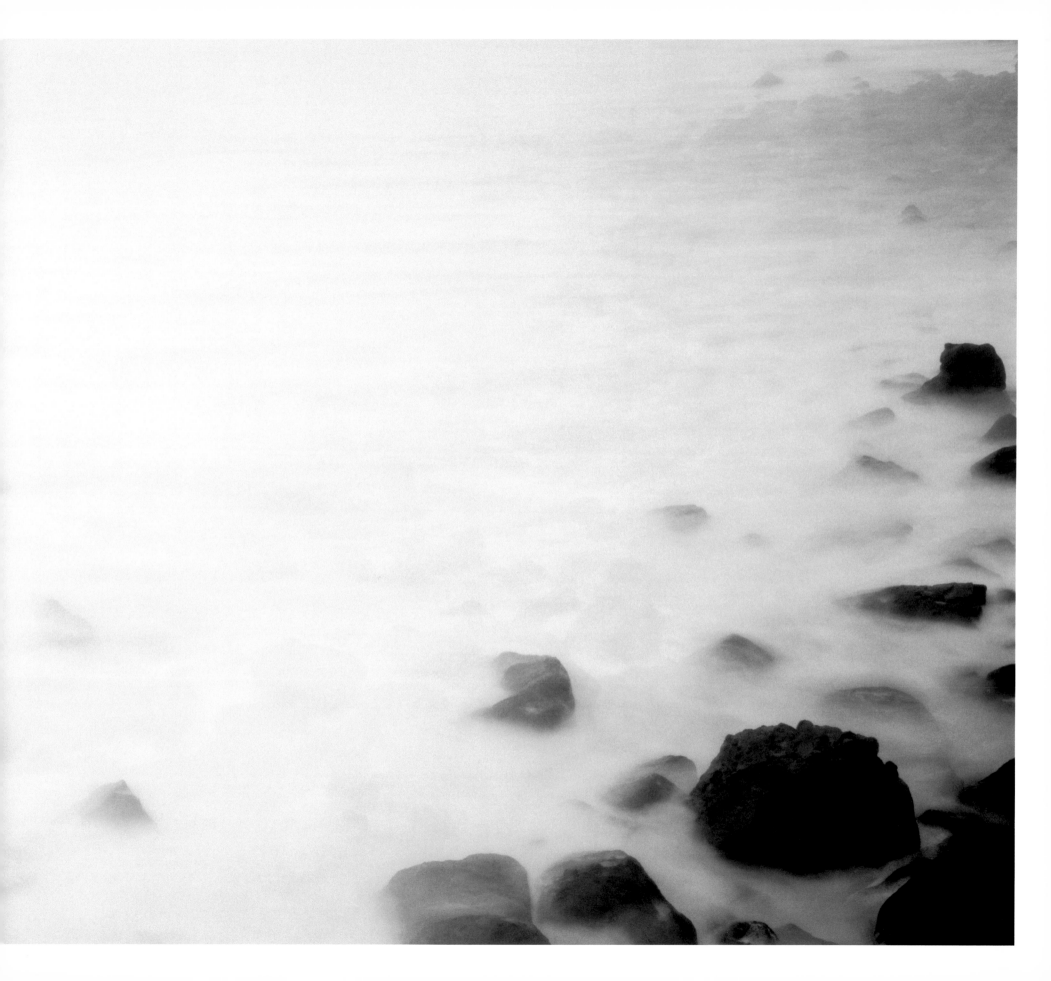

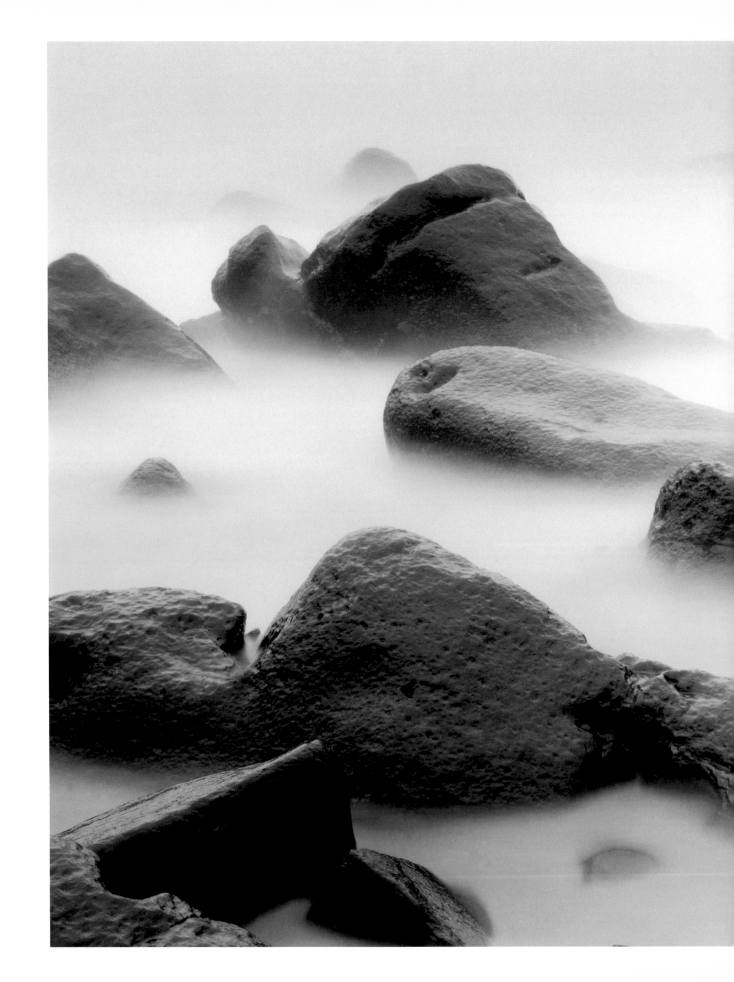

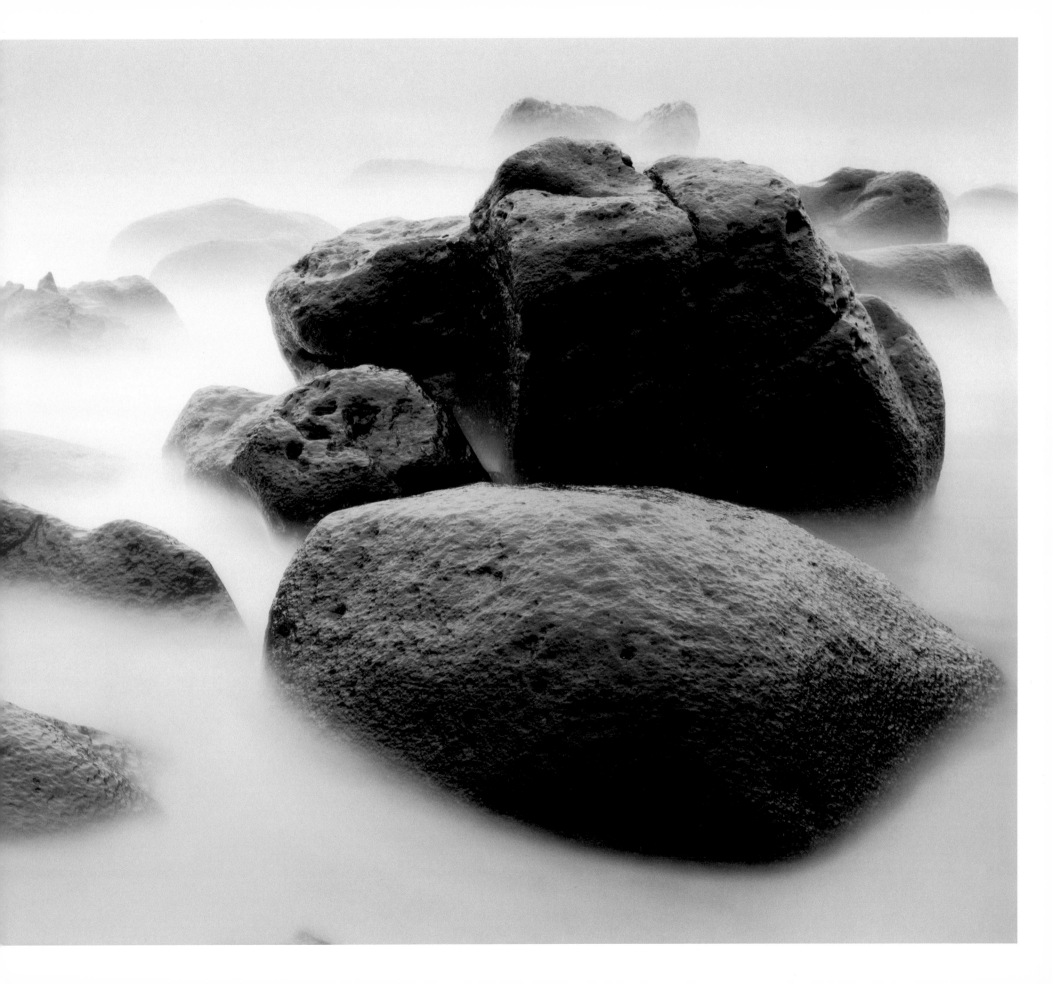

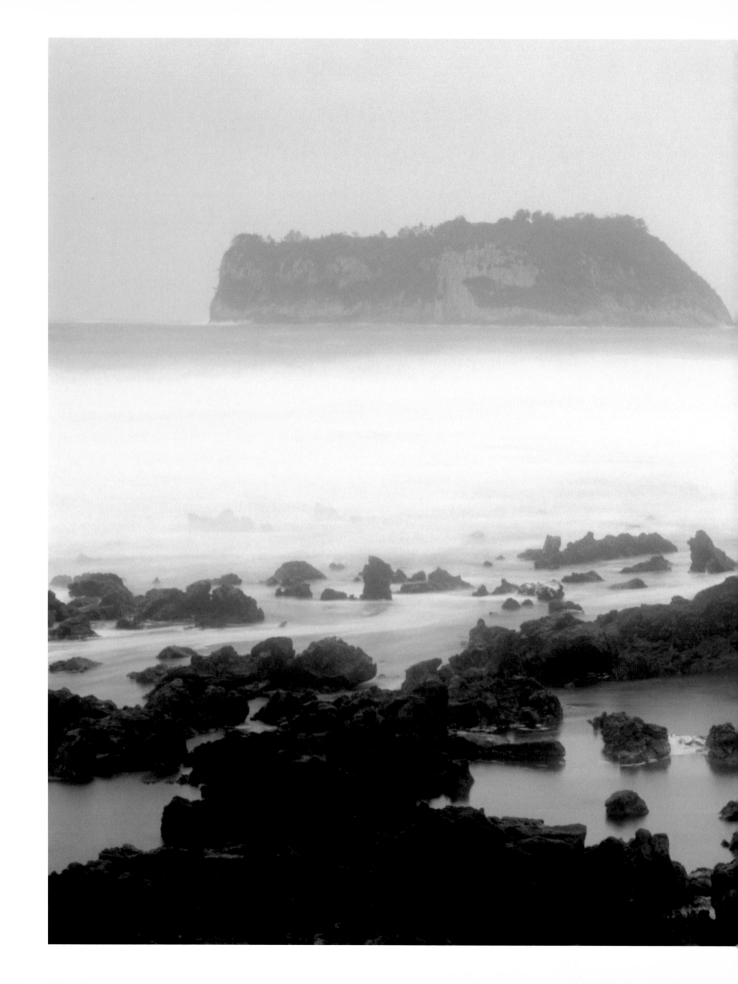

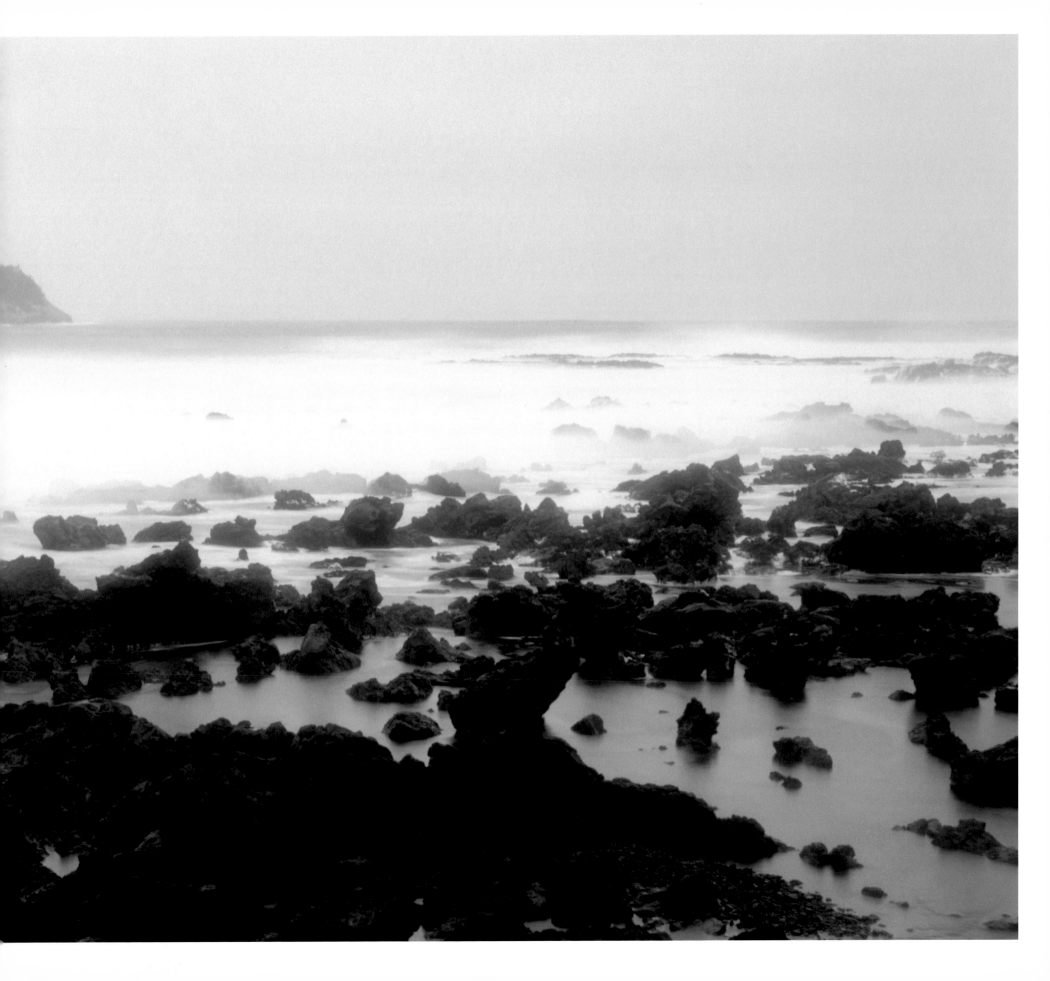

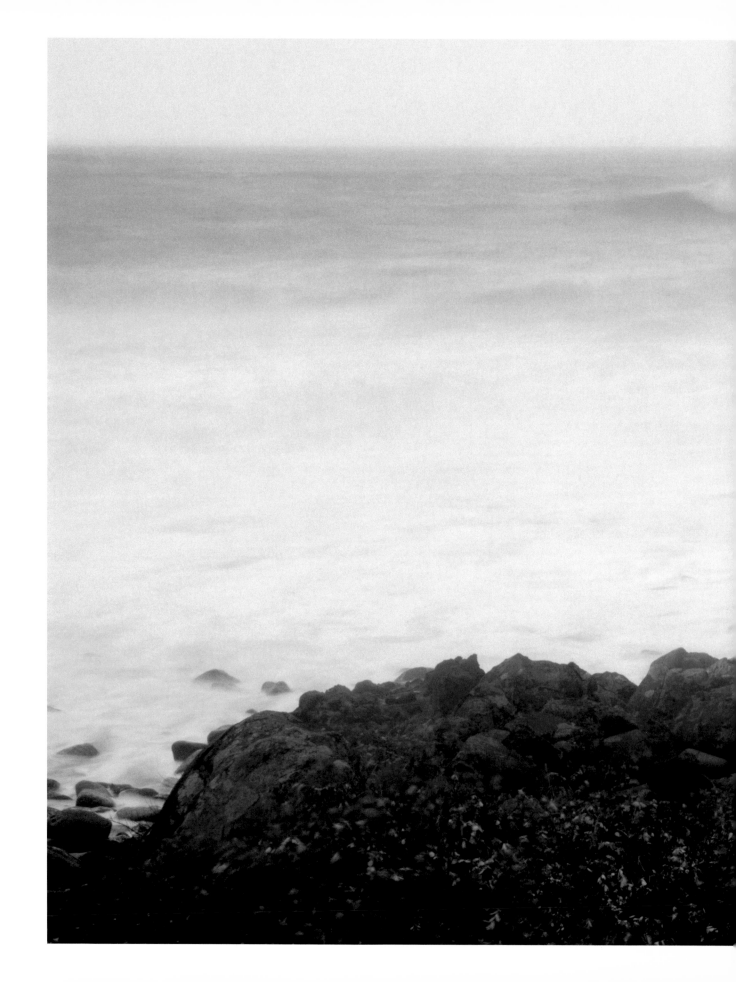

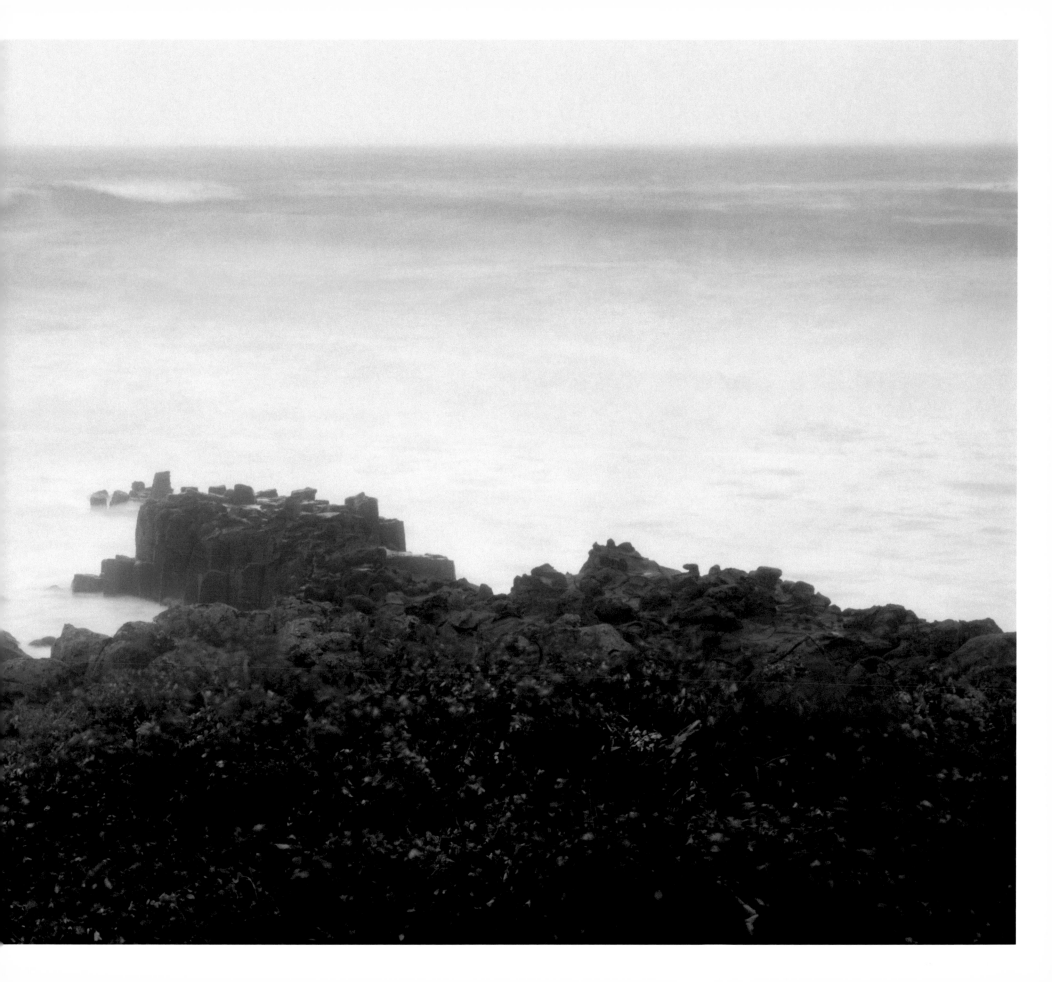

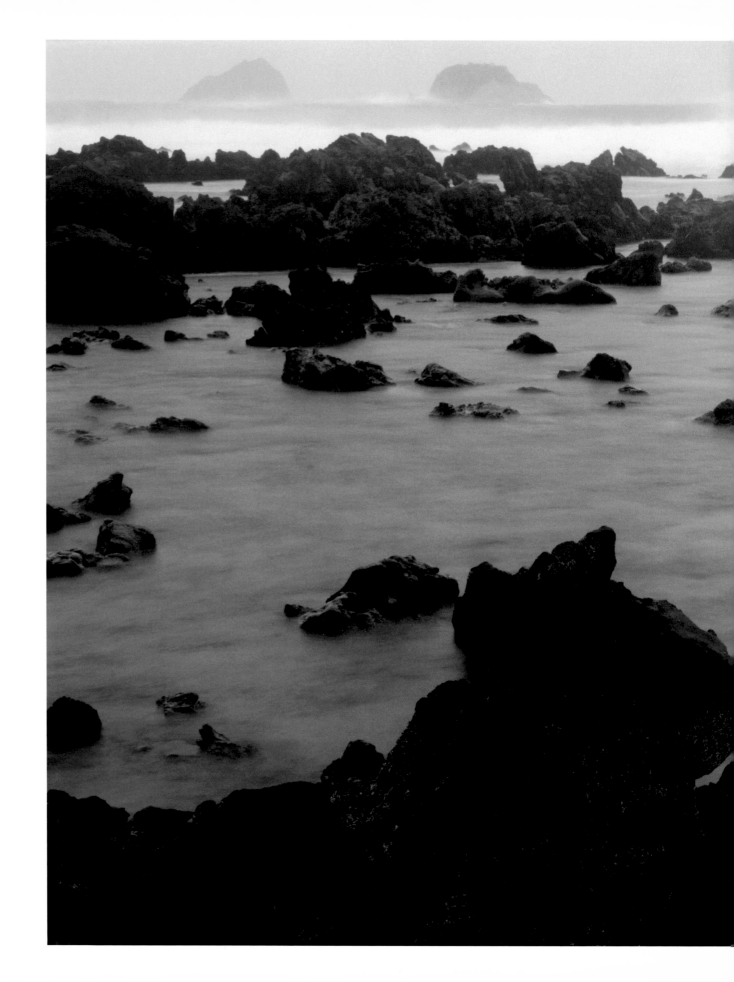

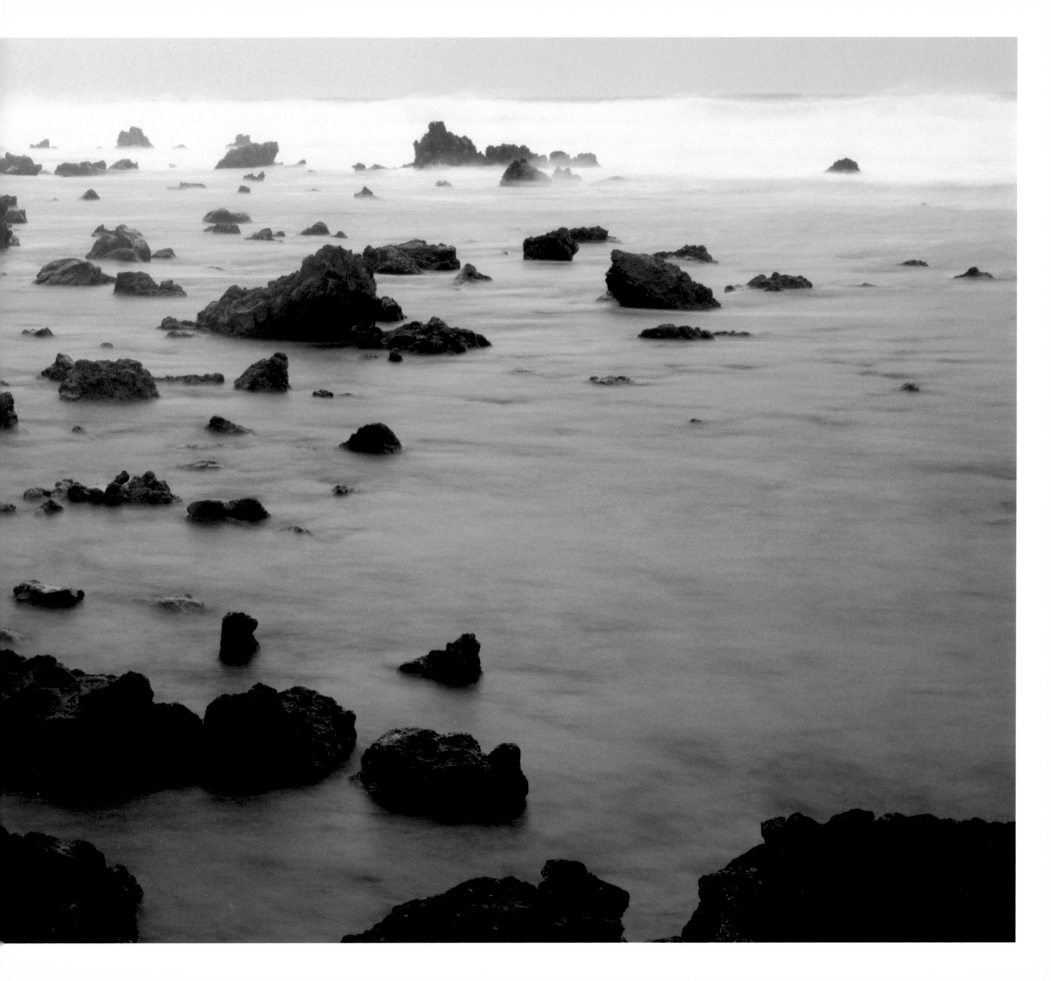

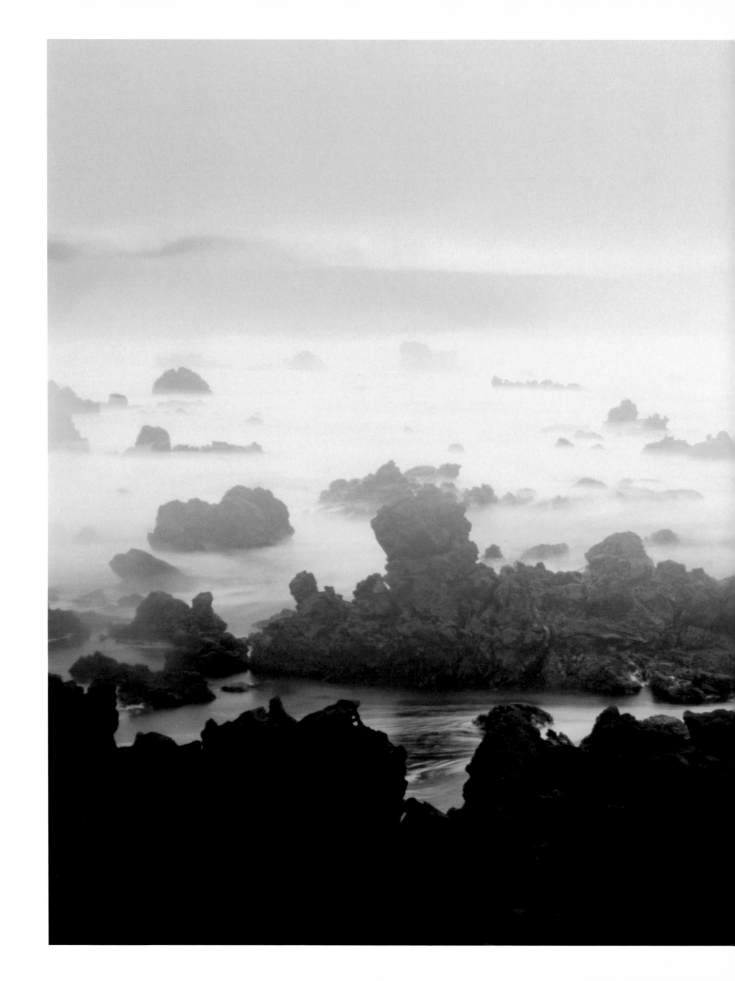

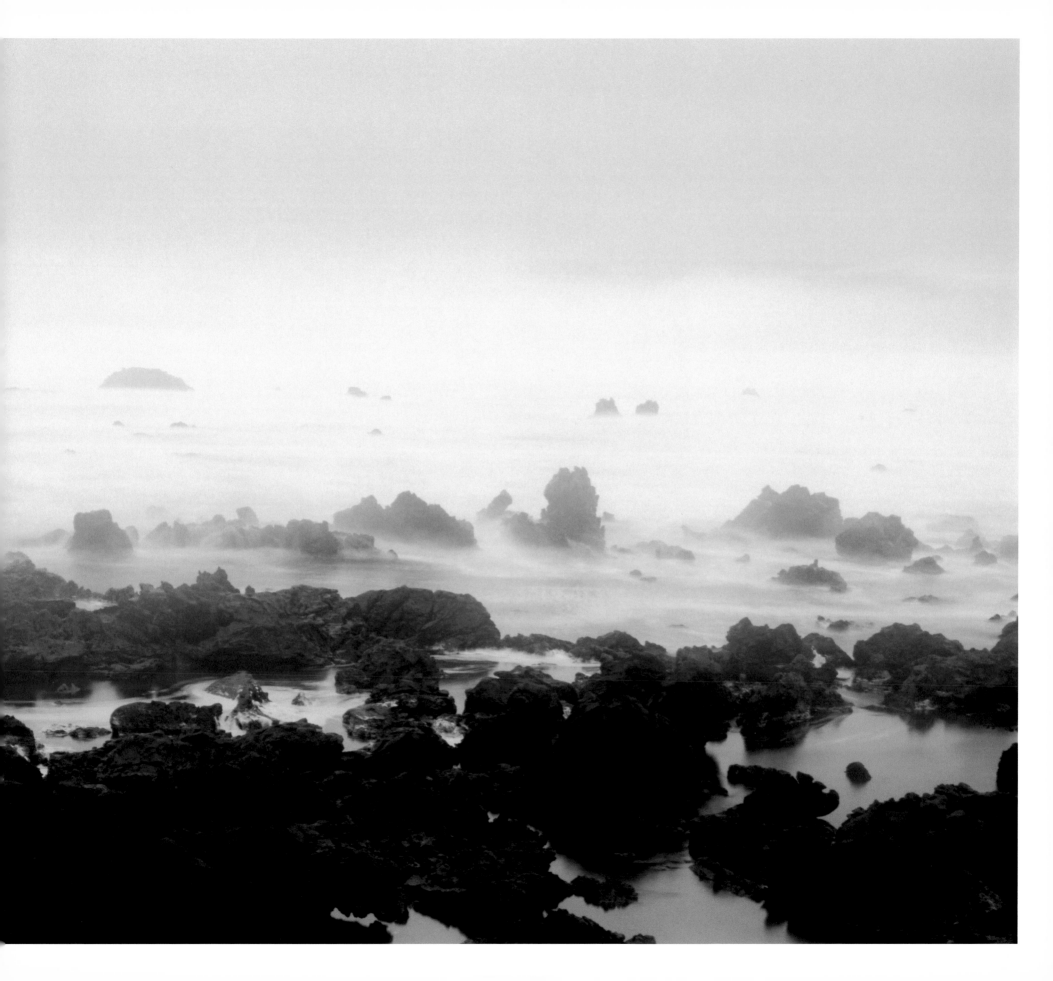

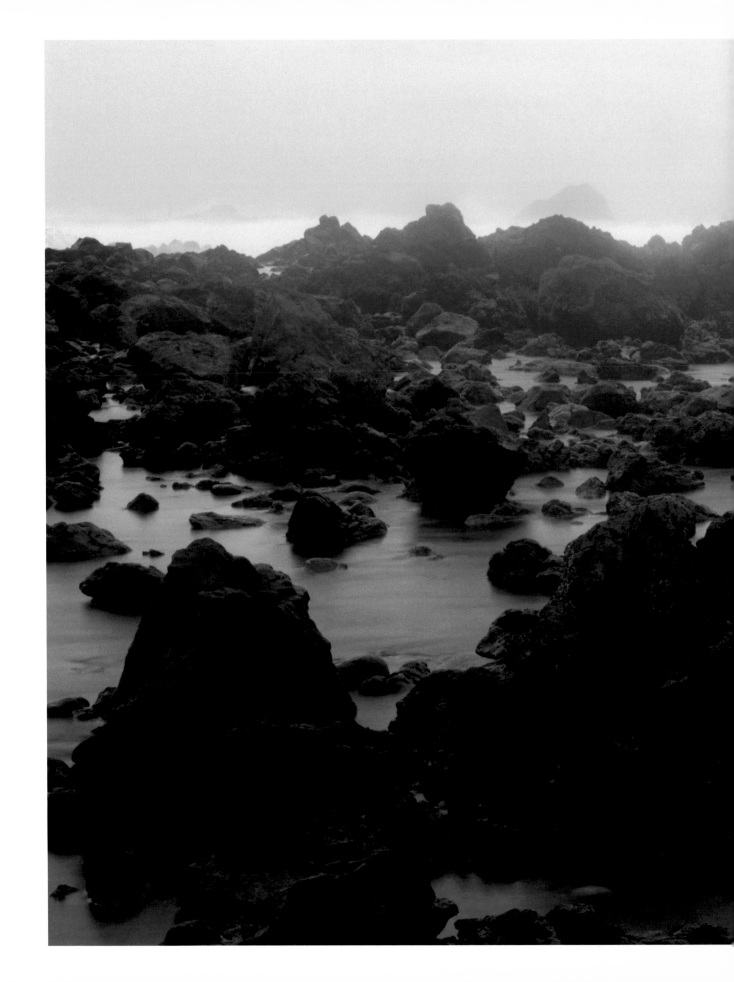

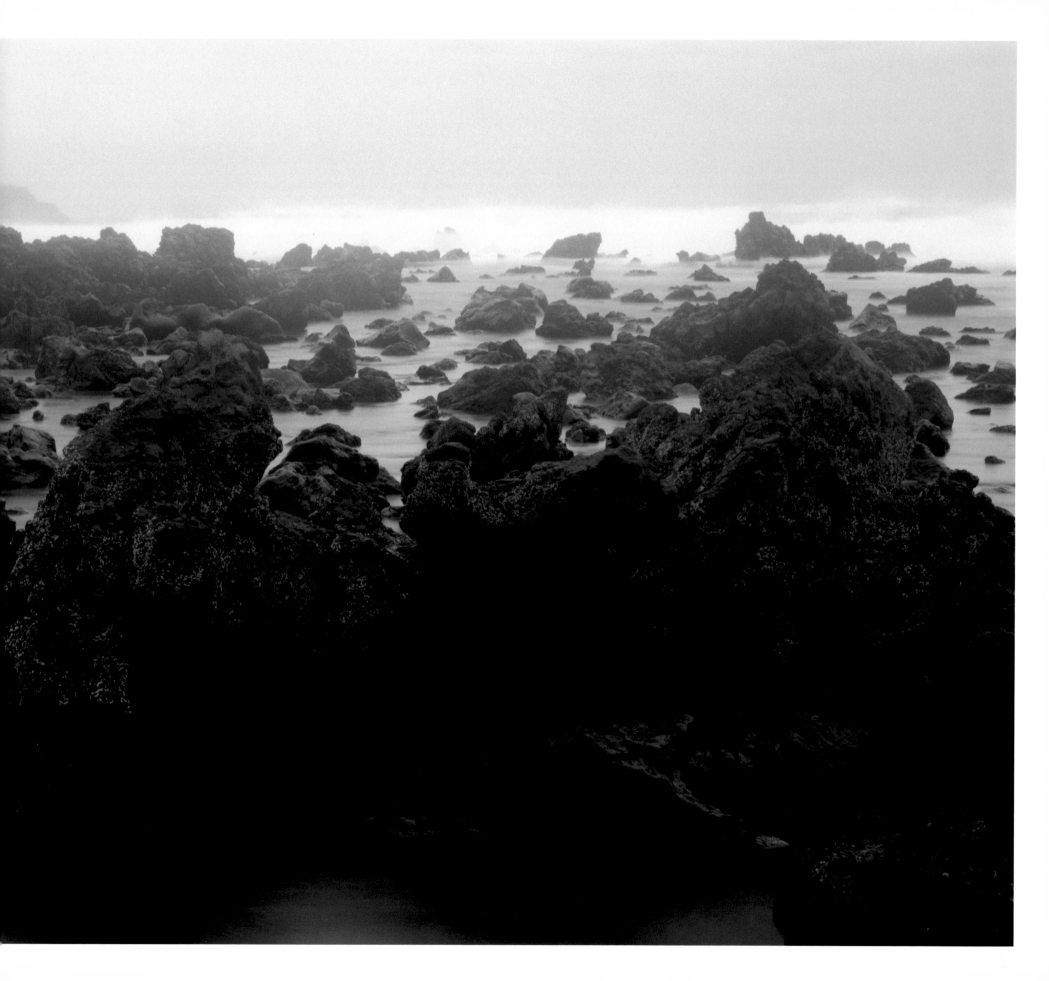

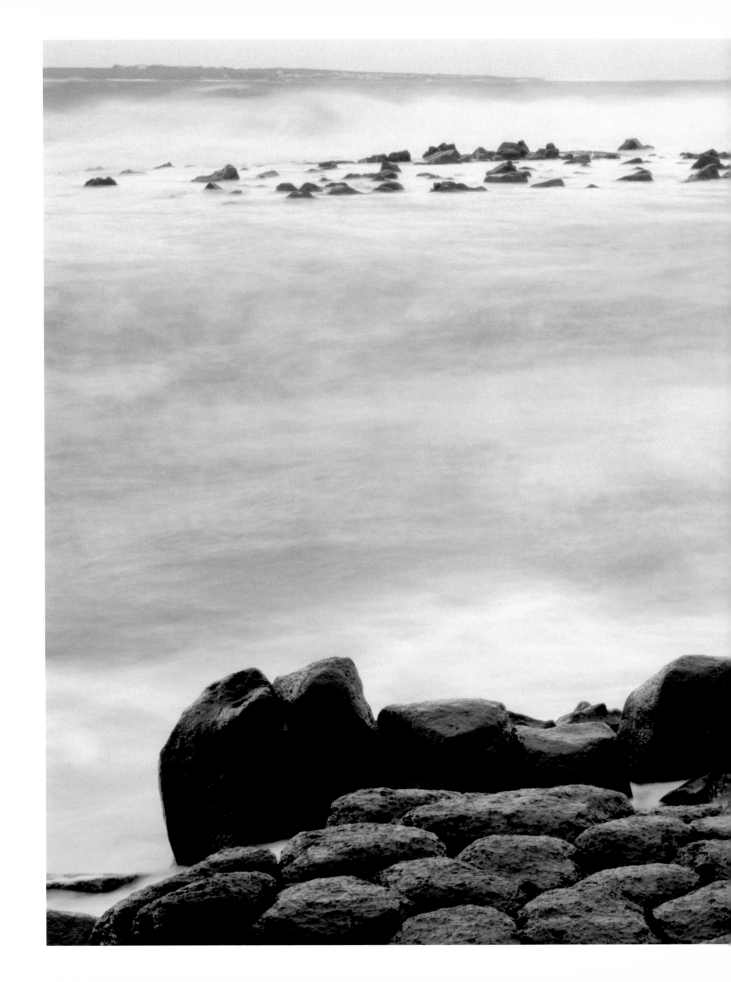

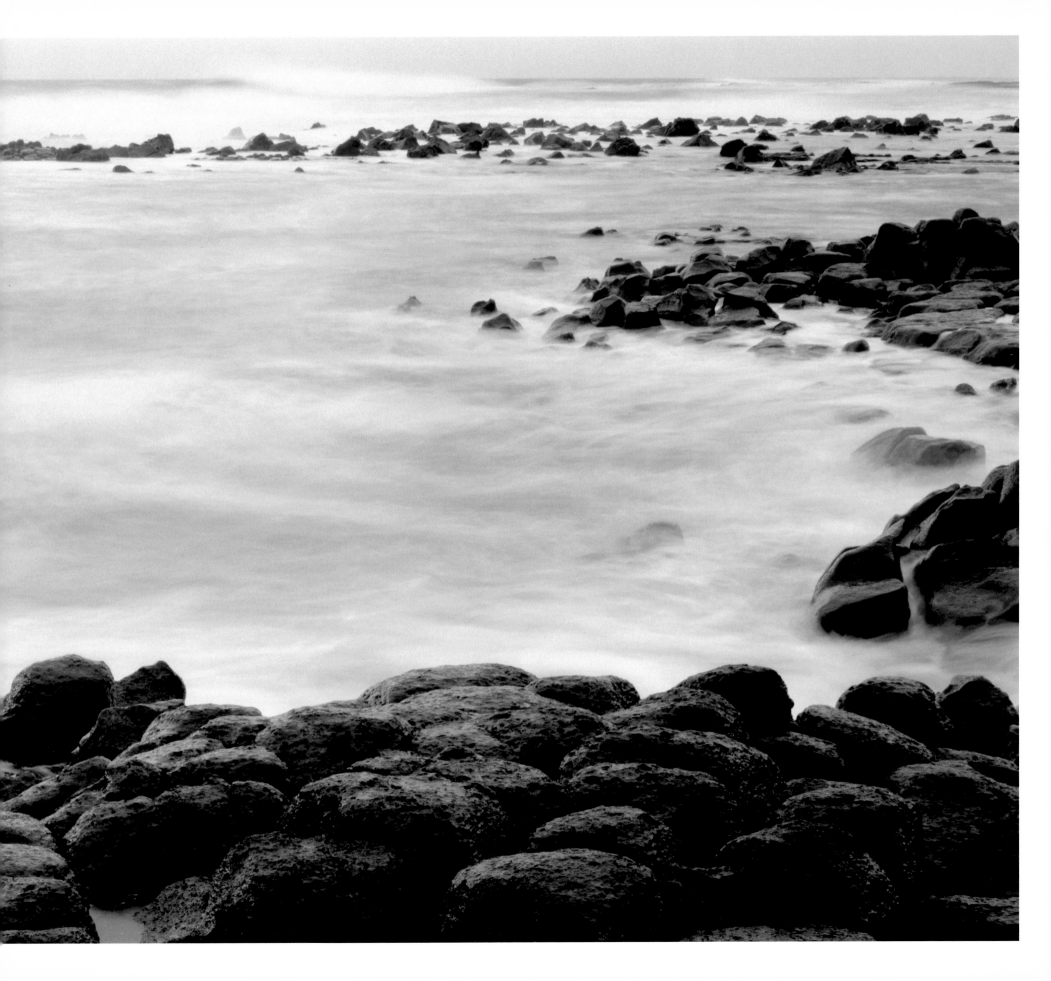

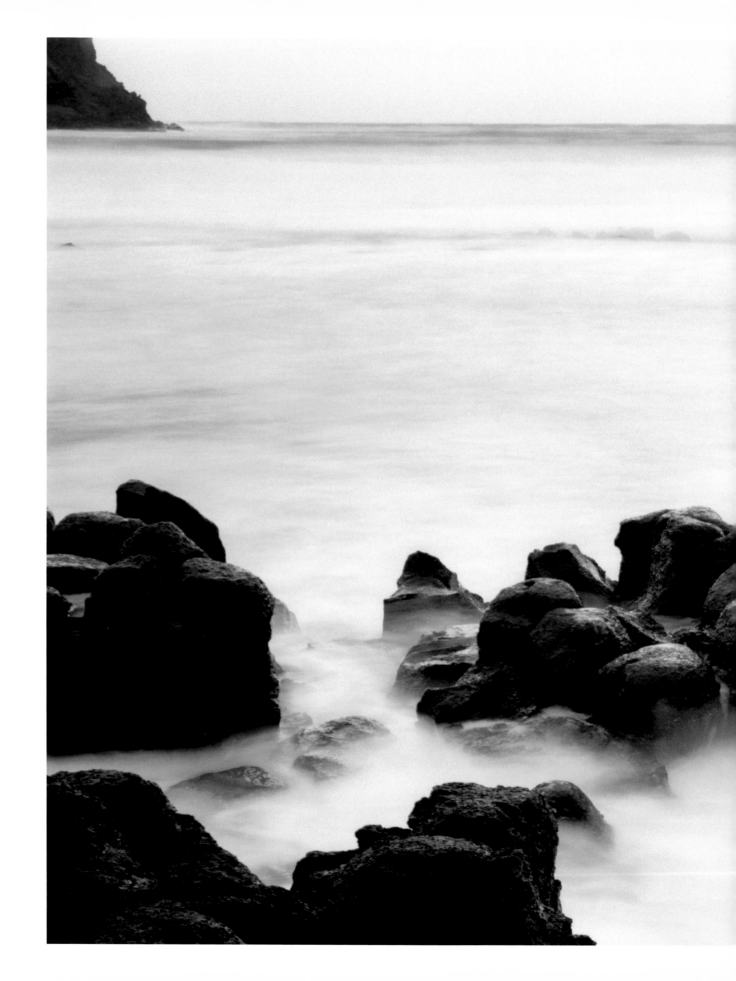

sea1a-089h, 2012

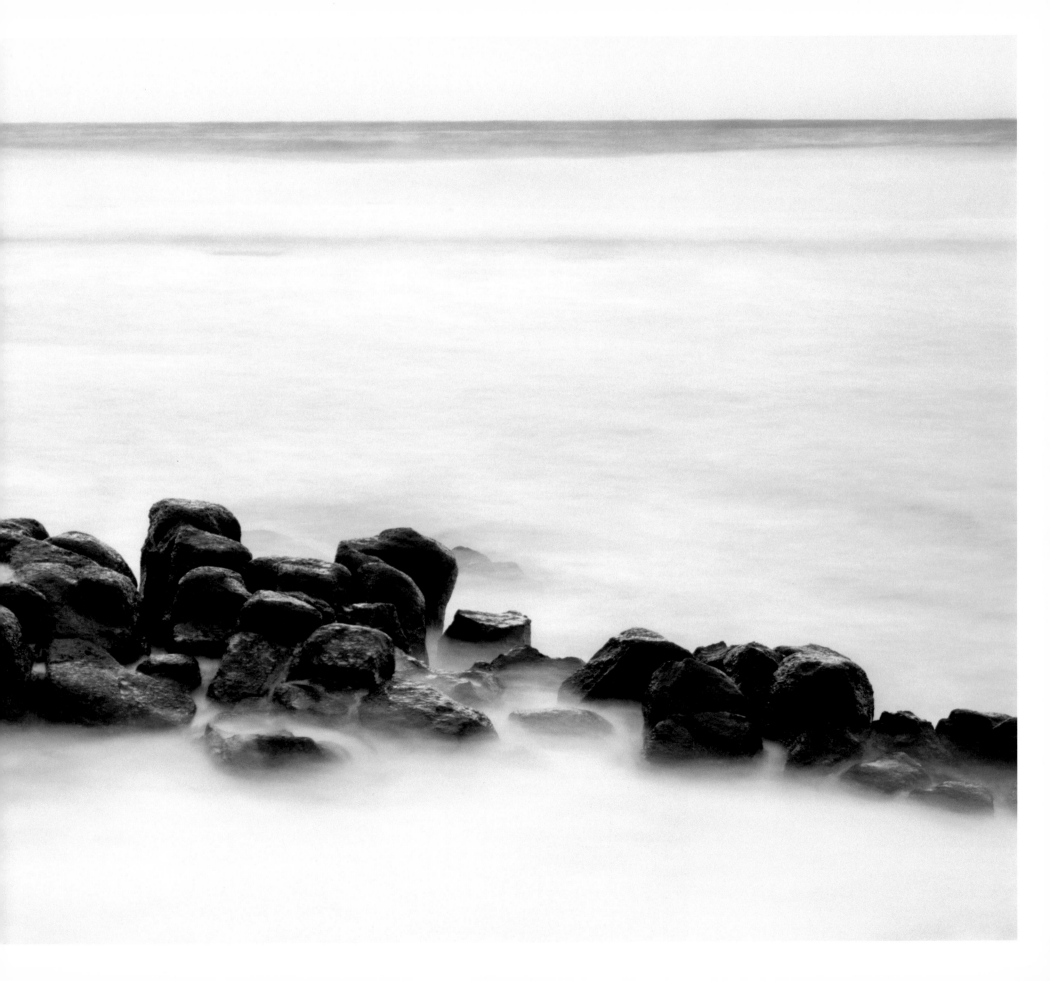

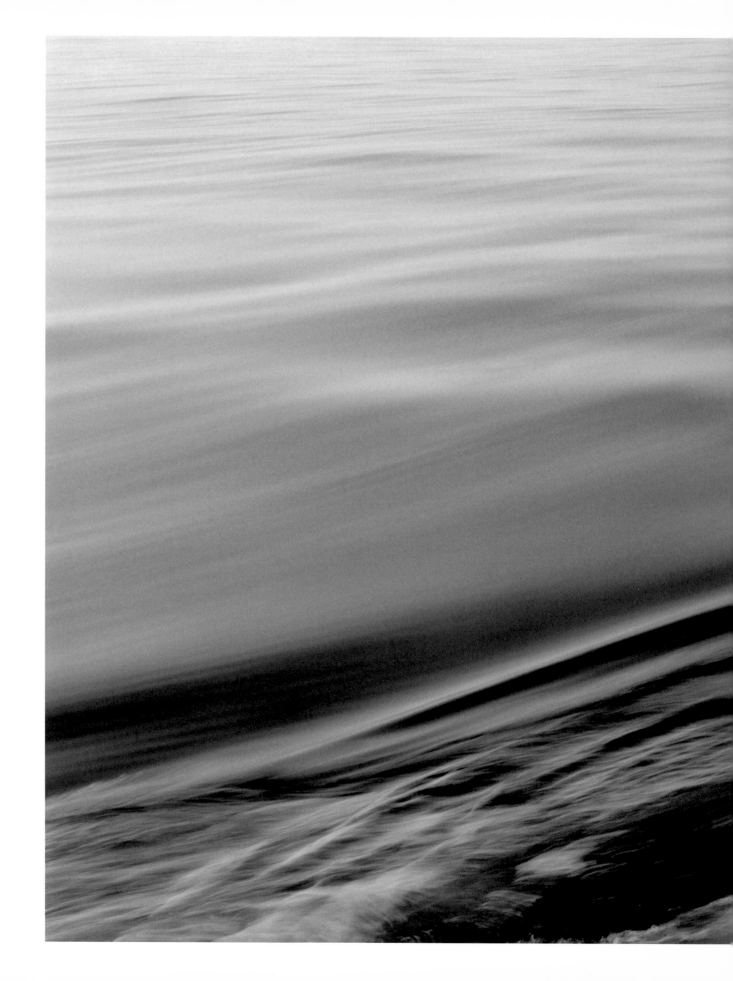

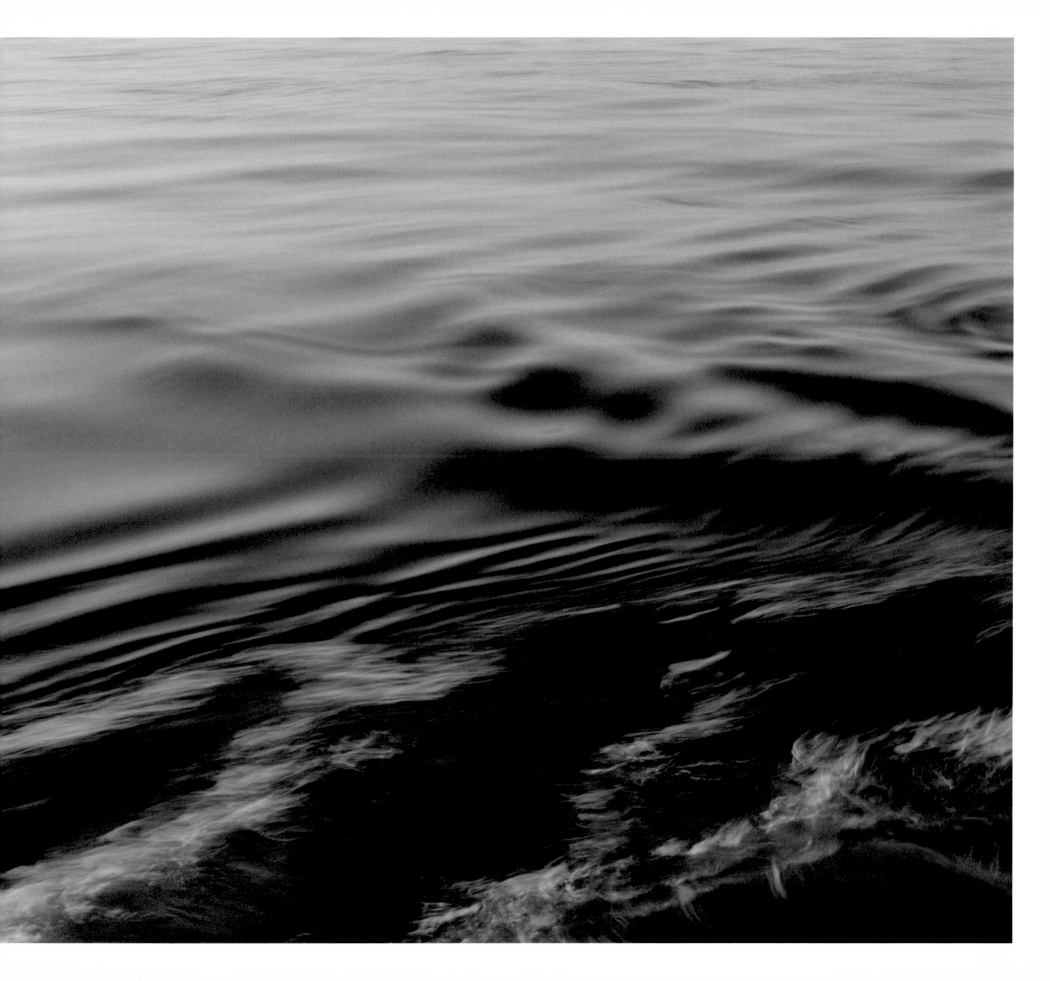

om1a-032h, 2002
Page 14

om1a-030h, 2007
Page 16

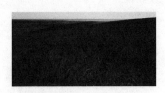

om1a-031h, 2007
Page 18

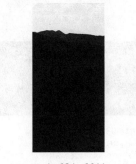

om1a-034v, 2011
Page 20

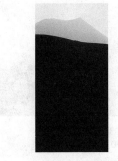

om1a-035v, 2002
Page 22

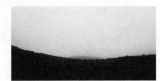

om1a-036h, 2009
Page 24

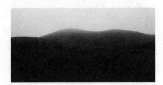

om1a-037h, 2009
Page 26

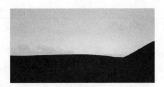

om1a-039h, 1999
Page 28

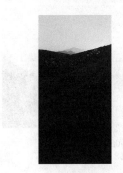

om1a-038v, 2011
Page 30

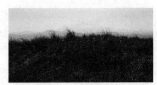

om1a-042h, 2007
Page 32

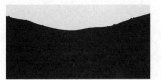

om1a-044h, 1999
Page 34

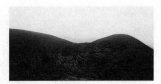

om1a-050h, 1999
Page 36

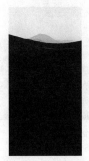

om1a-048v, 1999
Page 38

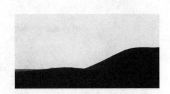

om1a-051h, 1999
Page 40

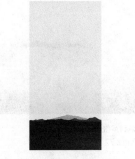

om1a-053v, 2007
Page 42

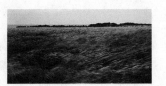

plt1a-029h, 2002
Page 44

All works are fiber-based gelatin silver in artist's frame, 102 × 197 cm.

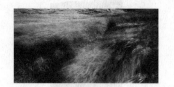

plt1a-030h, 2005
Page 46

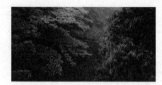

plt1a-031h, 2009
Page 48

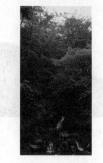

plt1a-044v, 2000
Page 50

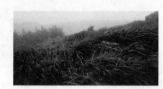

plt1a-032h, 2010
Page 52

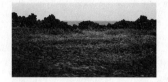

plt1a-033h, 2002
Page 54

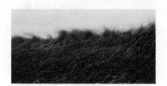

plt1a-043h, 2002
Page 56

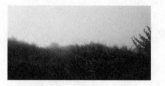

plt1a-034h, 2010
Page 58

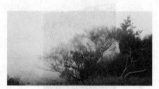

plt1a-035h, 2012
Page 60

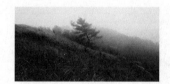

plt1a-040h, 2012
Page 62

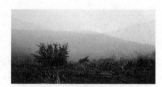

plt1a-045h, 2010
Page 64

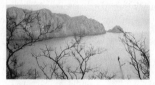

plt1a-041h, 2012
Page 66

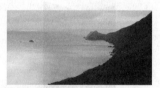

sea1a-064h, 2012
Page 68

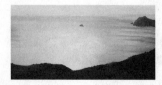

sea1a-066h, 2012
Page 70

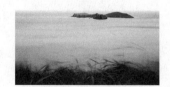

sea1a-063h, 2012
Page 72

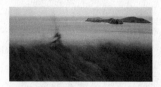

sea1a-061h, 2012
Page 74

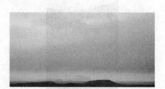

om1a-047h, 2007
Page 76

All works are fiber-based gelatin silver in artist's frame, 102 × 197 cm.

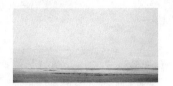

sea1a-071h, 1999
Page 78

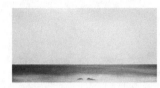

sea1a-072h, 2002
Page 80

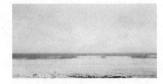

sea1a-073h, 2002
Page 82

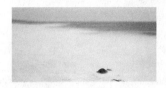

sea1a-079h, 2009
Page 84

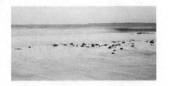

sea1a-082h, 2012
Page 86

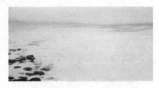

sea1a-075h, 1999
Page 88

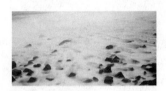

sea1a-051h, 1999
Page 90

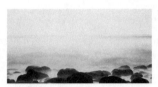

sea1a-062h, 2004
Page 92

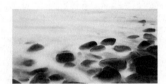

sea1a-050h, 1999
Page 94

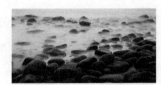

sea1a-054h, 1999
Page 96

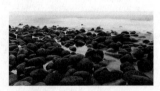

sea1a-008h, 2000
Page 98

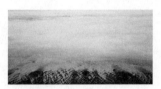

sea1a-084h, 2012
Page 100

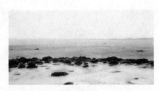

sea1a-060h, 2004
Page 102

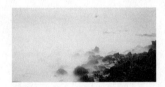

sea1a-068h, 2004
Page 104

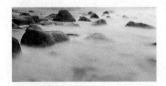

sea1a-069h, 1999
Page 106

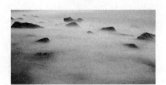

sea1a-032h, 1999
Page 108

All works are fiber-based gelatin silver in artist's frame, 102 × 197 cm.

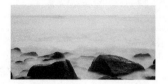

sea1a-074h, 1999
Page 110

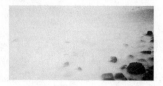

sea1a-053h, 1999
Page 112

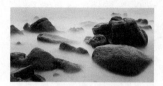

sea1a-076h, 1999
Page 114

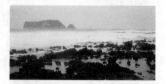

sea1a-090h, 2012
Page 116

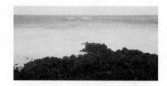

sea1a-092h, 2000
Page 118

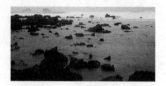

sea1a-085h, 2012
Page 120

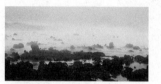

sea1a-081h, 2012
Page 122

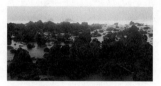

sea1a-086h, 2012
Page 124

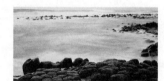

sea1a-087h, 2012
Page 126

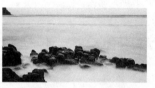

sea1a-089h, 2012
Page 128

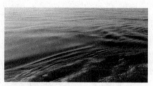

sea1a-024h, 2000
Page 130

All works are fiber-based gelatin silver in artist's frame, 102 × 197 cm.

APPENDIX

Biography · Exhibitions · Collections · Publications

Bae, Bien-U
Born in 1950, Yeosu, Korea
Lives and works in Seoul, Korea

Education

Since 1981
Professor of photography, Seoul Institute
of the Arts, Seoul, Korea

1988–89
Research Faculty, University of Applied
Sciences, Bielefeld, Germany

1978
MFA, Hong-ik University, Seoul, Korea

1974
BFA, Hong-ik University, Seoul, Korea

Selected Solo Exhibitions

2012
Windscape, AANDO FINE ART, Berlin,
Germany
Windscape, Christophe Guye Galerie,
Zurich, Switzerland
Windscape, Galerie RX, Paris, France
Sailing the Seas, GS Yeulmaru,
Yeosu, Korea

2011
Bae, Bien-U, Artsonje Museum, Gyeongju,
Korea
ConvexConcave, Axel Vervoordt Gallery,
Antwerp, Belgium

2010
Where God and Man Collide, House for
Mozart, Salzburg Festival, Salzburg, Austria
Bae, Bien-U, Ilwoo Space, Seoul, Korea

2009
Bae, Bien-U, National Museum of
Contemporary Art, Deoksugung, Seoul,
Korea
Soul Garden, Museo de Bellas Artes de
Granada, Palacio de Carlos V., Spain
Sacred Wood | Bae, Bien-U, AANDO FINE ART,
Berlin, Germany
Sacred Wood, Galerie Zur Stockeregg, Zurich,
Switzerland

2008
Bae, Bien-U, Phillips de Pury & Company,
London, UK
Timeless Photography | Bae, Bien-U, Bozar
Center for Fine Arts, Brussels, Belgium
Bae, Bien-U | Sonamu, Gana Art Center,
New York, USA

2007
K Collection "Bae, Bien-U," Lee C Gallery,
Seoul, Korea
Sea & Island, Gana Art Center, Busan, Korea

2006
Sonamu, Museo Thyssen-Bornemisza,
Madrid, Spain

2005
Bae, Bien-U, Galerie Poller, Frankfurt
am Main, Germany
Beauty of Korea, Insa Art Center, Seoul,
Korea

2004
Wind of Tahiti, Galerie Gana-Beaubourg,
Paris, France
Wind of Tahiti, Gana Art Center, Seoul,
Korea

2003
Tahiti Festival de la Photographie, Tahiti,
French Polynesia

2002
Bae, Bien-U, Artsonje Museum, Seoul, Korea
Pine, Galerie Gana-Beaubourg, Paris, France

2001
Bae, Bien-U, ISE Cultural Foundation,
New York, USA

2000
Tree | Bae, Bien-U, Galerie Bhak, Seoul, Korea
Bae, Bien-U, Sigong Gallery, Daegue, Korea

1998
Photographies du Kyungju, Galerie Jean-Luc &
Takako Richard, Paris, France

1993
Meeting and Departure, Seoul Art Center,
Seoul, Korea

1989
Landscapes, Hochschule Galerie, Bielefeld,
Germany

1988
Korean Landscapes, Raiffeisenbank Galerie,
Bamberg, Germany

1985
Marado, Hanmadang Gallery, Seoul, Korea

1982
Seascapes, Kwan Hoon Gallery, Seoul, Korea

Selected Group Exhibitions

2011
TRA: Edge of Becoming, Palazzo Fortuny, Venice, Italy
38°N Snow South: Korean Contemporary Art, Galleri Charlotte Lund, Stockholm, Sweden

2010
The Wind in the Pines: 5,000 Years of Korean Art, State Hermitage Art Museum, St. Petersburg, Russia

2009
Art in Busan, Busan Museum of Modern Art, Busan, Korea
Infinitum, Palazzo Fortuny, 53rd Venice Biennale, Venice, Italy
Korean Contemporary Photographers: 2009 Odyssey, Hangaram Art Museum, Seoul, Korea

2008
Bozar Festival: *Made in Korea,* Center for Fine Arts, Brussels, Belgium

2007
Void in Korean Art, Leeum Samsung Museum of Art, Seoul, Korea
Reminiscing the Medium: A "Post" Syndrome, MoA Picks, Museum of Art, Seoul National University, Seoul, Korea

2006
Simply Beautiful, CentrePasquArt, Biel, Switzerland
Le Gran Jardin, Joinville, Brazil
The Modern Photography, Gwangju Museum of Art, Gwangju, Korea
Bae, Bien-U and Elger Esser, 6th Photo Festival, Gana Art Center, Seoul, Korea

2005
Bae, Bien-U and Kim Atta, Galerie Gana-Beaubourg, Paris, France

2004
Real Reality, Kukje Gallery, Seoul, Korea
Bae, Bien-U, Bohnchang Koo, and Byung Hun Min, White Wall Gallery, Seoul, Korea

2003
Time of Nature Time of Human, Daejeon Municipal Museum of Art, Korea
Real-Scape Revisited, National Museum of Contemporary Art, Gwacheon, Korea

2002
Now, What Is Photo, Gana Art Center, Seoul, Korea
Tahiti Festival de la Photographie, Tahiti, France

2001
6th Internationale Fototage Herten, Herten, Germany

2000
Contemporary Photographers from Korea, FotoFest Biennial, Williams Tower & Tower Gallery, Houston, USA
Slowness of Speed, Artsonje Center, Seoul, Korea
Odense Foto Triennale, Odense, Denmark

1999
Figure and Landscape in Korea, Hanlim Museum, Daejeon, Korea
Commemorative Photograph Exhibition, The Korean Culture and Arts, Foundation Art Museum, Seoul, Korea
Contemporary Asian Artwork from the Sol LeWitt Collection, Montserrat, Spain

1998
Alienation and Assimilation, Museum of Contemporary Photography, Chicago, USA
Contemporary Art from Korea, Haus der Kulturen der Welt, Berlin, Germany
Slowness of Speed, National Gallery of Victoria, Melbourne, Australia

1997
Fast Forward, The Power Plant Contemporary Art Gallery, Toronto, Canada
Sonahmuyeo, Sonahmuyeo, The Hwanki Museum, Seoul, Korea
Inside Out, Institute of Contemporary Art, Philadelphia, USA

1996
Photography: New Vision, National Museum of Contemporary Art, Seoul, Korea
An Aspect of Korean Art in the 1990s, The National Museum of Modern Art, Tokyo, Japan

1995
Photography Today, Artsonje Museum, Kyungju, Korea
Territory of Mind: Korean Art of the 1990s, Mito Art Tower, Ibaraki, Japan

1994
Visions from the Land of Morning Calm, Pima Community College Art Gallery, Arizona, USA

1993
Contemporary Photography of Korea in Seoul, Seoul Art Center, Seoul, Korea

1992
Horizon of Korean Photography, Seoul Museum of Art, Seoul, Korea

1991
Horizon of Korean Photography, Total Museum of Contemporary Art, Jang Heung, Korea

1989
The 150th Anniversary of Photography Show, Bamberg Neue Residenz, Bamberg, Germany

1987
Three Men's Color Images, Gallery Gong-Gan, Seoul, Korea

Collections

National Gallery of Victoria, Melbourne,
Australia
National Museum of Contemporary Art,
Seoul, Korea
The National Museum of Modern Art,
Tokyo, Japan
Contemporary Arts Museum, Houston, USA
21C Museum, Kentucky, USA
Leeum Samsung Museum, Seoul, Korea
Ilwoo Foundation, Seoul, Korea
The Museum of Contemporary Photography,
Chicago, USA
Busan Museum of Modern Art, Korea
Daejeon Municipal Museum of Art, Korea
Rothschild Foundation, Paris, France
The Sol LeWitt Collection, New York, USA
Elton John Collection, London, UK
Afinsa Collection, Madrid, Spain
Calder Foundation, New York, USA
Monica Vögele Sammlung, Küsnacht,
Switzerland
Enzo Enea Sammlung, Jona, Switzerland
Sammlung Carolina Müller-Möhl,
Ebmatingen, Switzerland

Selected Publications

Drawing with Light: Bae, Bien-U. Seoul, 2010.
Bae, Bien-U. Exh. cat. National Museum of
Contemporary Art. Seoul, 2010.
Bae, Bien-U: Sacred Wood. Edited by
Wonkyung Byun and Thomas Wagner. Exh.
cat. Phillips de Pury. London, 2008; Bozar
Center for Fine Arts. Brussels, 2009.
Alhambra Jardin del Alma: Soul Garden.
Exh.cat. Museo de Bellas Artes de Granada.
Granada, 2009.
Changdeokgung Palace. Seoul, 2009.
Hwang, Hakju. *Gohyang.* Seoul, 2007.
Bien-U: Sonamu. Edited by Kim Seung-
Gon. Exh. Cat. Museo Thyssen-Bornemisza.
Madrid, 2006.
The Beauty of Korea. Paju, 2005.
Horizon. Seoul, 1999.
*Chongmyo Royal Ancestral Shrine of the
Chosun Dynasty.* Seoul, 1998.
Bien-U: Sonamu. Exh. Cat. Seoul Art Center.
Seoul, 1993.
Art Vivant: Contemporary Korean Artists.
Edited by Jaekook Chun. Seoul, 1992.
Marado. Seoul, 1985.

Bae, Bien-U: Windscape

Editor:
Wonkyung Byun

Project manager:
Veit Rieber

Text:
Prof. Dr. Jeong-hee Lee-Kalisch,
Freie Universität Berlin

Copyediting:
Leina González, Tas Skorupa

Translation:
Rebecca van Dyck

Graphic design and typesetting:
www.naroska.de

Production:
Nadine Schmidt, Hatje Cantz

Reproductions:
Jan Scheffler, prints professional

Printing and binding:
DZA Druckerei zu Altenburg GmbH,
Altenburg

Paper:
PhoeniXmotion Xantur, 170 g/m²;
Alster Werkdruck bläulichweiss, 60 g/m²

© 2012 Hatje Cantz Verlag, Ostfildern,
and authors
© 2012 for the reproduced works by
Bae, Bien-U: the artist
All works courtesy of AANDO FINE ART, Berlin
www.aandofineart.com

Published by
Hatje Cantz Verlag
Zeppelinstrasse 32
73760 Ostfildern
Germany
Tel. +49 711 4405-200
Fax +49 711 4405-220
www.hatjecantz.com

Hatje Cantz books are available
internationally at selected bookstores.
For more information about our
distribution partners, please visit our
website at www.hatjecantz.com.

Two special Collector's Editions are
available, each with a signed and
numbered gelatin-silver print on fiber-
based paper by Bae, Bien-U. The
two motifs (see pages 42 and 90)
are presented in oak frames with
museum glass, measuring 28 by 53
centimeters each, in a limited edition
of 25 + 3 a.p.

ISBN 978-3-7757-3497-4

Printed in Germany

Cover illustration:
sea1a-075h, 1999

Kind support was provided by
AMOREPACIFIC Corporation